SLAVERY IN

Wilkes County

NORTH CAROLINA

LARRY J. GRIFFIN

THE
History
PRESS

Published by The History Press
Charleston, SC
www.historypress.net

Front cover, top, far left: Thomas Ruffin (1787–1870), chief justice of the Supreme Court of North Carolina (1833–52). In the public domain; *second from left*: from *Treasure Troves*; *second from right:* courtesy of Evonne Raglin; *far right*: Fort Defiance Pictorial Collection; *bottom*: Fort Defiance Pictorial Collection.
Back cover: St. Paul's Parish Register; *insert: On a White Horse*. 2016. Oil painting used through the express permission of Wilton "Bud" Mitchell, great-grandson of William Henderson Waugh.

First published 2017

ISBN 9781540216601

Library of Congress Control Number: 2017931819

CONTENTS

FOREWORD

I am delighted to write a foreword for this book. It represents two subjects for which I have an insatiable thirst: history and genealogy.

For many years, I gave little thought to any connection I might have had to the South. Mammy Judy (though we never referred to her by that name, she was simply Grandma Judy) was dead. Grandma Clara and all of her children had relocated to Illinois and Pennsylvania in the 1920s. We all identified ourselves as northerners. I knew that there were distant relatives in northwestern North Carolina, but I had never been to Ashe or Wilkes County. They were just places I heard Mom and others mention on occasion. These relatives were not important to me. Little did I know their real importance to the Mammy Judy story.

My mother, Venie Smith Brooks, often referred to her relatives as the B-H-Ss—Barber, Harris and Smith. When I helped her start a family reunion more than forty years ago, she named the reunion "The Roots of Love: Barber, Harris, Smith." All three-hundred-plus members were related to her, but not necessarily to one another.

Grandma Clara Barber, the ninth daughter of Grandma Judy, had married a free person of color named Edmund Harris. Their youngest daughter, Mary Jean (Mamie), married Arthur Smith, also a free person of color. Reflecting back over my life, I remember that in school, the white kids would make snide references to blacks and slavery when the history lesson got to the slave era. Those remarks were cruel and hurting.

Mom would always tell us that two-thirds of her lineages were free people of color—never slaves. She would say, "Yes, Grandma Judy and Grandma Clara were slaves, but look at what we have accomplished in life." Mom would remind us that her aunts and uncles, children of Clara, did not appear to have been negatively influenced by the fact that Grandma Clara and her mother had been slaves. They were schoolteachers, a publisher of a newspaper, ministers and leaders in their churches and communities. All were landowners.

Those of us born in the North often gave little thought to the adversity our ancestors faced in the South. It was much later, when I began to have children of my own, that I began to think about the deep anguish Grandma Judy must have felt to have two of her children sold away from her. And I thought of the vulnerability she must have experienced when the "Master" fathered my Grandma Clara. Every challenge they overcame cannot be diminished in my mind ever again.

Earlier, I mentioned our relatives, the Smiths, who were free people of color. Census records list them as "mulatto." I do not know where they resided before 1850, when they moved from Wake County. Wilkes County was intended to be a rest stop on their way to Illinois. Grandpa Eldridge, Grandma Jane and their twelve children fell in love with the rolling hills and beautiful scenery of the Traphill area of Wilkes County. Some of their sons did leave Wilkes County, moved to Ashe County and finally settled in Vermilion County, Illinois. Eldridge and Jane never left. Grandma Jane lived her final years with her son, Uncle Isaiah, a prominent teacher and community leader also featured in this book.

It is because of marriages between children of Henderson Waugh and the Smiths that I also have relatives who are descendants of Colonel Waugh. He is a key figure in this book. In fact, he was often around Grandma Judy and may have fathered Grandma Clara's sister, Martha, who was sold as a child. If he did, then Martha, daughter of Mammy Judy, would have been Henderson Waugh's half sister.

My involvement in the research that preceded the publishing of this book came about because the author, Larry Griffin, had started a newspaper series on "Slavery in Wilkes County." I phoned him, a total stranger, and asked for his assistance in answering a critical question in my mind. The question was how my Grandma Judy—now called Mammy Judy—a slave, could ascend to a position of such high regard by blacks and whites in Wilkes County. I could only surmise the cunning it must have taken for Mammy Judy to move through the hierarchy of slave jobs to become so valuable to the running of

the Barber household. She was able to protect the majority of her children from being sold or sent to the fields to do grueling work. By now, our family had already published a book, *Treasure Troves*, about the lives of Mammy Judy and her descendants. I shared our family records with Larry, and the process began. We now have a valued friendship.

Our lives have been inexorably shaped by the legacy Mammy Judy and Grandma Clara left us. Their insistence that we always speak standard English and go to college was based on the fact that they found a way to become literate when it was illegal to teach slaves to read and write. Every facet of their existence was based on a determination to live a spiritual life, have their children gain an education, own land and have the respect of their community. Grandma Clara, Grandma Mamie and Mom had amazing wisdom. They always preached, "Be independent; dream big, and always remember that our lives will be shaped by the choices we make—decisions have consequences."

This intriguing book provides an in-depth view of the lives of African Americans during slavery and after. Enjoy!

—*Evonne Raglin*
Great-great-granddaughter of Mammy Judy

ACKNOWLEDGEMENTS

*P*erhaps the most daunting aspect of writing a book is this one—penning the acknowledgements. How can any author adequately acknowledge all who contributed, in one way or another, to the success of his endeavor to capture a "window frame moment" of history? There have been so many individuals who have stepped forward to share knowledge and/or encouragement as I have labored to bring this work to a "final state of incompletion." Though I cannot list all by name in the space allotted, I would like to highlight several whose support undergirded the process from research to rendering.

I am not native to Wilkes County and thus was unacquainted with its unique history. It was through Historic Ghost Tours, hosted by the Wilkes Heritage Museum, that I first heard the facts and folklore of the county's past. Later, I obtained additional insights while volunteering and working for a brief time at the museum. I am indebted to director Jennifer Furr and volunteer coordinator Diana Perry for affording me the opportunity to guide tours, work among the artifacts and listen to docents whose rich stories furthered my Wilkes County education.

It was through the museum that I became acquainted with lifelong residents Eric and Marilyn Payne. The Paynes opened their hearts and home to me while sharing their extensive knowledge of county history. They introduced me to other residents whose stories enhanced my understanding of a Wilkes long past. Though it was for a brief period that my life intersected with the Paynes, I am richer for having met them and will forever regard them as dear friends.

Just over the county line, in a pastoral area once a part of Wilkes, stands Fort Defiance, the home of General William Lenoir. Its stewardship is in the able hands of Becky Phillips, whose knowledge of the Lenoir family is unrivaled. Under her tutelage, I discovered a family history that spanned two centuries, from revolution to rebellion and consequent reconstruction. Becky introduced me to Ike Forester, a direct descendant of the Lenoirs. Ike's willingness to recount stories and loan files and rare books informed the writing of the section related to William Lenoir, his sons and grandsons.

Early in the research and writing process, I was contacted by Evonne Raglin, a descendant of Judith Barber. Subsequent to our initial conversation about her family's history, Ms. Raglin offered to assist in the research that I was conducting regarding her great-great-grandmother Judith. She introduced some of her relatives and friends to me, all of whom had insights to share—her sister Jerri Murray, Elizabeth Barber, Dwight Jones, Artie Gilreath, Clem Redmon and Paulette Turner. Evonne invited me to attend family reunions, birthday celebrations and, sadly, a couple of funerals. At these events, I was able to interact directly with descendants of Judith Barber and Henderson Waugh. Her inestimable contributions have been noted throughout the narrative and in endnotes. She is a valued friend and colleague in whose debt I will forever remain.

Ms. Raglin introduced her cousins Wilton "Bud" Mitchell and his sister Billie Matthews to me. Being descendants of Henderson Waugh, they were able to enlighten my understanding of family legend and lore, thereby facilitating my efforts to differentiate fact from fiction. Besides being an educator and coach, Mr. Mitchell is an accomplished artist. He graciously permitted a couple of his paintings to be included in this book.

"Bud" introduced me to other relatives who had valuable information, such as his uncle Warner Waugh, who resides in Philadelphia. Mr. Waugh spoke with me by phone for about one and a half hours, detailing events and recounting stories that his mother told him about his grandfather Henderson Waugh, who died prior to his being born.

The inspiration for this book came from a series of articles that I authored for Wilkes County's only international newspaper, the *Record of Wilkes*. Editor Jerry Lankford agreed to collaborate with me in the publishing of a column entitled "Setting the Record Straight," a history exposé that dissevered myth from fact. Jerry's encouragement, support and willingness to attempt something a bit "cutting-edge" fueled my determination to somehow translate news stories into a book format. Equally, I am grateful to Ken

Welborn, owner and publisher of the *Record*, for embracing the collaboration and giving us the latitude to explore it for its possibilities.

I am also indebted to the staff of the Wilkes County Public Library, thoughtfully managed by Julia Turpin, county librarian. Among the staff members is Wendy Barber, who used her expertise to acquire resources from libraries near and far, strengthening the research underpinning this book. Adult librarian Mara Lynn Tugman brought her considerable technical talents to bear upon any formatting difficulties encountered along the way. Though not a member of the staff, Roger Wingler—president of the Wilkes Genealogical Society, housed within the library—provided salient information drawn from his extensive understanding of Civil War battles, regiments and the Confederate soldiers who populated them.

My heartfelt appreciation goes to former students and dear friends across the country—like Wendy Simmons McGavock—who have animatedly averred that I should be writing books and to the plethora of Wilkes County residents who provided encouragement and took the time to share their stories with me over the last several years. I am also grateful to the North Carolina Society of Historians. In the past few years, it has conferred three awards on the newspaper series that I wrote regarding slaves and slavery in Wilkes County.

I owe much of my professional success related to public speaking and writing to my high school advanced English teacher and now dear friend, Maxine McCall. Often, while speaking to audiences in this country and abroad, I have expressed gratitude to Maxine—who was not present—for her pedagogical investment in my career. And I want to thank her for it in the opening pages of this book. She is the reason that I commenced teaching and writing in the first place.

To my daughters, Janis Marie Mullis and Wendi Sexton: I don't have the adequate vocabulary to express my gratitude for your unconditional love and encouragement as "dad" completed his book. It is for you and your children—my grandchildren—that I endeavor to preserve history.

Finally, it is only fitting to say "thank you" to the person from whom I first heard the intriguing stories of Wilkes County history. This book would not have been written had I not taken a museum tour one warm, humid mid-June evening. She need not be named; she knows who she is.

—*Larry J. Griffin*
2016

Photograph by Faith Keaton, 2015.

INTRODUCTION

In order to subjugate or enslave a people, those who dominate must think themselves superior—in every aspect—to those whom they seek to dominate. It becomes, then, an obligation—yea even an inalienable right—to become a "master" who wields the power of influence to civilize, instruct, guide, and protect their subjects. The enslaved are regarded as simple-minded children who are incompetent and, therefore, incapable of supervising their own lives and affairs. Even their social contracts are viewed as transient and emotional expressions puerile in comparison to those of the "Master."

—Larry J. Griffin, history investigator/writer
the Record, *February 16, 2015*[1]

*S*lavery was an ignominious chapter in the history of the United States; yet, it remained a pervasive practice until the peace concluded by warring factions brought an end to a bloody civil war. Though forced labor was employed in both the upper and lower South, it seems that treatment of the enslaved varied from region to region, state to state and—indisputably—owner to owner. Some writers of history maintain that slaves generally experienced better conditions in the upper South than did those in the lower South. Others posit that the number of servants was a factor; counterintuitively, slaveholders with fewer slaves tended to deal more harshly with their human chattel than those possessing more.

Some historians theorize that owners in North Carolina's western mountain counties were more indulgent than were those of the east. I was born in one of these mountain counties almost ninety years after the cessation of slavery; I live in one of them now—Wilkes County. A few years ago, when I took up residence, I heard stories that Wilkes slaveholders tended to be more benevolent, more conscientious about keeping slave families together—especially mothers with their children—and that the punishment meted out was infrequent and somehow less severe. Something about those assertions seemed questionable to me, for the idea of a "benevolent slave owner" sounded like an oxymoron. So, I committed to conducting comprehensive research in an effort to separate myth from fact and to set the record straight regarding slavery in Wilkes County.

The inspiration for this book came from a multi-award-winning series of thirty investigative articles that appeared in one of the local newspapers, the *Record of Wilkes*. The series captured the attention of local residents and sparked substantive interest and conversation. Feedback from the reading public indicated that the stories contributed to a collective understanding of a very painful chapter in the history of Wilkes County, within the larger contexts of both state and national events.

Local families began to express appreciation that the series clarified and deepened their understanding of forebears who lived during the antebellum and Civil War eras. The assiduous research undergirding the articles enabled readers to clarify unquestioned family legends and traditions and to assimilate more accurate information. For instance, one reader learned that her antebellum uncle did indeed die of natural causes and was not in fact ambushed and killed. Descendants of slaves discovered factual information about who actually owned their ancestors and how, where and under what circumstances they conducted their lives.

The series certainly augmented and clarified the extensive, extant documentation of the slave with whom Wilkes residents are most familiar—Judith Williams Barber. Several of Judith's descendants had already compiled familial records, traditions and government documents detailing her life, culminating in the publishing of the 1996 book *Treasure Troves*. I partnered with Evonne Raglin, one of Judith's great-great-granddaughters and one of the volume's authors, to conduct additional research about Judith. That investigation informed the writing of a number of articles in the series. Ms. Raglin noted that our collaboration enhanced her personal understanding of the history of her antecedents—both black and white.

As important, members of the community became involved. Several contacted me and the newspaper, offering information that extended understanding of slavery in Wilkes County. Pete Bishop and his wife, Betty, telephoned the newspaper office to locate me. I learned that their house is built on property in the western part of the county once owned by John Brown, one of the "founding fathers" of Wilkes and a notable slaveholder. The Bishops invited me to their home to examine primary source documents and to photograph the graves of Brown, his wife and one of his children located in their front yard.

Marilyn Payne, lifelong Wilkes resident, first acquainted me with the writings of her best friend, Betsy Barber Hawkins, that detail the history of her great-grandfather's family. Richard Wainwright Barber was the respected rector of St. Paul's Episcopal Church, the first superintendent of Wilkes County Schools and a slaveholder-by-default. His household was the last in which Judith Williams Barber resided as a slave woman.

The slavery series garnered attention from two other newspapers—the Lenoir *News-Topic* and the Wilkes *Journal Patriot*. The Wilkes County Public Library sponsored an event to highlight the series and asked that I come to speak about slavery in Wilkes County and North Carolina. Evonne Raglin, who assisted with the research pertaining to her slave family, shared history and insights regarding her great-great-grandmother. I was invited to Chicago to be the keynote speaker for the Barber, Harris and Smith reunion to share the essence of my research. That event is an annual celebration of the legacy of Clara Barber Harris, the ninth of the twelve daughters born to the slave woman locals knew as "Mammy Judy."

Though the series sparked controversy and conversation throughout the Wilkes and Caldwell communities primarily, at least one of the stories, read online, caught the attention of a New Jersey attorney who writes history relative to antebellum jurisprudence. He read the article describing the hanging of Kit Robbins, who was convicted of torturing a senior slave to death. Though familiar with the story, this lawyer was uncertain as to whether or not Robbins was actually hanged—uncertain, that is, until he read my account of the incident on the newspaper's website.

Equally impressive was the number of individuals who saw me in stores or stopped me in parking lots just to express appreciation for the newspaper articles. One gentleman's approach sums it up: "Hey, you are that guy who writes articles for the newspaper about slavery." The voice resounded from the window of a truck passing by me in the parking lot of a grocery store. I responded affirmatively. "I love that stuff; I just wanted to tell you that I am

enjoying your stories. Keep it up." Many expressed dismay when the series was concluded weeks later. I was often asked during the time in which the series appeared, "When is the book coming out?" Thus, the idea was born to use the research to chronicle the history of a "time that tried men's souls" within the Carolina Foothills County of Wilkes.

For me, it was insightful to note how much emotion continues to swirl around the slavery issue and the consequent Civil War, even 150 years after peace was concluded. Little wonder, though. The controversies that sparked that conflagration in the mid-nineteenth century plague us still.

1

ANTEBELLUM WILKES COUNTY

1790–1860

*A*s 1790 dawned, the United States was but a fledgling confederation of thirteen states, three districts and one substantial territory, barely a decade removed from the birth pangs of revolution. Less than three years before, on September 17, 1787, a new Constitution of the United States had been signed by thirty-nine of the forty-two delegates present. Then, eleven days later, the Congress of the Confederation voted to disseminate the document to the thirteen states for ratification. Nine states would have to ratify the Constitution before it could supplant the Articles of Confederation. That milestone would not be achieved until New Hampshire endorsed the document on June 21, 1788. Almost a year after it was initially signed, the Constitution was officially adopted by the Congress of the Confederation, and dates were established for the first meeting of the new federal government and for a presidential election. (North Carolina would not ratify the Constitution until November 21, 1789, becoming the twelfth state to do so. Ironically, almost seventeen years later, North Carolina would technically be the next-to-last state to decide to secede from the Union.)[2]

The first election held under the auspices of the new governing document was conducted between December 15, 1788, and January 10, 1789. On February 4, electors from ten of the thirteen states met to cast their votes. George Washington and John Adams received thirty-four of sixty-nine electoral votes to become the first president and vice president of the United States, respectively. In an April 6 joint session of Congress, electoral votes

were counted and certified; on April 30, the newly elected administration took the oath of office at Federal Hall in New York City.

On January 8, 1790, President George Washington delivered the first State of the Union Address to the Congress of the nascent nation. Less than a year after his inauguration, the president signed a congressional measure authorizing a count of citizens within the United States, under the supervision of Secretary of State Thomas Jefferson. The official commencement date was set for August 2, 1790. Marshals from U.S. judicial districts bore the responsibility for ensuring that the first census was conducted efficiently and accurately. Specifically, each census taker was required to collect data in six different categories per household: head of house; number of free white males older than sixteen years; free white males under sixteen; free white females; all other free persons; and total number of slaves.[3]

Marshals or their designees were expected to finish the count by May 1, 1791; however, Congress had to extend the deadline until March 1, 1792. Nineteen months after it began, the 1790 census results were released in a fifty-six-page publication. The nation's total population was tabulated to be 3,929,214. Both George Washington and Thomas Jefferson expressed doubt as to the accuracy of the figure. North Carolina was the third most populous state, with 393,751 residents. Virginia and Pennsylvania claimed the first and second spots, respectively. North Carolina ranked fourth among those states that owned slaves, with 100,572—slightly more than a fourth of its total population.

Twelve-year-old Wilkes County contributed 8,160 residents to the state population, distributed among 1,277 households. Only 132 families—slightly in excess of 10 percent of residences—owned at least one slave. The 550 slaves counted in the census made up 6.7 percent of the county population.

The major slaveholders in 1790 were John Brown and Benjamin Herndon, each with twenty-two slaves. Brown resided in the western part of Wilkes, Herndon in the eastern sector before moving to South Carolina shortly after the census count. Their holdings were modest in comparison to those of slave owners in other states. For example, in South Carolina, General Francis Marion reported that 194 slaves lived on his Pond Bluff Plantation in St. John's Parish. And his holdings were by no means the largest in his native state.[4]

Details of the conditions under which slaves lived and labored in 1790 Wilkes are sketchy. However, by examining records, some insight can be gained about the family life of Wilkes slaveholders. One of the most notable slaveholders was Captain Robert Cleveland; he and his older brother,

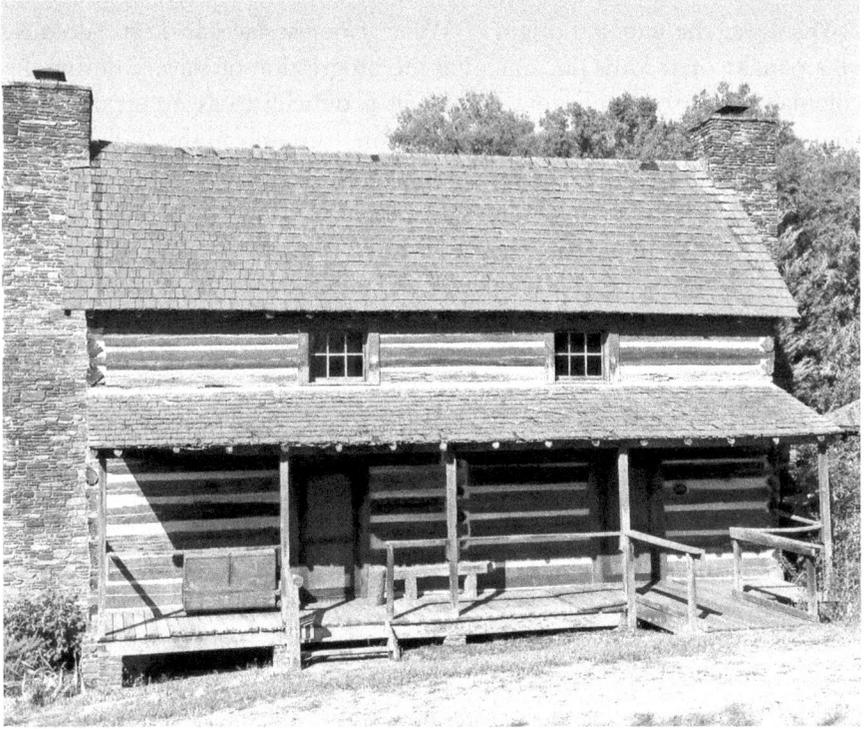

Robert Cleveland House, built in 1779 in western Wilkes County and relocated to the site of the Wilkes Heritage Museum. *Author's photographic collection.*

Benjamin, distinguished themselves during the Battle of King's Mountain. Robert and his family lived on a plantation in the present-day unincorporated community of Purlear, in western Wilkes County. It was there in 1779 that he constructed a spacious house on his property, with architectural features that only the rich could afford. There were two sizable rooms, each with its own fireplace and front and back entrances. One served as a kitchen, the other a family room. A narrow staircase located in one of the rooms toward the rear of the house wended its way to an upstairs loft spanning the length of the residence—likely the family sleeping quarters.

The 1790 census assigned twenty-four people to the Cleveland household, fourteen family members and ten slaves, who likely lived underneath the structure in a cellar compartment. A few servants were doubtlessly assigned to house duties; most worked the fields that made up the Cleveland plantation. Such was the lot of slaves in the dawning years of the plantation era in the South.[5]

What was the national origin of Wilkes County slaves in 1790? Because of a paucity of records documenting the progression of slavery during the colonial and early antebellum periods, it is difficult to ascertain the exact composition of the county's slave population. Certainly in the 1600s, during early colonization efforts in the New World, the British subjugated and enslaved Native Americans.[6] Almost two decades of the seventeenth century passed before the first Africans arrived in North America. In 1619, twenty slaves were transported via a Dutch ship to Jamestown for the express purpose of providing a cheaper, more plentiful labor force to cultivate lucrative crops, such as tobacco.[7]

From about 1700 onward, however, Europeans procured African peoples and employed them as slaves in their colonies, according to Wilma Dunaway in her essay "Put in Master's Pocket: Cotton Expansion and Interstate Trading in the Mountain South." Likely, these Africans came primarily from the west coast of the continent.

Corroboration for Dunaway's notion can be found in neighboring Burke County. John Inscoe, in his book *Mountain Masters, Slavery, and the Sectional Crisis,* recounts merchant William Walton Jr.'s slave-purchasing activities in the 1790s. Walton moved to Morganton to open a mercantile business with his brother. One of their more lucrative ventures was the importation of slaves for sale to Burke residents. In fact, it became so profitable that Walton decided to move to Charleston for several years in order to purchase African labor directly from the ships transporting them. He would then send them to his six-hundred-acre Burke County plantation, which he had previously acquired, for the purpose of training them. There they learned English and local farming methods from other slaves prior to being resold locally. William Walton remained in Charleston, persisting in this business endeavor, until Congress halted African slave importation. Logically, some of his acquisitions were sold or traded to other slaveholders in contiguous counties, of which Wilkes was one.[8]

Marvin Kay and Lorin Lee Cary, professors emeriti of history at the University of Toledo, paint a slightly different scenario in their 1995 book *Slavery in North Carolina, 1748–1775.* They posit that a significant number, if not a preponderance, of slaves were acquired from other American colonies, especially Virginia and South Carolina. In fact, George Burrington, who served as governor of the royal colony of North Carolina from 1731 to 1734, complained that the colony had no alternative but to purchase slaves from other colonial governments because very few were procured "directly from Affrica [*sic*]." Because of this factor, Kay and Cary aver, "it is impossible to

calculate anything resembling precise estimates of the ethnic origins of the colony's slaves." At best, the authors maintain, it is reasonable to assume that the ethnicity of North Carolina's forced-labor population was reflective of those found in Virginia and South Carolina.[9]

It is reasonable to conclude that the first slaves owned by early antebellum Wilkes County residents were undoubtedly of similar origin to those found in other slave states, including ones located farther east in both the Piedmont and Coastal Plain regions of North Carolina. Many descended from Sub-Saharan West Africa; others had Native American antecedents. For instance, Judith Williams Barber's descendants described her as a petite woman with an Indian-brown complexion. Still other county slaves were the progeny of Europeans.

The inexactitude of their ethnicity notwithstanding, the slave population began to proliferate as slaveholding families established residence in Wilkes County. The census of 1800 indicates that slaves composed 11 percent of the county's inhabitants; William Lenoir of Fort Defiance was the largest owner, with twenty-nine slaves. In 1810, the percentage of slaves increased to 13 percent, with James Wellborn owning the largest number (forty-one). In 1820, the enslaved population dipped to 11 percent; William Dula was the leading owner (forty-seven slaves). The percentage jumped to almost 13 percent in 1830; Dula owned sixty slaves at that juncture—the most possessed by one person for the duration of the Wilkes slave era. In 1840, Thomas Lenoir, the second of General William Lenoir's three sons, maintained a force of thirty-eight slaves, making him the most prodigious of slaveholders at that time. However, the percentage of the force-labor population decreased to 11 percent. This declension would persist until the final slave count in 1860.[10]

In the 1850 Slave Schedule, the county's largest slaveholder was a wealthy, respected community denizen and civic leader whose life story connected two families of color—one enslaved, the other free. But in 1835, he and two other men made up a notorious band whose activities wrought fear throughout the population of the enslaved. They were popularly known as the "patty-rollers."

2

THE SLAVEHOLDERS

THE PATTY-ROLLERS

Between dusk and dark rode the three horsemen—known as the "patty-rollers" to the slaves who had come to fear them. Both oral tradition and court records substantiate their existence. In 1835, three Wilkes County men with large slave holdings patrolled the town looking for slaves who were AWOL from their masters' plantations.

The law stipulated that a slave could be away from his owner's property if he had written permission. Without that documentation, he risked being apprehended by the patrollers and summarily punished. (For whatever reason, court scribes spelled "patrol" as "patarole." When the latter word is pronounced, it sounds similar to the blacks' pronunciation of "patty-rollers.)[11]

In the early evening shadows, a slave would hide with bated breath—lying in a ditch, flat against an embankment, or alongside a fallen tree—until the patrollers concluded that no one was lurking in an area under surveillance. A slave knew all too well the price for "tardiness" that would be exacted in the event of capture.

The Reverend George Washington Petty was born into slavery on August 31, 1844. According to popular memory and granddaughter Artie Gilreath, Petty was sold to a Texan when he was eight years old. Ms. Gilreath, herself a centenarian, recounted the family story that she had heard as a girl growing up in Wilkes County. "Some years later, as a young man, my

grandfather managed to return home and showed up at his mother's door. When she opened the door, she didn't recognize him. It was his brother who said, 'Mom, this is your son George!'" Ms. Artie continued, "He was saved and baptized before he was twelve years old and later became a minister. He kept us all straight." Then she smiled. Reverend Petty remembered the patty-rollers and described their activities for another granddaughter, Loree Harris Anderson:

> *After dinner on a Sunday Afternoon, if a young man wished to visit a young woman or "girlfriend" on another plantation, he had better plan and manage to be back by or before nightfall. Why? The "Patty-Rollers" patrols would be on horseback. Slaves would lie down alongside a hollow log and "hold their breath" until the patrols were convinced that none were in the area. How relieved they must have felt…if not apprehended. The punishment was to be hung up by one's thumbs and beaten until the blood ran down—salt would be rubbed into the open wounds.*[12]

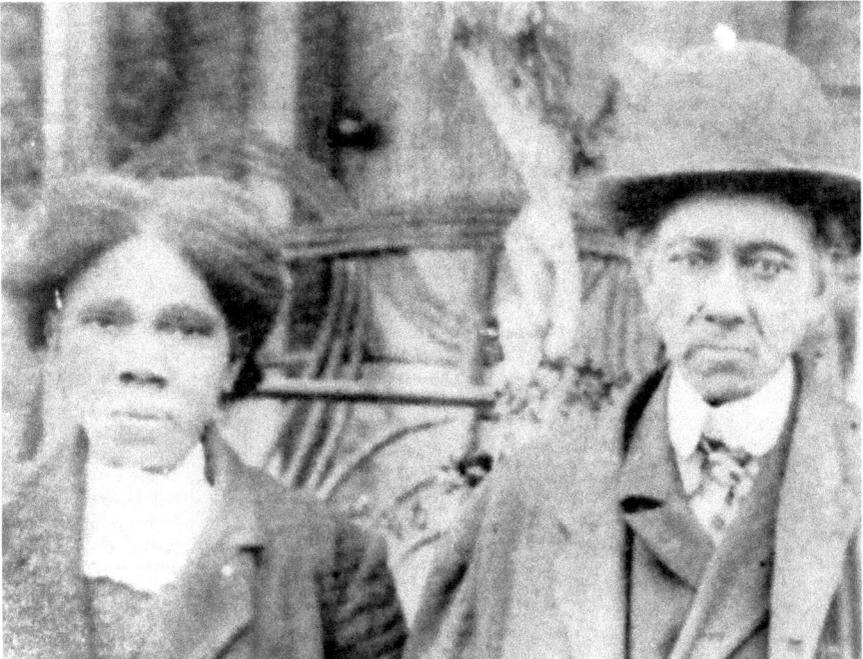

George Washington Petty recalled the "patty-rollers," who rode by night searching for slaves away from plantations without permission. He is pictured here with his wife, Mary Jane Riddick. *Wilkes Genealogical Files and Documents.*

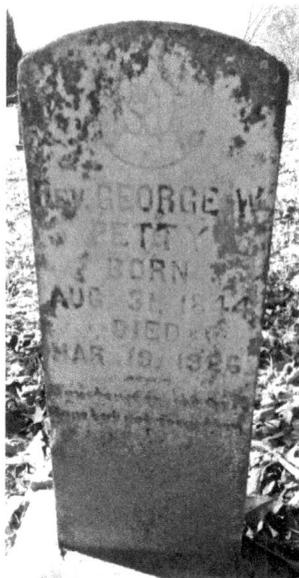

Gravestone of Bishop George Washington Petty (1844–1926), located in Old Damascus Cemetery. *Author's photographic collection.*

That such punishment as described by the Reverend Petty was meted out is a matter of public record. Slave documents from Wilkes County, housed at the state archives, indicate that an auction block and a whipping post were located at the Wilkesboro Court House. Anthony Williams—the partner of Judith Barber—was ostensibly whipped at the courthouse for some indecipherable offense. His chastisement was by no means an exception.[13]

So, who were these dreaded horsemen patrolling the countryside? Wilkes County Court Minutes, dated 1835, identify them as William Pitt Waugh, his cousin John Finley and Finley's son-in-law Dr. Thomas S. Bouchelle—all respected citizens of Wilkes County.[14]

William Pitt Waugh was born in 1775 in York County (now Adams County), Pennsylvania. In 1803, he and several of his brothers moved to Wilkes County, where Waugh purchased property in Moravian Falls. He built a house and a mill and obtained slaves. When his cousin John Finley joined him from Virginia in 1805, the two struck a partnership and built a general store in Wilkesboro. Initially, they hired Finley's nephew Samuel Finley Patterson to run the store. He did so until 1820. Sometime later, the two hired Waugh's nephew William Waugh Peden as their clerk.[15]

William Peden was born in 1814; his family apparently migrated to Wilkes County from Adams County, just as Colonel Waugh and some of his brothers had done. He managed the Waugh and Finley Wilkesboro store and was the secretary-treasurer of the mercantile enterprise. In 1839, he married Mary Taylor Williams, with whom he fathered three children. Tragedy struck in 1844, when Peden was assassinated as he rode his horse from Moravian Falls to Wilkesboro. A free man of color and skilled rifleman, James Underwood, was retained by a white business owner to shoot Peden, with whom he had a dispute. Eventually, Underwood and Duncan would be arrested and tried for the murder. (The Peden-Underwood-Duncan affair will be recounted in chapter 4.)

There is evidence contained within the Waugh-Finley Account Books, housed at the North Carolina State Archives, suggesting that Waugh

John Finley, partner of William Waugh, respected community leader and one of the "patty-rollers." *Wilkes Genealogical Files and Documents.*

was something of an entrepreneur who founded what is tantamount to a "chain of general stores" in North Carolina and other southern states. Ledger entries in the account books show transactions and a bill of sale attributed to a store in Jefferson, North Carolina. Located in Ashe County, "Waugh, Poe, and Murchison" was referred to as the "Ashe Store" because of its Jefferson address.[16]

The "Waugh/Harper Store" was built at the conjunction of Burke and Caldwell Counties. In 1827, James Harper, another Pennsylvania native, moved to North Carolina and became a business partner. In 1833, he also became a family member when he married Caroline Ellen Finley. Yet another store in the chain was ostensibly located in Cherokee County, North Carolina, where Waugh had purchased several tracts of land on the Valley River. This general store was referred to by the natives as the Valleytown Store. Suffice it to say, the colonel's successful land and mercantile ventures provided the necessary profits to acquire thirty-five slaves by 1850, making him the largest slaveholder in Wilkes County.[17]

Waugh also served the Wilkes community as a justice of the peace. His store became the local post office, and he was the postmaster from about 1832 to 1844.[18] It was during his tenure, in 1835, that Waugh, Finley and Bouchelle assumed the responsibilities as "patty-rollers."

There is one other anecdote of interest. According to family tradition, the story is told of a man of color who rode a white horse into Wilkesboro from Delaware subsequent to the Civil War, returning to his former hometown. He was purportedly the son of a free woman of color named Matilda Grinton and the unmarried William P. Waugh. In 1832, court records indicate that the eight-year-old boy and seven-year-old daughter of Ms. Grinton were "bound to Colonel Waugh." The very next year, Waugh posted bonds for both children of color. Evidently, the colonel felt a connection to Ms. Grinton and her two mulatto or biracial children. Matilda moved to Ashe County, and the colonel sent his son to Delaware,

where "he could live more freely." The 1870 census substantiates his residence in New Castle County.[19]

John Finley was no less accomplished than his cousin William. Born just three years after the colonel in 1778, he moved to Wilkes from Augusta County, Virginia, to become his business partner. He married Ellen Tate in 1807 before moving to Wilkes County, and the couple had six children together; four of them survived into adulthood. The 1830 census indicates that Finley owned twenty-six slaves—over twice as many as his cousin at that juncture. By 1850, however, his slave population had dwindled to twenty, while Waugh's increased to thirty-five.

Finley's community service record was also distinguished. In addition to his patrolling activities in 1835, he was an ardent supporter of education and served on numerous boards for area schools and academies. Moreover, he was a tanner who once personally taught the trade to a twelve-year-old boy who was bound to him until his twenty-first birthday. In 1837, he worked in concert with four other people to establish what is considered the oldest church in the county, Wilkesboro Presbyterian Church, and stepped in as postmaster for a year when his cousin William resigned the post in 1844.[20]

John Finley was the only one of the "three horsemen" who lived long enough to witness the terrible political upheaval that culminated in a civil war through which the slavery question was settled "forever and aye." He died at the age of eighty-seven, seven months and five days after peace was concluded at Appomattox Courthouse.

Of the "three horsemen," Dr. Thomas Slater Bouchelle remains an enigma—research revealed very few biographic details. He was born in 1804 or 1805 in Morganton, North Carolina, in Burke County to Thomas Bouchelle and his second wife, Clarissa Polly, herself a "Bouchelle" by birth. They came to the area from New Castle County, Delaware. Young Thomas's father was himself a doctor with a successful practice in Burke, Caldwell and Wilkes Counties. Burke resident Colonel Thomas George Walton wrote of the elder Dr. Bouchelle in a biographical sketch published in the old *Morganton Herald* in 1894: "I attribute his wonderful success in curing the sick more to his cheerful manner and persuading his patients to believe they were not seriously sick….He would approach the sick…saying, 'Oh my dear fellow, there is nothing serious the matter with you…' and at the same time telling some humorous anecdote." The elder Bouchelle died suddenly in 1841 while visiting a patient; he was eighty-one years old and is buried on the Swan Ponds Plantation in Morganton.[21]

Left: Gravestone of John Finley (1778–1865), located in the Wilkesboro Presbyterian Church Cemetery. *Author's photographic collection.*

Right: Gravestone of William Pitt Waugh (1775–1852), wealthy merchant, community leader and plantation owner. The grave is located in Wilkesboro Presbyterian Church Cemetery. *Author's photographic collection.*

Three days after Christmas in 1826, young Dr. Bouchelle married the firstborn daughter of John and Ellen Tate Finley, Clarinda Jane Elizabeth. Just three years later, he commenced an eleven-year tenure as a Wilkes County clerk and master of equity and welcomed an addition to the family, his first son, Thomas. The 1830 census reveals that of the eleven people assigned to his Wilkesboro residence, seven of them were slaves. However, when 1835 dawned, he was considered one of the largest slave owners in the county. At that juncture, he joined his father-in-law, John Finley, and Colonel Waugh in their patrolling endeavors.[22]

Eventually because of health issues, Dr. Bouchelle and his family moved to the lower South and Alabama; the date of that relocation is uncertain. According to one account, he died there in a flood around 1843; other sources list the year of his death as 1852. Regardless of the date, the good doctor died at a young age. His wife and family returned to Wilkes County, where Clarinda lived out the remainder of her short life.

Now, the "three horsemen" lie in silent repose in graveyards near and far. Two of the three—Colonel William P. Waugh and John Finley—rest within

feet of each other in the Wilkesboro Presbyterian Church cemetery. A worn iron fence delimits their gravesite. Within the same plot, buried a few feet from her father, lies Clarinda Jane Elizabeth, the wife of Dr. Thomas Slater Bouchelle. It is presumed that Dr. Bouchelle reposes in an Alabama cemetery.

On the tombstone of William Waugh, these words were inscribed in 1852: "A public spirited and valuable citizen. A kind and generous friend and during his residence in North Carolina, a most active, enterprising, and successful merchant."[23] He at one time was the largest slaveholder in the county and one of the "three horsemen" who patrolled the roads from dusk to dark, searching the highways and byways for slaves.

JOHN BROWN AND SONS

Betty Bishop led me up the slope to the little family cemetery in which John Brown was laid to rest after he died in his Brown's Ford home in 1812. "He owned all this property back then," she said with a sweep of her arm toward the tree-rich ground across New Brown's Ford Road that bisects the acreage that was once his. With her finger pointing, she traced the path of the old road that ran to the northwest of the property. "That was the road until the new one was constructed by the state. His house sat down the road a piece—about five hundred yards—just in behind those trees there; Governor Stokes was his neighbor," Betty said, continuing her story.

"Do you know why they call it Brown's Ford?" Betty asked during the course of our conversation. "It was one of the only places to ford the Yadkin River back in the day." Pete Bishop added, "Why my daddy and I drove our old A-Model across that ford!"

Pete and Betty Bishop have been married for more than half a century and are descendants of Wilkes sheriff John McEwen and his wife, Nannie Bledsoe. Both are informal historians of the area and own a portion of the property that was once part of the several thousand acres of the Brown estate in Wilkes County. "About thirty-seven acres of it," Pete informed me. "My father owned about one hundred acres of it, but it was divided up among us children when he died."[24]

John Brown was born in County Derry, Ireland, on Halloween Day in 1738—the same birth year as Benjamin Cleavland, under whom he would serve at King's Mountain. It was sometime after 1740 that members of the Brown clan immigrated to the United States, apparently settling in and

Left: Gravestone of John Brown (1738–1812), located in a private cemetery on property Brown once owned. *Author's photographic collection.*

Right: Jane McDowell Brown, wife of John Brown, reposes next to her husband, who was twelve years her senior. *Author's photographic collection.*

around Lancaster County, Pennsylvania. "Family legend maintains that 'John came to America at the age of 12 accompanied by an older family member and taught school,'" writes Brown's great-great-great-great-grandson Joe Brown, who resides in Mississippi. But, he continues, "we have not found evidence to verify this."[25]

One of the first records of John Brown's presence in the colonies was a reference in a family Bible noting his marriage to Jane McDowell in Lancaster County on December 19, 1770. He was thirty-two years of age; she was only twenty. Less than a year after the wedding, Jane gave birth to their first child, James, in 1771. There would be ten more—seven boys and three girls—all of whom were born in Wilkes County: William (1774), Elizabeth (1776), Alexander (1778), John Jr. (1780), Ann (1782), Hugh (1784), Hamilton (1786), Thomas (1788), Margaret (1790) and Allen (1792/93).[26]

Though not verified, it appears that John and Jane Brown migrated from Pennsylvania to Wilkes County, North Carolina, sometime after 1771 but before 1774. What is known is that, in 1778, the County of Wilkes was established in the Brown's house and the first court convened there. Two

years later, the 1790 census included all of the family—except Allen—and listed twenty-two slaves. Only Wilkes County resident Benjamin Herndon owned as many slaves.[27]

Clearly, John Brown was a prosperous man of considerable wealth who owned thousands of acres of land in both North Carolina and Tennessee. Ostensibly, he obtained a portion of his holdings through substantial land grants in both states as payment for negotiating treaties with Native Americans.

When he died at age seventy-three, Brown's will—included in the Hamilton Brown Papers—was executed by two of his sons, John Jr. and Hamilton. Each of the children was given land and resources enough to develop their own futures. The slaveholdings, however, were all bequeathed to Brown women. His wife, Jane, was willed seven slaves: Apper, Mima, Joe, Peter, Malta, George and James. Daughter Elizabeth was given Leah; daughter Ann received Milley; and daughter Margret was willed a girl named Dinah.[28]

The final request in his will reveals John's sense of humor: "It is my wish that if any of the Legatees shall be dissatisfied with this my last will, that in such case, I wish my Executors, and they are especially directed to he, she, or they who may be dissatisfied, nothing more than ten pounds for their full portion of my estate."[29]

Now, it could have been that the elder Brown anticipated problems among his posterity regarding the estate. In ensuing years, there would be disputes over land and slaves resulting in a public court battle that embroiled the entire family, according to descendant Joe Brown. Prolonged and painful, these disagreements would not be settled until the Civil War was concluded.[30]

Among John Brown's sons, Hamilton was doubtless the most accomplished. He was a business entrepreneur with interests in landholdings, slaves, livestock, lumbering, merchandising, other estates and politics in Wilkes County and elsewhere. According to his papers cached at the University of North Carolina, Chapel Hill, his dealings took him to Tennessee, Alabama, Georgia, Louisiana, Mississippi, South Carolina and Virginia.[31] After serving in the War of 1812, Hamilton was elected to the office of Wilkes County sheriff in 1816. Two years after his tenure ended, he was appointed a justice in 1820.

In 1830, he married Sarah Herndon Gordon, a woman he had previously courted but who decided instead to marry Nathaniel Gordon. (General James B. Gordon was born to their union.) About a year after Gordon's death, Sarah married Hamilton, and the couple had two sons, both of whom

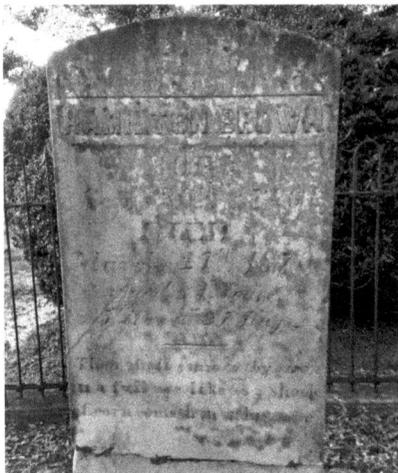

Gravestone of Hamilton Brown (1786–1870), a community leader who arranged slave-trading deals for owners. The grave is located in the cemetery at St. Paul's Episcopal Church in Wilkesboro. *Author's photographic collection.*

bear the names of Brown's brothers: Hugh Thomas and Hamilton Allen. It was in 1835 that Brown built a house for his family, referred to locally as the Brown-Cowles House. It is the second-oldest residence in Wilkesboro.

Though considered a respectable community leader, Hamilton Brown earned a commission for arranging interstate slave sales for his neighbors. In writing about such activity in an article, "Put in Master's Pocket: Interstate Slave Trading and the Black Appalachian Diaspora," Wilma Dunaway maintains that when Brown deemed prices were too low, he would withhold laborers for a better profit. She cites a letter, dated June 5, 1838, in which he advised an owner: "I think the opportunity will be much better for selling them in the fall. I have no doubt but I shall be able to sell for a much better price then than at this time."[32] Clearly, Hamilton Brown earned some of his wealth through professional slave trading.

Brown also earned income through the "hiring-out" of slaves. According to a letter included in the Hamilton Brown Papers, he once sent a slave trained as a blacksmith to work for a master in Virginia. When the term of employment was completed, the slave dictated a letter that he forwarded to Hamilton requesting that his master allow him to remain there to open his own shop. He proposed to share profits with Brown, asserting that his owner could make profits greater than those received for simply hiring out his servant to other masters. No record of Brown's response exists. However, it is likely that this display of budding independence by his slave was less than appreciated by his owner.[33]

When the 1850 census was compiled, Hamilton Brown owned eleven slaves—over half of them were children, ranging in age from one to eight. The four youngest children were female. In the 1860 census, his slaveholdings had diminished by three; only eight were assigned to his household. Six of those were children, ages one to fifteen, four of whom were female. Likely, some of the slaves he owned had once been part of his father's holdings.

Though records reveal that there was some concern demonstrated for the welfare of his slaves, Hamilton Brown made no concerted efforts to keep slave families intact and children with their parents.

And in 1856, some of the slaves whom John Brown bequeathed to his children were at the center of the controversy between Hamilton's older brother, Hugh, and his youngest brother, Allen. In a missive dated February 1, 1856, Allen pleaded with Hamilton to intervene in a contentious, venomous standoff between himself and Hugh. Wishing to avoid a public, humiliating lawsuit, the youngest Brown complained, "Is it not strange that brothers with any proper self-respect and pride of family would be unwilling to have a friendly settlement of their differences, but choose rather to settle them, by a public disgraceful squabble?" John Brown's fears of contention between his offspring over land and slaves had become a reality. It would continue to divide the family long after the last lawsuit was settled in court.[34]

JAMES GWYN AND LYTLE HICKERSON

Lytle Hickerson established a partnership with James Gwyn, speculating in both land and slaves—buying and reselling Missouri properties and acquiring slaves to sell to new landowners there. *Wilkes Genealogical Files and Documents.*

In October 1848, the congregation of the first Episcopal Church commenced constructing the building that was eventually consecrated in July 1849. Samuel Finley Patterson—John Finley's nephew—and the Gwyn family had donated the land on which the church was erected. Charter members included Dr. and Mrs. James Calloway; Fanny Williams and her sister Mary Taylor Peden (who would later marry the Reverend Mr. Richard Barber); and Mr. and Mrs. James Gwyn II.[35]

In 1858, a diocesan convention was held in the town of Edenton, North Carolina. St. Paul's was admitted as a parish, and its delegates were seated. Among them was James Gwyn. When the vestry for the church was formed, Gwyn and his nephew Ransom Hickerson were numbered among the members.[36] And during the time that he was involved with church business, James

Gwyn and Ransom's father, Lytle Hickerson, were engaged in the lucrative secular business of land and slave speculation.[37]

Make no mistake, slave-trading was alive and well in Wilkes and surrounding counties. Slave traders Frank White and William Beasley came to this county to gather coffles of slaves for the markets in Charleston, South Carolina. Wilkes notable Calvin Cowles purchased and hired slaves; he earned profits by contracting them out as "annual hires." And there seemed to be a flourishing slave-trading venture centered in neighboring Surry County, where the notorious slave driver Christopher "Kit" Robbins brokered deals in a six-county area.[38]

James Gwyn Sr. had already established a plantation near Ronda that he called Green Hill. Likely, the senior Gwyn grew up in that same vicinity. The story is told that, as a boy, he was present when Ben Cleveland hanged Tory Zachariah Wells near his Roundabout Plantation. The young Gwyn, who was probably no older than thirteen, begged the colonel not to hang Wells. Cleveland insisted that, for the peace of the country, it was necessary to hang such dangerous characters.[39]

It was in 1812 that James II was born to the senior Gwyn and his wife, Amelia Lenoir. The younger Gwyn eventually married Mary Ann Lenoir, the daughter of Thomas Lenoir and the granddaughter of General William Lenoir, in 1839—the same year that his bride's illustrious grandfather died. According to the James Gwyn Papers, housed at the UNC–Chapel Hill Library, Gwyn Jr. established a partnership in 1845 with brother-in-law Lytle Hickerson, who was married to his sister Amelia. Apparently, this business enterprise persisted through the Civil War.[40]

One of Gwyn's relatives from Missouri suggested a venture in which the partners would obtain military bounties to resell to new Missouri settlers. Then they would procure slaves for resale to those new plantations. Wilma Dunaway asserts that in a matter of months, Gwyn began purchasing young male field hands at bargain prices from neighbors who were burdened with debt and needed money. In order to amass coffles of slaves for export, Gwyn, Hickerson and their associates attended public auctions throughout western North Carolina. When the two partners accumulated enough slaves for transport, they sent them in overland caravans to east Tennessee, where they were herded onto flatboats for their long journey "down the river" to Missouri.[41]

In at least one questionable business maneuver, James Jr. manipulated the legal system to obtain slaves from a local widow who attempted to protect them from speculators like Gwyn. He persuaded the courts to declare him the

"guardian" of her estate, as she was "a fit subject for the asylum." The court concurred, giving him the legal right to dispose of her property, including her servants. Friends of this unfortunate widow testified that if she did not have "nigrose," that neither Gwyn nor the court would care what became of her.[42] All of this came down during the same time frame that James Jr. was working diligently to establish St. Paul's Episcopal Church as a viable parish.

GENERAL WILLIAM LENOIR AND SONS AND GRANDSONS

James Gwyn's grandfather-in-law General William Lenoir never lived in any Carolina county other than Wilkes. And at no point in time in which he resided at Fort Defiance did Lenoir not own slaves. In the 1790 census, twelve slaves were assigned to his household. Eight years later, the number of servants had more than doubled. By 1814, he owned forty slaves; by 1820, there were forty-one—the most that he ever held at one time. At first, the general viewed the institution of slavery as "protection of the slaves from the harmful uncertainties of freedom." He eventually became convinced that slavery was, in fact, morally just—reasonable punishment for the transgressions of slaves' ancestors.[43]

According to extant documents, there was only one occasion in which Lenoir sold a substantial number of slaves. However, he did have a penchant for purchasing children, with and without their parents, for two compelling reasons: they could be procured for lower prices, and they were easier to train. If their behavior was exemplary as they grew up, he might teach them the skills necessary for carpentry, leatherwork or blacksmithing, thereby increasing their productivity and worth.[44]

As he aged, General Lenoir turned over management of his property to sons and grandsons. They continued the family commitment to carefully attend to the physical and emotional welfare of their labor force. Providing food, clothing, shelter and medical attention could be both time-consuming and financially taxing.

At times, it was equally challenging to deal with the vexing, rebellious behavior of a few of their slaves. In 1856, the general's grandson Rufus "Teddy" explained in a letter to his brother Thomas Isaac that he had to "thrash" a slave for "going off on Sunday without permission and not getting back in time to feed the cows." The offender told Rufus that he

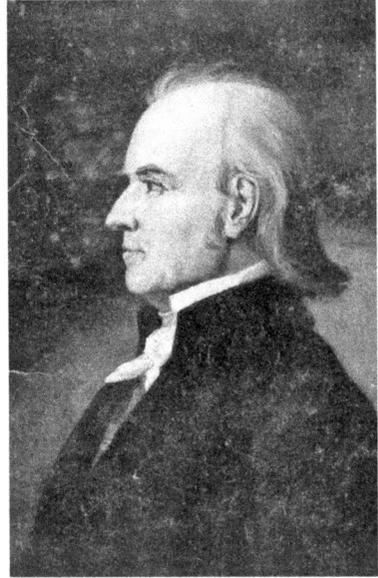

Right: William Lenoir (1751–1839), noted community leader, Constitutional Convention member, first president of the University of North Carolina at Chapel Hill and a major county slaveholder. *Fort Defiance Pictorial Collection.*

Below: Fort Defiance, home of William Lenoir, completed in 1792 and currently a Caldwell County historic property open for public viewing. *Fort Defiance Pictorial Collection.*

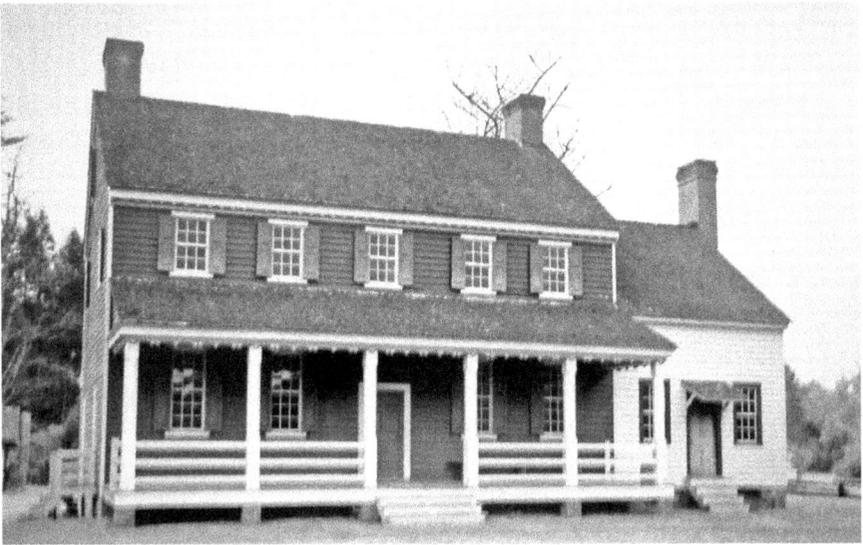

would rather be sold than whipped. Rufus replied that he was obliged to whip him, as he had previously done so for the same offense. Then "father could sell him if he wished."[45]

Early in September 1862, Louisa, Rufus's mother, complained to her son about the impudent behavior of a young slave girl named Delia. Though warned to desist, Delia's behavior did not improve. Rufus ordered her to

the house with the intention of applying the lash. Delia ran from him to the kitchen; he followed her, offering her a choice between a "whipping or take a knocking down." After telling her three times, Rufus "gave her a tap which she will probably remember for some time."[46]

When corporal punishment failed, the Lenoirs often sold recalcitrant slaves to other owners. As early as July 1850, Walter Waightstill Lenoir asked his older brother, Thomas Isaac, to assist him in persuading their father to allow him to sell families who were causing trouble and had been for some time. Though reluctant to sell, Thomas Lenoir acquiesced to his son's request a couple of months later, and Walter sold a family of eight for $3,475 ($105,303.03 in 2015 currency).[47]

In 1864, as it became obvious that the outcome of the Civil War would not favor the South, Rufus Lenoir expressed a desire to "divest himself of recalcitrant slaves" whom he considered dishonest. Clearly, the Lenoir family was growing weary of the burden of maintaining and managing their labor force. In March of the same year, Walter Waightstill—who by now had lost a leg in the Battle of Chantilly while serving as a captain in the Confederate army—articulated the growing frustration in a letter to his sister "Aunt Sade": "You know that I had made up my mind before the war that I would not again be a slave owner, not from doubt it was right for the people of the south in this age to continue to own their slaves, but because I prefer to avoid the trouble and worry of owning them."[48]

Evidence garnered from Lenoir family documents and letters suggests that periodic efforts were made to keep slave families together and children with their parents. However, any decision to do so was weighed against keeping the plantation economically viable and profitable.

By the time North Carolina voted in February 1861 to decide the question of supporting a convention for secession from the Union, the Lenoirs of Fort Defiance were residing in Caldwell County, which had been carved out of two others—Burke and Wilkes. Of the 801 votes cast, 615 men (78 percent) voted against secession. Caldwell County joined Wilkes and eight other of the fifteen western North Carolina counties in expressing a desire to retain ties to a central federal government.[49] Doubtless, counted among those opposed to Southern secession were the sons and grandsons of General William Lenoir.

3

ANTEBELLUM NORTH CAROLINA COURT CASES RELATIVE TO SLAVERY

THE DEATH OF JIM BEARD

Before he was hanged, Christopher "Kit" Robbins sang a hymn with a "haunting cadence" that wafted eerily across the sea of faces that had come to bear witness to the event. That's according to a story written by educator and writer Ruth Linney for the July 25, 1956 edition of the *Wilkesboro Hustler*.[50]

In 1917, Linney boarded with a woman in Yadkin known as "Aunt Mat" Howard. She describes her host as a "fairy godmother" who lived in a "house strung out in a row as if made from boxes." It was through Aunt Mat's stories that Linney discovered details that lead to the arrest, conviction and hanging of Kit Robbins in 1856.

Aunt Mat was actually Martha "Mattie" Mayberry, one of the stepdaughters of the condemned man. At the age of fourteen, she was forced by Robbins to participate in his murderous assault on a sixty-year-old slave named Jim Beard. Martha claimed that her stepfather was a decent, "right good fellow" with a conscience when sober but wicked and cruel when inebriated. The latter was the case in the early evening of July 20, 1855, when Robbins came home from an election celebration where alcohol had been imbibed. He called for the aging slave to help with some work that he wanted done. The women of the house protested that "Uncle Jim has done all the work he can today." Kit, undeterred, was determined to make the elder servant work. It was at that juncture that the tortuous beating commenced that culminated in the early morning death of Jim Beard.

Tory Oak Jr., grafted from the infamous Tory Oak in 1932, stands adjacent to the Wilkes Heritage Museum in Wilkesboro. *Author's photographic collection.*

Robbins was tried in superior court at Wilkes County Courthouse, convicted of murder and condemned to hang. He appealed his case to the state supreme court; his conviction and sentence were both upheld. On April 4, 1856, while the mournful notes of a hymn lingered in the ears of the crowd that had gathered for the occasion, Christopher Robbins was hanged by Sheriff Esley Staley—likely from the Old Tory Oak. According to local lore, Robbins was buried on a lonesome mountainside, isolated from the rest of his family. Even in death, his relatives wished to distance themselves from the heinous crime perpetrated by one of their own.[51]

Kit Robbins was not the first North Carolinian to stand trial for killing a slave. Iredell County resident John Hoover was arrested for the continual torture of a female slave named Mira. The maltreatment commenced in December 1838 and culminated with her death in late March 1839. He even continued his brutal chastisement during her pregnancy and subsequent recovery. The cruelties to which he subjected her—whippings, scourging and privations—were too "barbarous for the court to recite" aloud. Her offense? Hoover claimed that she was rude to both him and his wife and that she stole turnips from his garden to sell to some poor trash.[52]

For his actions, Hoover was convicted by an Iredell County jury and sentenced to hang. His appeal to the North Carolina Supreme Court was dismissed, and Hoover was hanged subsequent to the court's ruling. Chief Justice Thomas Ruffin authored the opinion for the Hoover case. Associate Justice William Horn Battle cited the decision seventeen years later when writing the court's ruling for the Robbins case. Prior to the Hoover incident, Ruffin had written the decision in the 1829 case *State v. Mann*, in which he maintained that "the power of the master must be absolute."[53]

Himself a major slaveholder, the chief justice believed that an owner was entitled to the legal latitude to punish his slaves as he saw fit—the severity of which was left to his judgment and was not to be questioned. A slave had to yield to the discipline of his master—it was his "duty," in fact—and resistance was seen as insubordination. The senior jurist's position was commonly shared among people in the South. Mark Twain describes the prevailing, unquestioned attitude toward slave disciplinary treatment in his 1897 book *Following the Equator*. After observing a scenario in which a servant was unnecessarily "cuffed" on the jaw by his German overseer, Twain wrote:

> *I had not seen the like of this for fifty years. It carried me back to my boyhood, and flashed upon me the forgotten fact that this was the* usual *way of explaining one's desires to a slave. I was able to remember that the method seemed right and natural to me in those days, I being born in to it.* [Emphasis in original.]

Twain recounted an instance from his childhood when, at age ten, he saw an angered man hurl a piece of iron ore toward his slave for accomplishing some task "awkwardly—as if that were a crime." The metal struck the slave's skull, rendering him unconscious. He was dead within an hour. Twain recalled: "I knew the man had a right to kill his slave if he wanted to, and yet it seemed a pitiful thing and somehow wrong....Nobody in the village approved of that murder, but of course no one said much about it."[54]

But in 1845, when this incident occurred, did a master have the right to kill his slave with impunity? Not according to associate justice William Gaston, himself a slave owner and a colleague of Thomas Ruffin on the North Carolina Supreme Court. Justice Gaston maintained that a master's authority was not altogether limitless. He had to stop chastisement short of jeopardizing the life of a slave. If the death of a servant accidentally occurred during punishment, then the owner could be found guilty of manslaughter. If the intent was to kill, then an owner could be found guilty of murder. Ruffin agreed with his colleague that in the Hoover and Robbins cases, malice of forethought was the pivotal factor.

In the early throes of Reconstruction, Wilkes resident Tom Dula (Dooley) was tried in Statesville, North Carolina, for his role in the alleged 1866 murder of Laura Foster. Less than two years after Foster's mysterious disappearance, Dula was hanged in the same city on May 1, 1868. A reporter from the *New York Herald* was dispatched to North Carolina to cover the entire imbroglio.

But he came south with an agenda: to depict southerners as backward and depraved. In an article appearing in the *Herald* a day after the hanging, the reporter opined:

> *The community in the vicinity of this tragedy is divided into two entirely separate and distinct classes. The one, occupying the fertile lands adjacent to the Yadkin River and its tributaries, is educated and intelligent, and the other, living on the spurs and ridges of the mountains, is ignorant, poor and depraved. A state of immorality unexampled in the history of any country exists among these people, and such a general system of freeloveism prevails that it is "a wise child that knows its father."*[55]

At first glance, it would appear that the Dula case has nothing to do with those of John Hoover and Kit Robbins. Curiously, however, in 1868—approximately four months prior to the Dula hanging and twelve years after the hanging of Kit Robbins—C.K. Lenow wrote to North Carolina governor Jonathan Worth inquiring after both the Hoover and Robbins cases. He wanted to ascertain whether or not the death sentence imputed to each had actually been carried out. Worth responded in two missives, one dated May 22, 1868, and the other a week later, on May 29. In the former, he informed Lenow that he was aware of convictions in both cases but unsure about the status; but if the sentences had not been carried out, then the court system was not to blame. Further, he assured the New Yorker that "few instances of wanton *depravity* would occur where a man would destroy his own property."

A week later in his follow-up response, the governor indicated that he had communicated with the sheriffs of the counties in which the two men were tried; they confirmed that sentences had been executed according to the law. He closed this letter by declaring, "*Depravity* has never got such a hold here that our Courts and juries would not hang a man guilty of murdering his slave as soon as any other."[56] These responses, penned just weeks after the Dula hanging, recommend to suspicion that this first Reconstruction governor of North Carolina was aware of the contents of the *New York Herald* article, in which a contingent of Wilkes County residents was accused of an unparalleled depravity. Perhaps he viewed Lenow's inquiry as yet another attempt by a Yankee to use these court cases to reinforce the notion that southerners were "ignorant, poor, and depraved." It strains credulity that his use of the word "depravity" had a mere coincidental link to the acerbic accusations of the *Herald* reporter.

Five years before *State v. Hoover*, Justice Gaston wrote the unanimous opinion for another seminal case: *State v. Will*. In January 1834, Will, a slave of James Battle of Edgecombe County, inflicted a fatal knife wound to the arm of his white overseer, Richard Baxter, during a disagreement and ensuing struggle. Will, convinced that Baxter was going to kill him, fled for his life. The overseer emptied his gun in the slave's back in an attempt to thwart his escape. When Baxter approached the wounded servant, Will stabbed him with a knife. The overseer later died. Will was tried by the Edgecombe County Superior Court, convicted of murder and condemned to hang.

James Battle, convinced that Will reacted to Baxter's assault in self-defense, retained two attorneys to plead his case before the state's Supreme Court. The court ruled in favor of the slave, charged him with manslaughter and overturned his death sentence. In his summary, Gaston averred that if a white man had slain another white man under similar circumstances, the charge would be manslaughter, not murder. He further maintained that in this case, Will clearly felt his life to be in jeopardy and reacted in "a brief fury"—one that did not leave the mind capable of the sort of calm, rational thought required to plan a murder.[57]

These North Carolina cases served to gradually improve the status of slaves, who were generally regarded as little more than chattel or property. None, however, entertained the notion that a black man was equal to a white man in any measure; he was merely a possession of the owner who had purchased him. A slave had no rights except for those his master allotted him. Laws passed in the antebellum era served to reinforce this notion. Even the Constitution of the United States regarded the enslaved black man as less than a whole person.

Article One, Section 2, Paragraph 3 of the Three-Fifths Compromise of 1787 stipulates that state representation and taxation be predicated on the whole number of free persons, including those indentured to service for a specified number of years. Excluded were Native Americans who were not taxed, but all other persons—slaves—were to be counted as "three-fifths" of a person. Such apportionment actually benefited the southern slave states by giving them a disproportionate representation in the House of Representatives. Therefore, they wielded an unfair influence on the outcome of elections for the presidency and the speakership of the house and in assigning justices to the Supreme Court—an advantage that was maintained until the Civil War. Ultimately, the Thirteenth and Fourteenth Amendments to the Constitution, passed in 1865 and 1868, respectively, superseded the Three-Fifths Compromise.[58]

It is worth noting that even national political figures vying for the presidency in 1860 did not embrace or advocate for "full social and political equality for blacks." William Seward, Salmon Chase and Abraham Lincoln shared the belief that blacks were people and should have the status afforded to whites; but none of them really believed that the races could coexist. According to Doris Kearns Goodwin in her book *Team of Rivals*, Lincoln asserted that he had never favored "making voters or jurors of negroes, nor of qualifying them to hold office, nor to intermarry." As late as 1858, he acknowledged that "a physical difference between the two would probably forever forbid their living together upon the footing of perfect equality."[59]

Such attitudes as these reveal how deep the roots of racial prejudice were in this country at a time when Colonel William Waugh, John Finley and Dr. Thomas S. Bouchelle were considered major slaveholders in Wilkes County, patrolling the highways and byways for errant slaves. It becomes relatively easy to reconcile two very different notions: that these gentlemen could be revered as kind, generous, enterprising county citizens and that they owned human beings, with the attendant responsibilities of buying, selling, trading and discipline.

4

Slave Woman

The Story of Judith Williams Barber

The Assassination of William Peden

Seldom does a man hear the sound of the shot that slays him. And surely the report of an assassin's rifle was silent to the ears of an unsuspecting William Peden, who was suddenly jolted from his saddle on a spring day in 1844.

William Waugh Peden was born on August 15, 1815, in Adams County, Pennsylvania. He was a nephew of Colonel William Pitt Waugh, for whom he was named. Judge Johnson Hayes maintains in his book *The Land of Wilkes* that Peden migrated to Wilkes County about the same time that his Waugh uncles did.[60] However, he had yet to be born at the time Colonel Waugh came to the county. Rather, it was likely Peden's mother and father who migrated simultaneous to the Waughs' relocation.

When Colonel Waugh took up residence in Wilkes County in 1803, he purchased land in the Moravian Falls area, built a house and a mill and purchased slaves. Two years later, he formed a partnership with his cousin John Finley, who moved to Wilkes from Virginia. The two men built a general store in Wilkesboro. Account books used to record business transactions for Finley & Waugh—housed at the North Carolina State Archives—suggest that the enterprise may have operated continuously from 1805 to 1861.[61] In addition to the Wilkesboro store, the partners apparently established ten to fifteen more stores in strategic locations ranging from near the Tennessee state line to Columbia, South Carolina. In an oral presentation made at a cemetery ceremony on October 24, 1999, commemorating the

restorative work spearheaded by Philip Southwell, George McNeil indicates that Finley & Waugh distributed goods to stores throughout western North Carolina, western Virginia and eastern Tennessee.[62] Irrespective of their scope of operations, William Waugh and John Finley were indisputably entrepreneurial merchants.

Initially, the partners hired Finley's nephew—Waugh's great-nephew—Samuel Finley Patterson to run the store. He did so until 1820, when he turned twenty-one. Afterward, young Patterson managed his own profitable mercantile business in Wilkesboro from 1820 to 1840. Later, he would gain prominence as the president of the Raleigh and Gaston Railroad and serve three terms as the state treasurer of North Carolina. It was during the second of his three terms that he donated the land on which St. Paul's Episcopal Church was constructed in 1848.[63]

At some subsequent time, Waugh and Finley enlisted the services of young William Peden to serve as secretary and treasurer of their mercantile enterprise, though his exact date of employment remains elusive. However, it seems that in addition to his work at the mercantile, Peden was elected to serve as county trustee in 1836. In an ironic twist of fate that same year, the court also licensed Benjamin Duncan to sell spirits at his store on Stony Fork.[64] Little did either man know at the time that their paths would conjoin at a fatal intersection four years later.

Perhaps the only hint at rancor between Peden and Uncle William involved a girl. William Pitt Waugh, a noted bachelor, cast his eyes on the daughter of Joseph Williams Jr. of Surry County. Her name was Mary Taylor Williams. Born on December 7, 1819, young Mary was reputably beautiful and desirable. But when William Pitt proposed to her, she dismissed his suit. Enter nephew Peden, who sought the hand of the same lady. His proposal was met with a favorable response. So on Saturday, April 13, 1839, Mary Taylor Williams and William Waugh Peden were united in marriage. Evidently, Uncle William bore no lasting resentment. He built a home in Wilkesboro for the newlyweds and spent many an hour with them in the ensuing years.[65]

By 1840, Peden's star had begun to rise. He was elected to represent Wilkes County in the state legislature, an office he held until 1842. In 1840, the Peden family expanded, as Mary gave birth to their first child, John Taylor, on January 22. An unexpected addition occurred under tragic circumstances—Mary's father, Joseph Williams Jr., died on his estate in Surry County. Significantly, when his will was probated, Williams had bequeathed a young slave woman, Judith; her husband, Anthony; and their newborn

daughter, Lucy, to his older, unmarried daughter Fanny. Eventually, she and her slaves came to live in Wilkesboro with her younger sister, Mary, and husband William Peden.[66]

In March 1841, a board of superintendents of common schools in Wilkes County subdivided the county into sixty-two districts and appointed three committeemen for each district. In District 13, where one hundred school-aged children were enrolled, William W. Peden is listed as one of the three appointees. Also in 1841—the last year of his tenure as state legislator—William became a father again when Mary gave birth to a second child, Joseph, on October 11. Daughter Fannie was added on September 26, 1843. In 1844, Peden purchased a mercantile business in Wilkesboro from William H. and Benjamin Martin.[67]

But trouble was also brewing for the Peden family in April 1844. Benjamin Duncan, a Stony Fork merchant, and James Underwood expressed their mutual disdain for William Peden during a conversation. With witnesses around them, Duncan declared to Underwood that he would kill Peden or have him killed for preventing him from obtaining a certificate of bankruptcy. A sympathetic Underwood replied that he wished Peden was in hell. "He is breaking up all the poor people," Underwood complained, "and he denies that he owes me a debt of $100." That's how it all started—just talk about an official they disliked, each for his own reason. But then Duncan crossed a fateful threshold. "I will give you $250 and my roan mare, if you kill him."

James Underwood was a free person of color—some referred to him as a mulatto. Anyone who had ever attended a shooting match, however, knew of his reputation. He was a "crack shot," a sharpshooter who was invariably awarded first prize at shooting events. No one seemed to be able to best him in a contest of accuracy. But Benjamin Duncan had a live, likely moving, target in mind, so he secured Underwood's services as the nineteenth-century version of a hit man. William Peden was a dead man—he had only days to live.[68]

May 21, 1844, was a pleasant spring day. With the pastel shades of the season surrounding him, William Peden climbed atop his horse for the ride back to Wilkesboro from his Uncle Waugh's estate in Moravian Falls. Perhaps the "circus of spring" eluded his notice altogether as thoughts of his newly acquired mercantile business preoccupied his mind. Possibly, the faces of his wife, Mary, and their three children at home intruded on half-conceived business transactions. A twinge of guilt momentarily arose, and he resolved to spend more time with his family.

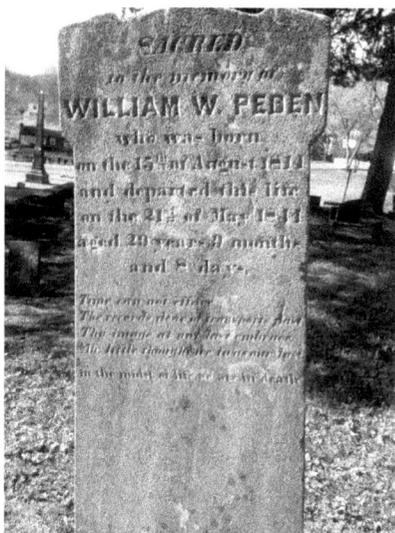

Gravestone of William Peden (1814–1844), husband of Mary Taylor Williams. He was assassinated while riding back to Wilkesboro from his uncle William Waugh's Moravian Falls plantation. *Author's photographic collection.*

As if by memory, Peden's horse turned at the fork in the old road toward Cub Creek and home. The assassin nested in his lair—undetected in the shadows of day. He waited patiently for his target to center in the sights of his rifle; he kept his index finger on the trigger. He drew in a breath and squeezed.

Seldom does a man hear the sound of the shot that slays him. A flash of searing light exploded inside his forehead. Then insensate darkness. William Peden was dead before his lifeless body fell from his saddle. His mount stopped abruptly where his master had fallen—as if transfixed—and faithfully remained beside his lifeless form until some passerby happened upon the tragedy.

AFTERMATH OF AN ASSASSINATION

When Mary Taylor Peden heard of the murder of her husband, how could she conceivably look beyond the devastation that this tragedy wreaked on her life and the lives of her young children: four-year-old John, two-year-old Joseph and seven-month-old Fannie? There was a household to maintain, replete with slaves; a mercantile business to operate; and bills to pay. Neither she nor her sister Fannie Williams was employed. There was the mental stress of being alone again after five years of marriage and the agony of attempting to help her children cope with the miserable fact that "your father is never coming home again." How would they—how could they—sustain themselves?

James Underwood anticipated that any inquiry into the shooting of William Peden would point in his direction. He confided in an acquaintance on the evening after the ambush that "he expected to be taken up for it." Underwood then warned his confidant: "I wish that you would not tell what

you know. If you do, then I will kill you. The jail is not sufficient to hold me, and when I get out, I will kill you."[69]

Underwood's premonition became reality—his renowned dexterity with a rifle was the clue that led to the discovery of evidence implicating both him and Benjamin Duncan. The two men were arrested and indicted in Wilkes County Superior Court—Underwood was named principle and Duncan accessory before the fact in the murder of Peden. Immediately, the defendants filed a joint motion for trials to be removed to Iredell County. Both prisoners were aware that William Peden had been politically well connected. His uncle, Colonel William Waugh, was one of the wealthiest men in western North Carolina, and his late father-in-law, Joseph Williams, was a politically connected planter in the Yadkin Valley area. Neither Underwood nor Duncan believed that an impartial jury in Wilkes County could be obtained. Their motion was granted.[70]

At the fall term of the Superior Court of Law of Iredell County in 1845, with Judge Richmond Pearson presiding, a grand jury was selected through a random drawing of names by a thirteen-year-old boy. (This factor would later be of significance in the appeals of both cases.) The court allowed James Underwood a separate trial from Benjamin Duncan. According to trial records, Underwood ostensibly represented himself.

The first witness offered by the accused was so intoxicated that he was incapable of "understanding the obligation of an oath or giving testimony." The court refused to allow the witness to take the stand but stipulated that the prisoner could recall him when he became sober enough to respond intelligently to the oath being administered to him. The witness was summarily remanded to the Wilkes County Jail until such time. In what seems a curious course of events, Underwood proceeded to examine several other witnesses and then closed his case without recalling or attempting to recall his first witness. It came as no surprise when the jury rendered a verdict of "guilty as charged."

The prisoner then moved for a new trial, predicated on two factors. First, he was deprived of the benefit of his star witness, who was too inebriated to respond to the oath when it was initially administered. Second, Underwood maintained that if the grand jury had been drawn by a boy of the proper age, it might have "consisted of different persons" and, consequently, the petit jury of twelve citizens by which Underwood was tried would have also been of different composition. According to the argument, a different petit jury might have rendered a more favorable verdict. The court refused that motion and one filed for arrest in judgment. James Underwood was

sentenced to hang. He immediately appealed both his conviction and the sentence to the North Carolina Supreme Court.[71]

When case 28 NC 96, *State v. James Underwood,* was heard during its December term in 1845, it was Chief Justice Thomas Ruffin who proffered the opinion of the court. The court rejected the dual grounds on which the appeal had been based and ruled that no error of law had been made by the lower court. Ruffin wrote, "We do not perceive any reason for arresting the judgment; and therefore, it must be certified, that there is no error in judgment, in order that it may be duly proceeded on."[72] With those words, the fate of James Underwood was sealed.

Prior to the sentencing of Underwood, the trial of Benjamin Duncan commenced in the Superior Court of Iredell County during the fall term of 1845, with Judge Pearson presiding. Immediately, Duncan moved that his trial be removed to another county. He asserted that several individuals, whom he named, had used their influence to prejudice citizens against him in Iredell County and had succeeded by means stipulated in the motion affidavit. The court refused the motion. Next, Duncan moved for a continuance because a key witness for the defense was absent, though he had been properly summoned. Duncan stated that he was not aware of this absence when asked if he was ready to stand trial. This motion was also refused; the trial proceeded.

The state first offered, in evidence, the conviction of James Underwood on the same indictment in which Benjamin Duncan was named as accessory before the fact. Counsel for Duncan objected to this information being admitted, on the grounds that Underwood had yet to be sentenced. The court overruled the objection.[73]

Witnesses were called by the prosecution to establish the fact that Duncan had hired Underwood to kill Peden. Among them was an unnamed witness who swore that about a month before the killing, he heard Duncan declare to James Underwood that he wanted to kill Peden for blocking his attainment of a certificate of bankruptcy. Underwood had replied that he wished for the deceased to be consigned to hell because he was breaking up all the poor people and had denied owing him $100. The witness testified further that he heard Duncan offer Underwood $250 and his roan mare if he would kill Peden.[74]

On cross-examination, the defense asked the witness why he had not detailed all of this information when he was initially deposed by the magistrate. He said that he had not because on the night of the shooting, Underwood had threatened to kill him if he disclosed all he knew to the authorities. The defense objected to this response, but the court allowed it to stand.[75]

Duncan's counsel insisted in a closing argument that if Underwood killed Peden, he did so of his own volition and malice—he had clearly declared his reasons for wishing that the deceased was in hell. However, Judge Pearson instructed the jury that, although Underwood might have had a grudge against Peden, if they were "satisfied that Duncan had hired, incited, and procured him to commit the murder, he, Duncan, was an accessory before the fact." When the jury returned from deliberations, they rendered a "guilty as charged" verdict against defendant Duncan. The court then passed on a sentence of death first to James Underwood and then to Benjamin Duncan. Duncan, like Underwood before him, appealed his conviction to the state supreme court.[76]

In December 1845, the Supreme Court of North Carolina heard the case *State v. Benjamin Duncan*, 28 NC 98. Duncan based his appeal on four factors. First, he, too, took exception to the drawing by which the grand jury had been selected. The court rejected this objection for the same reason cited during the Underwood appeal. Second, prisoner Duncan complained that the lower court had refused him a second change of venue, even though he claimed that citizens of Iredell had been prejudiced against him. The Supreme Court dismissed this claim as well. Third, Duncan objected to the testimony given by the witness who asserted that Underwood threatened to kill him if he divulged information to authorities. The court also rejected that objection.[77] Fourth, the defendant complained that Underwood's conviction was erroneously admitted as evidence against him and adversely influenced the judgment of the lower court. Further, at the time Duncan was tried, Underwood had yet to be sentenced. This was ruled a procedural mistake. Citing a multiplicity of legal precedents, the court upheld this fourth objection, and a new trial was granted.[78]

By the time his case came to trial again, Benjamin Duncan had successfully obtained a change of venue—the trial was removed to Davie County. He was tried there in the spring of 1846 and again convicted and sentenced to hang. He filed a second appeal with the Supreme Court of North Carolina; his conviction and his sentence were affirmed. Chief Justice Thomas Ruffin wrote the high court's opinion in which the fate of Benjamin Duncan was sealed. The prisoner had exhausted all of his legal options. Reality sunk in—he was a dead man.

No records provide insight into Mary Taylor William Peden's impressions of the legal wrangling of the trials of her husband's assassins. No accounts exist of her reaction to the convictions or subsequent hangings. One can only surmise that during the ensuing two years after William's death,

she had been preoccupied with caring for her family. Mary had no way of knowing that out of the tragedy that had befallen her, something good would eventually emerge.

"...THE DICTATES OF YOUR BETTER NATURE"

By such excuses and upon such pleas as I have described, you are in danger of justifying your delay of God's service; you are encouraged to put off till some more convenient season duties enforced by the dictates of your better nature.

—Richard Wainwright Barber, February 13, 1859, Grogan's Chapel[79]

Perhaps he was still in love with her. Or maybe, as the closing words of Reverend Barber's sermon suggest, he might have felt responsible for her out of a sense of duty, "enforced by the dictates of [his] better nature." After all, Colonel William Waugh had proposed to Mary Taylor Peden. Though he was forty-four years her senior, he apparently was enamored of the lovely Mary Taylor and ventured a proposal, which she declined. It was sometime afterward that Waugh's nephew, William Waugh Peden, asked for and received her hand in marriage. According to North Carolina Marriage Records, the couple was married on April 13, 1839.[80]

Ostensibly, the colonel bore no ill will toward the newlyweds. He built a house with a beautiful portico and dormer windows for them on the corner of Bridge and Main Streets across from the Wilkes County Courthouse. Although his primary residence was in Moravian Falls, Waugh spent many an hour with the Pedens in the ensuing years.

With the assassination of her husband, William, in May 1844, Mary and her unmarried sister, Fanny, shouldered the responsibility of raising three very young children while managing the affairs of a business, a house and a number of servants. Colonel Waugh became the family's benefactor for the widow and the children of his nephew. For the next nine years, it was his generosity that sustained the Peden family. Mary, however, depended on him for more than financial support; she needed a male "father-figure" for her two sons, John and Joseph. Doubtless, the colonel became that role model.[81]

But sorrow found the Peden household once again. On August 14, 1852, William Waugh drew his last breath. In his will, the colonel had

Waugh-Peden House, built in 1839 in Wilkesboro by William Waugh for his nephew William Peden and his wife, Mary Taylor Williams Peden. *St. Paul's Episcopal archival files.*

made a special bequest to Mary and her children. He left them $1,000, the Wilkesboro house and lot, and proceeds from the sale of land in Carol County, Pennsylvania. Additionally, he canceled any outstanding balances on account and stipulated that they should receive food staples from the mercantile for a year.[82] This final act of generosity notwithstanding, Mary Peden found herself alone once again.

It was during their hour of bereavement that spiritual comfort and reassurance was provided to the Peden family by the new Episcopalian priest, Richard Barber. Deacon Barber had moved to Wilkesboro about one year before Waugh's death at the invitation of his friend and the first missionary to St. Paul's Church, William Gries.

Richard Wainwright Barber, a Rowan County native, was born on June 18, 1823, to William and Margaret Hughey Barber. The first of five children, Richard was likely baptized early in life, with his godparents taking vows for him. According to family historian Betsy Barber Hawkins, his parents and grandparents served as his first teachers; he learned to read and write, memorize the catechism and read the Bible and the Book of Common Prayer. Eventually, young Richard took his own vows and became

a member of the Episcopal Church. The confirmation ceremony was performed at Christ Church in Cleveland, North Carolina, by the second bishop of North Carolina, Bishop Levi Sullivan Ives.[83]

Bishop Ives was appointed to his post in 1831 when he was thirty-one years old. A native of New York, Ives was a convert from the Presbyterian Church who embraced "high church" practices steeped in ceremony and liturgical tradition reminiscent of the Roman Catholic elements of worship. During the early days of his tenure, most congregants were delighted with his drive to increase programs in religious education, expand the church's membership and extend its influence. Through the efforts made during his first year, settlements eventually grew into missions and parishes. He came to Wilkesboro in 1836 to confirm the three children of James and Susan Williams

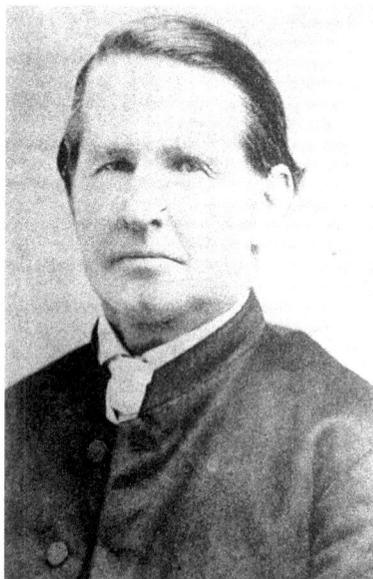

Reverend Richard Wainwright Barber, rector of St. Paul's Episcopal Church (1851–1896), was the first Wilkes County school superintendent and husband of Mary Taylor Williams Peden Barber. *St. Paul's Episcopal archival files.*

Dodge. Dodge was himself a New York native and Episcopalian from birth. He came to the South to practice law and eventually married Susan, the sister of Mary Taylor and Fanny Williams, all of whom were the children of the distinguished Colonel Joseph Williams. It is this occasion that marked the genesis of St. Paul's Episcopal Church.

Ives was enthralled with the western mountains of North Carolina and believed them to be fertile ground for spreading the gospel. He needed trained priests and missionaries, so he concocted a plan in 1842 to locate a seminary on property that he purchased in the mountains. The confluence of three streams there formed a shape similar to a bishop's cross, so the good bishop christened the area Valle Crucis (the Vale of the Cross). He located the first Episcopal Church there and, as importantly, founded the Valle Crucis Mission School. The school offered both classical and agricultural education for boys. The students were also expected to perform chores on the farm located on the premises. Significantly, he now had a seminary for the training of future priests, just as he had envisioned.

The vision of Bishop Ives and the resolve of Richard Barber to study for the priesthood eventually intersected. Barber was being trained under the tutelage of the priest of Christ Church, Dr. Thomas Frederick Davis. While studying with Dr. Davis, he became a serious student of Greek and Latin and devoted attention to history, mathematics and theology. Davis, unlike Ives, was an advocate of "low church" practices, which did not follow a prescribed order of service and deemphasized the priesthood, sacraments and rigid devotion to ceremony. Young Barber enthusiastically embraced the philosophy of his mentor—a predilection to which he fervently adhered for the duration of his ministry. Upon completion of his study with Dr. Davis, Barber declared his intention to study for the Episcopal priesthood—the first to do so from Christ Church. When Bishop Ives's seminary opened in 1845, Richard Wainwright Barber was one of six original seminarians enrolled at Valle Crucis, he along with Dr. Davis's son Thomas.[84]

But the school was not long for this world. Two factors contributed to the demise of a bishop's dream. First, many of the boys who attended had significant behavioral issues that could not be managed by the teaching staff. The antics of these boys soon turned community opinion against the church and school. Opting to maintain the church's standing with the settlers in lieu of attempting to reclaim the boys, the school disbanded in 1847. Most of the original seminarians remained; two decided to accept posts elsewhere. One of them was Barber's good friend William Richard Gries, who finished his studies, was ordained a missionary and was assigned to the mission in Wilkesboro.[85]

A second action by Bishop Ives proved to be the coup de grâce and called into question his mental stability. He angered both clergy and laymen when he decided to create a quasi-monastic order that he designated the Valle Crucis Society of the Holy Cross. He mandated that seminarians, including Barber, take vows of chastity, poverty and obedience. Sensing the order's Catholic leanings, some of the young men refused to do so; one of them was Richard Barber.[86]

Betsy Barber Hawkins wrote that when a procession came down the mountain to Wilkesboro to consecrate St. Paul's Episcopal Church, Barber did not accompany the group; he felt that the march was too "Roman Catholic" for his theological tastes. Instead, he secured a horse and rode into town a day early to stay with his friend William Gries, the missionary in charge of the budding parish.[87] How could Richard have known that in two years he would be the missionary to fill the pulpit at St. Paul's?

In the midst of controversy created by Bishop Ives, Barber completed his studies, was ordained a deacon and was sent by the bishop to serve Grace Episcopal Church in Plymouth, North Carolina, in the northeastern corner of the state. But a letter dated January 2, 1851, from his friend and colleague William Gries turned his attention westward, toward Wilkesboro. Gries indicated an urgent need to return to his home in Pennsylvania and suggested that his friend consider coming to St. Paul's. In the summer of 1851, William embarked on a trip north, and Richard Barber left Plymouth for the western foothills of Wilkes County, perhaps compelled by that inward call of duty "enforced by the dictates of [his] better nature"—words that he penned for a sermon delivered almost eight years later.

Arriving in Wilkesboro less than a year before Colonel William Waugh's death, Richard Wainwright Barber wrote in his journal in 1851:

> *August 17 St. Paul's Ch Wilkesboro*
> *Said Morning Prayer at six o'clock*
> *Ante-communion service and sermon at eleven o'clock*
> *Offering $1.10*
> *Evening Prayer St. Paul's Ch*
> *Instructed the negroes* [sic] *& said prayers.*[88]

On that August Sunday evening, one of the "negro" congregants was a thirty-one-year-old female slave named Judith.

THE WIDOW AND THE PRIEST

On December 7, 1852, Mary Taylor Peden celebrated her thirty-third birthday. A week later, Colonel Waugh would be dead for four months; eleven days later, it was Christmas. For the Pedens, it was not the happiest of holiday seasons, as they had recently lost an important member of the family. Within a period of twelve years, Mary Peden had lost three significant men in her life: her father, Joseph Williams Jr.; her husband, William Peden; and now, the family benefactor and uncle, Colonel William Waugh.

On the day of the colonel's demise, Mary had been widowed for slightly longer than eight years. During those hours in which she battled overwhelming loneliness, Waugh certainly provided a modicum of companionship for his deceased nephew's wife. But Mary was still a young

woman desiring to experience a personal, intimate relationship akin to that which ended abruptly with the assassination of her husband.

For Richard Barber, life was beginning to fall into place. Earlier that year, on May 23, 1852, Deacon Barber was ordained a priest by Bishop Eli Ives at St. John's Church in Fayetteville, North Carolina, during the annual diocesan convention. Now, he was sanctioned to consecrate the elements and give communion to his St. Paul's communicants.[89] In June, the newly ordained priest celebrated his twenty-ninth birthday, and his thoughts turned to starting a family of his own.

In August, William Waugh died, leaving the Peden family bereft of their benefactor. The burgeoning hamlet of Wilkesboro mourned a revered community leader, and the aspiring Episcopal parish lamented the loss of a generous friend. Though Waugh was Presbyterian, he nevertheless made significant contributions to the Peden family's church. The Reverend Barber visited the home to console the grieving family as they adjusted to their recent loss. In the ensuing months, however, it became obvious to everyone that Barber had other than pastoral interests in the family, specifically toward Mary Taylor.

There are no extant letters or records chronicling the journey to love for Richard and Mary. But by the spring of 1853, the couple declared their intentions to marry, and marriage bonds were published. St. Paul had not celebrated a wedding since its inception. On June 23, 1853, five days after the church members observed the thirtieth birthday of their priest, they gathered to celebrate his marriage to Mary Taylor Williams Peden. Among the celebrants were Mary's two sisters: Susan Dodge, who lived across Main Street from the Waugh-Peden house; and Fanny Williams, who had resided with Mary since about 1840. Both sisters were happy for their youngest sibling, who had experienced an inordinate amount of tragedy during her life of a little over three decades.[90]

According to Betsy Hawkins, Mary's children—John, Joseph and Fannie— witnessed their mother's marriage to a man whom they would come to accept and admire as their stepfather. Hawkins notes, in her 2007 book detailing the life of her great-grandfather Richard, that Fanny Peden was especially devoted to her stepfather. Fanny was but an infant when her father, William, was murdered; she had no recollection of him. For all intents and purposes, Richard Barber was her father. Fanny never married. When she died in 1916, she requested to be buried beside her stepfather in St. Paul's Churchyard.[91]

Those with family ties to Wilkes County noted the Barbers' marriage from as far away as Alabama. In a letter dated July 15, 1853, John T. Finley wrote

to his brother-in-law Hamilton Allen Brown, who resided in Columbia, Tennessee, detailing the news from "home." After inviting Allen to visit them in Silver Springs, Alabama, before his vacation concluded, Finley reassured him that all was well in Wilkesboro. Then he added, "No other news except that Mr. Barber and Mrs. Peden were married."[92]

For the next four years or so, the Barbers lived in the Waugh-Peden house, on the corner of Main and Bridge Streets. In the fall of 1855, the couple welcomed their first child, William Wainwright Barber. About two years later, Richard purchased a large farm approximately two miles east of Wilkesboro. Known as the Benjamin Jones place, this property adjoined land that the Peden children had inherited from their father. Records indicate that only a few cabins were located on the plantation, with rich bottomland that ran along the Yadkin River and a "wonderful spring."[93] An opulent house was soon built atop a hill ensconced in a cedar grove. Christened "Cedar Lawn," it was the showpiece on the Yadkin. In addition to the cabins for servants,

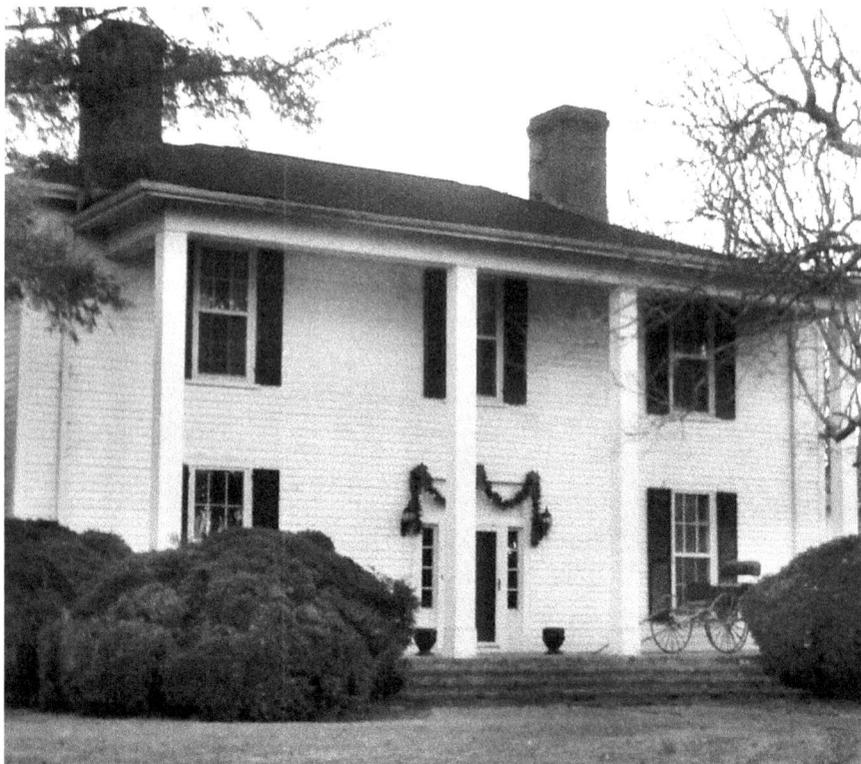

Present-day Cedar Lawn, where the Richard Barber family moved around 1858. *Author's photographic collection.*

there were other buildings constructed on the property—a kitchen, loom house, smokehouse, granary, wash house, barn and blacksmith shop.[94]

The Barber family moved into their new home sometime in 1858, though the exact date is unknown. Likely, the move had not taken place before Mary gave birth to another child, Mary Taylor (Mamie) Barber, on January 5, 1858. She would be the last child born to Richard and Mary.

The year 1858 was an eventful one for St. Paul's Episcopal Church as well. The annual diocesan convention was convened in Edenton in May. The St. Paul delegation was composed of church members James Gwyn, James Calloway, James Dodge and Ransome Hickerson. During the convention, St. Paul was officially admitted as a parish, owing to Richard's exemplary leadership. Now that it was a parish, the church's minister could rightly be referred to as Rector Richard Wainwright Barber.[95]

As the Barbers commenced building a life together in the 1850s, the country was beginning to feel opposing forces tearing at the very fabric of the Union. As early as 1833, Andrew Jackson had gazed into the future and predicted that southern leaders would do anything necessary to dissolve the Union and form a confederacy bounded to the north by the Potomac River. Senator Thomas Hart Benton mused that no topic of national significance could be discussed within a public forum unless the question of slavery was injected into it. "Here it is, this black question, forever on the table, on the nuptial couch, everywhere!"[96]

John C. Calhoun, the fiery lawmaker from South Carolina, observed that some of the "cords" holding the tenuous Union together were beginning to snap over the slavery question. He noted that if the rupture of common cords was not abated, then "nothing will be left to hold the States together except force."[97]

In the Thirty-First Congress, Henry Clay, from Kentucky, rose to declare that the country was on the brink and pleaded with his colleagues to take action to thwart any attempt to dissolve the Union. If dissolution occurred, then he foresaw a conflagration that would be so furious and so bloody…that it would forever mark the pages of our history. Then he offered support for the Compromise of 1850; if adopted, it could mend the widening rift. After much debate, the compromise was introduced by Illinois senator Stephen Douglas as five separate pieces of legislation that passed in both the Senate and House. Though the South received more concessions than the North relative to the slavery question, the bill's passage appeared to cool the flames of crisis. Incensed by the compromise, abolitionists in both sections of the country increased their antislavery efforts.[98]

In the fall of 1858, as members of St. Paul's Episcopal Church continued to bask in their official recognition as a parish, the Lincoln-Douglas debates culminated in the election of Stephen Douglas to the U.S. Senate. By that time, the divisive question of slavery was beginning to take center-stage in the national debate. Every region of the country was embroiled; Wilkes County was no exception. Many St. Paul parishioners owned slaves, including the Calloway, Gwyn, Dodge, Hickerson and Williams families; all had to have been aware of the rising sectional tension over the slavery issue.

Richard Barber was not a slave owner when he came to Wilkes County in 1851. The servants in the home in which he would eventually live belonged to Fanny Williams and the woman who became his wife, Mary Taylor Peden. In fact, the census of 1850 documented ten slaves between the two sisters—Fanny with seven, Mary with three. Most were part of their inheritance from Joseph.

There can be no doubt that numbered among Fanny's slaves was a "family" comprising a man named Anthony, a woman named Judith and their child, Lucy. With the death of Joseph Williams, all had come with Fanny to live in the Peden household. When the head of that house, William, was assassinated in 1844, the family, including slaves, fell under the protective eye of Colonel Waugh. As fate would have it, less than a year after his death, the Peden-Williams family and their servants had become members of the household of the Episcopal priest.

"SHE WILL BE PRAISED"

On February 6, 1820, the U.S. government announced that the country's population numbered 9,638,453; 18.4 percent, or 1,771,656, were black.[99] Ironically, on the same day, the first organized emigration of blacks was transacted from the ports of New York to Sierra Leone, a small country sandwiched between Guinea and Liberia on the West African coast. And on that very same day, the first 86 African American immigrants started a settlement in Liberia, sponsored by the American Colonization Society (ACS), known formally as the Society for the Colonization of Free People of Color of America.

Less than a month later, on March 3, the controversial Missouri Compromise passed both houses of Congress, and Missouri was admitted to the Union as its twenty-fourth state, despite the fact that slavery was legal there.

Northern leaders were vehemently opposed to the admission of Missouri as a slave state; they had aspired to contain slavery in the South.[100] Doris Kearns Goodwin writes that southern leaders viewed northern opposition as a direct threat to their economic way of life and threatened to secede from the Union if Missouri was not admitted because of its stance relative to slavery.[101] A compromise was reached through the efforts of Henry Clay. Ultimately, the state in question was admitted to the Union, simultaneous to the admission of Maine as a free state. Moreover, the bill prohibited slavery in all of the remaining territory of the Louisiana Purchase north of the thirty-sixth parallel. That line of latitude fell across the southern border of Missouri, making the state an exception to the redefined boundaries.[102]

Over a month later, on April 9, 1820, a black infant girl was born into slavery in Surry County, North Carolina. Her mother named her Judith. Hebrew in origin, the name means "she will be praised." How could her mother have known that the appellation she had given her tiny daughter would characterize her life?

Details of Judith's early life are sketchy and difficult to substantiate through extant records. According to one family tradition, her parents likely came from Africa and were conducted to Virginia; their names are unknown. Another tradition indicates that Judith was born in Yadkin County in 1820; however, that county was not carved out of the southern part of Surry until 1850, when she would have been thirty years old.[103]

Yet another tradition maintains that Judith was sold to Richard Barber and conveyed to Wilkes County in 1833, when she was thirteen. Barber was three years younger than Judith and would have been a boy of ten and living in Rowan County during that year. Moreover, records clearly indicate that Barber did not own slaves prior to his marriage to Mary Taylor Peden in 1853.[104]

In a family book collaboration entitled *Treasure Troves*, Elizabeth Grinton, one of Judith's great-granddaughters, states that a bill of sale for Judith was located. It stipulates that her great-grandmother was sold to Joseph Williams of Logtown, Rockford County Seat, in Surry County, when she was twelve years old.[105] There is merit to this tradition.

Tracing the history of the Joseph Williams family is challenging. Colonel Joseph Williams (1748–1827), the son of Nathaniel Williams, resided in Surry County. His picturesque home near Shallow Ford, named Panther Creek, stood along the Yadkin River. He was married to Rebecca Lanier in 1772 and fathered a dozen children.[106] His second son, Joseph Lanier (1775–1840), is likely the buyer whose name appears on the sale document. He would, as an adult, also reside in Surry County.

In Colonel Williams's 1812 registered will, he listed the names of twenty-one slaves whom he bequeathed to family members.[107] A codicil was appended in 1819, a year before the accepted date of Judith's birth. Likely his son Joseph inherited some of those servants when his father died in 1827. As a slave owner, he continued to buy and sell slaves for the duration of his life and could have easily acquired twelve-year-old Judith.

What is known, with a substantial degree of certainty, is that Judith was born on or around April 9, 1820, according to census records. Born into slavery, she resided on the Joseph Lanier Williams plantation in Surry County until his death in 1840. When his will was executed, it revealed that Judith; her partner, Anthony; and their child, Lucy, born in 1840, had been bequeathed to one of his daughters, Fanny. There is some notion that Judith legally belonged to Fanny's younger sister, Mary Taylor. However, all extant documentation provides evidentiary support for Fanny's ownership. In addition to the will, an 1850 court order sentencing Anthony to the whipping post names Fanny Williams as his owner.[108] Moreover, St. Paul's Parish Register (SPPR) clearly indicates that Fanny owned Judith and her children, all of whom were confirmed church members. Although Anthony was not a member, his death in 1864 appears in SPPR, and there is reason to believe that he may have been buried in the St. Paul's cemetery in Wilkesboro.[109]

LOGTOWN

It was on his 2,500-acre plantation overlooking the south bank of the Yadkin River, near the Surry County seat of Rockford, that Joseph "Jo" Williams built a house around 1810 for his wife, Susan Taylor, of Granville County. Married in 1806, the Williamses would raise seven children—three boys, four girls—in their home, named Logtown.[110]

But the house was much more than a structure fabricated from logs. Betsy Barber Hawkins, in her biography of Mary Taylor Williams—Joseph's youngest daughter—described it as a home constructed of massive logs that were subsequently covered with a sheathing "to make it the most outstanding house" in the area. A number of slaves worked the expansive fields and labored in the limestone quarry located on the property.[111] (Surry County Land Entries, Grant 1229, dated January 1, 1779, stipulates that Colonel Joseph Williams entered one hundred acres of land near Snow Creek—

adjoining property owned by Jonas Lawson—"including a Limestone Quarry on said claim." His son Jo, who would be the future owner, was barely three years of age then.)[112]

Without question, the Williams family lived in high style in the early part of the nineteenth century. An inventory of the house effects listed a pianoforte, silver soup dipper, dining room chairs, china and silver enough to host a large party. The substantial library contained religious books, the classics and even novels.[113]

Jo and his wife, Susan, were evidently well-educated people who provided for the schooling of their children. For instance, academic records reveal that all four of his daughters attended Salem Academy, established by the Moravians in 1772, located in present-day Winston-Salem. Susanna was the first to enter, in 1821, a year before her mother died; Mary would be the last to matriculate, in 1835. According Betsy Barber Hawkins, each of the four girls stayed at least a year and a half, at a basic cost of $30 per quarter ($811 in 2015 currency). Tuition included board, washing and instruction; music lessons and ornamental needlework were offered for additional costs.[114]

But on February 7, 1822, tragedy struck. "My dear wife departed this life…about half after 2 o'clock PM aged 35 years & 29 days."[115] Jo was grief-stricken and would never marry again. However, his youngest daughter, Mary, had just turned two and was bereft of her mother's care. Williams had no other choice but to rely on his own mother and thirteen-year-old daughter, Susanna (Susan), to provide care for the toddler. Moreover, there were five other children for whom provision had to be made: John, fifteen; Joseph, twelve; Rebecca, ten; Fanny, eight; and Robert, six. The two oldest boys could essentially manage for themselves and perhaps assist their father with the younger children. Likely, some of the slaves assisted in child-rearing; Isabel must have been one of them. When his will was probated in 1840, Jo Williams acknowledged her contributions to his family. He stipulated that Isabel could decide with which of his children's families she wanted to reside and live out the rest of her days.[116]

In the early spring of 1820, a slave woman gave birth to a daughter whose life would subsequently intersect with that of the Williams family. Judith, as she was named, possibly lived out her childhood near the Virginia–North Carolina border learning the responsibilities of plantation life from her mother and others.[117] In 1832, "Logtown Jo"—a name by which Joseph Williams was known—bought the twelve-year-old slave girl and conducted her to his plantation. It is reasonable to infer that Judith was not a single

acquisition; other slaves, perhaps her parents, were among those purchased. However, there are no documents to substantiate this conjecture.

When Judith came to Logtown, she was the same age as Mary Taylor, the youngest of the Williams children. It is conceivable that the two girls played together as they grew up in their parallel universes. Perhaps it was at this juncture that a lifelong bond was forged between the two women, as they would be invested in one another's lives for the next sixty years. In fact, family tradition maintains that Judith's descendants hold the Mary Taylor Williams Barber family in loving regard to this day.[118]

Conceivably, Judith was acquired to serve several purposes: to be, perhaps, a playmate for young Mary Taylor; to eventually labor on the plantation; and to bear other slave children, particularly boys. Slaveholders certainly found it expedient to breed slaves; by this time, it was illegal to purchase imports from Africa. It was not unusual for a female slave to be advertised as "good breeding stock." If childbearing could begin as early as thirteen years of age, as it often did, then Judith was but one year away from that eventuality when Williams bought her in 1832. Family records and folklore agree that her first child of record was born when she was a young woman of twenty years.[119]

Judith's descendants have historically maintained that she bore thirteen children—all daughters—in her lifetime. No documentation of any of their births exists, save for one, the St. Paul's Parish Register (SPPR). However, scrutiny of the actual register for 1849, the year of the church's consecration, revealed that only twelve daughters were documented: ten who lived to adulthood, one infant twin who died at eight months and one who died when she was fourteen months old.[120] Currently, SPPR is the most reliable historical record that documents the births of Judith's children.

Popular memory maintains that a male slave named Anthony was the partner with whom she conceived at least half of her children, ten of whom grew to adulthood; one ostensibly died when she was about twenty-four. Biographical information about Anthony is sketchy at best. The date of his birth can only be ascertained from the date of his death, 1864.[121] Presumably, he was born around 1818, two years before Judith. Extant documents place him at Logtown during the time that Judith lived there, though information related to when and how he was acquired remains elusive. When Joseph Williams's will was executed in 1840, it provided for his children to inherit certain slaves. Clearly, Fanny Williams was bequeathed Judith, Anthony and their child (Lucy), and she retained that ownership throughout slavery's duration.[122]

Two other records remain regarding Anthony. According to court minutes, he was sentenced to the town whipping post in 1850 for an infraction that remains unknown. That document unequivocally states that Fanny Williams was his owner. In 1849, when Judith and some children were baptized and confirmed as colored members of St. Paul's Episcopal Church, Fanny is designated as their owner in SPPR. Although it appears that Anthony was never a confirmed member of the church, his death was recorded in 1864 within the register. It is also plausible that his remains were laid to rest in the church's cemetery.

Could Anthony have been the biological father of all of Judith's twelve children? The first child, Lucy, was born in 1840; the last child who lived to adulthood was Eliza, born in 1863. Based on those dates, it can be logically concluded that Anthony fathered all of them before his demise in 1864. However, some family researchers and historians theorize that he fathered only several of her children; others say that it may have been at least half of them.

Evonne Raglin, Judith's great-great-granddaughter, noted that the first daughters who were born to Judith were of darker hue, while those of subsequent years tended to be lighter in complexion.[123] Her observation suggests that some of the daughters may have been fathered by another man or men. If that is the case, who could those other fathers have been?

BECOMING "MAMMY JUDY"

On Tuesday, April 9, 1839, Judith celebrated her nineteenth birthday. She had become a petite young woman, with an Indian brown hue, high cheekbones and fine, dark hair. Immaculate in appearance, she discharged her duties as cook, laundress, seamstress and nursemaid with such aplomb that it garnered both attention and praise from the Joseph Williams family.[124] This revered servant would eventually become known to the community as "Mammy Judy."

Four days after Judith's birthday, Mary Taylor married William Waugh Peden in Surry County. Little did the young slave woman realize that she would eventually become part of the Peden household and attend a second wedding of Mary Taylor after her first marriage was precipitously terminated.

About a year and a half after the marriage, on October 5, 1840, Mary's father, Joseph Williams, died in Surry County. Subsequent to his death,

Daughter Fanny decided to live with Sister Mary and her new husband, William, in the house that Waugh built in Wilkesboro. At some point between 1840 and 1844, the move was effected; consequently, Judith, Anthony and at least one child, Lucy, were conveyed to Wilkes County for the first time.[125]

The Waugh-Peden home was arguably the most beautiful house in town at the time. Extant records locate the construction on a block to the west of courthouse square, the façade facing Main Street. Slave cabins and other outbuildings were erected on the lot to the back and side. Betsy Barber Hawkins writes that one cabin facing the courthouse—now the Wilkes Heritage Museum—was still standing with the main house in the late 1940s.[126] The home, fashioned in the Greek Revival style, and its grounds bedecked with boxwoods and large cedars dominated the center of Wilkesboro for more than one hundred years.[127] It was on this property that Judith and Anthony raised Lucy while working in the master's house and fields.

Daughter Lucy was born into slavery on February 27, 1840, on Joseph Williams's Logtown Plantation in Surry County. She was but a bairn when her owner, Fanny Williams, moved her and her parents to the Wilkes County home of her sister, Mary Taylor Peden. When Lucy was about eighteen years old, she became a part of the Richard Barber household, though Fanny Williams would retain ownership of her and her family. She married Frank Wilborn and had three children: Annie, Callie and Anthony.

It was ninety-four-year-old Elizabeth Barber, the wife of Callie's son Arthur and Lucy's grandson, who described Lucy during an interview about a year before her death: "She was a short woman, a little over five feet tall. Her complexion was darker, like her mother Judith's." Ms. Barber recalled that her grandmother-in-law was "exceptionally intelligent" and certainly able to read and write.

Lucy continued to work for the Barber family subsequent to emancipation, earning a favorable reputation among the female students who attended Mary Taylor Barber's home school for girls and young women. She appears by the name "Lucy" in the census of 1900, working as a "Servant" in the household of Richard Barber. The census of 1910 lists her as "Lucy Barber," employed still by the Barber family.[128] Judith's and Anthony's firstborn child lived to be ninety; she died on December 31, 1930, eighteen years after her ninety-two-year-old mother. She was interred in the Old Damascus Baptist Church Cemetery; her grave is unmarked.[129]

Sometime in 1842, Judith and Anthony had an addition to the family— their second daughter, Rachel. Precious little is known about her life. Perhaps she was one of the slaves counted among the seven assigned to

Left: The actual St. Paul's Parish Register (SPPR), 1849. It is arguably the most reliable primary source for family documentation of Judith Williams Barber and her children. *Property of St. Paul's Episcopal Church.*

Right: SPPR record of the confirmation of Judith Williams Barber's first four daughters: Lucy, Rachel, Martha and Mimia. *St. Paul's Parish Register.*

Fanny Williams in the 1850 slave census.[130] The first time she appears by name in a document is in 1849 in the SPPR; she is listed as a "coloured parishioner," along with three other girls—likely her sisters Lucy, Martha and Mimia—all belonging to Fanny Williams. On January 7 of that year, all the girls were baptized. However, SPPR indicates that Rachel was not "confirmed" as a member until over a decade later, on August 28, 1859. At that time, she would have been about seventeen years old.

That notation is significant, for in a DVD released in 2001, family member and historian Elizabeth Grinton states that Rachel was about eleven years old when she died. Given SPPR records, however, it is clear that Ms. Grinton must have been alluding to a tradition repeated from popular memory. In addition to the 1859 date previously cited, a twenty-four-year-old Rachel appears with mother Judy Williams in an 1866 parish record, but she is not

SPPR record, September 1859, lists seventeen-year-old Rachel Williams, Judith Barber's second daughter, as a "communicant." One family tradition indicates that Rachel died around 1853. *St. Paul's Parish Register*.

SPPR entries listing twenty-four-year-old Rachel, with her mother, "Judy," and sister "Lucy" in 1866 as "sponsors." *St. Paul's Parish Register*.

listed with her mother and sisters in the census of 1870.[131] The inference could be drawn that she died prior to the collection of census data. Family lore avers that only nine of Judith's twelve daughters reached adulthood— Rachel was not counted among them, though it appears that she should have been.

Tragedy struck the Peden home on May 21, 1844, when William was assassinated while returning from his uncle's plantation in Moravian Falls. Mary Taylor and Sister Fanny were left with the Pedens' three children, about ten slaves, a household to run and a business to manage. Notably, a little less than five and a half months after William's murder, Judith gave birth to another child, Martha, on November 2, 1844. Family tradition holds that she was of fair complexion, considerably lighter than either Judith or Anthony. Though her death certificate stipulates that Anthony was the father, relatives maintain that Martha could have been the offspring of a white man. A couple of compelling reasons support that belief. First, Fanny

Williams, her rightful owner, sold Martha while she was just a child, perhaps to a man named William Barnes of Tennessee.[132] The motive for the sale remains a mystery. Certainly, the Peden-Williams household did not need the money. However, a slave child of light complexion might have caused the neighbors to speculate as to the identity of the father.

Second, years later, Martha was noticed in a church meeting in Jellico, Tennessee, by an itinerant minister, Reverend Wood, who was married to another of Judith's daughters, named Alice. The good reverend mentioned to Martha that she bore a striking resemblance to his wife and suggested that the two should meet. When Reverend Wood returned home to Red Ashe, Kentucky, he told his wife of Martha and requested that she accompany him on his next trip to Tennessee. When the two ladies met, they made amazing discoveries—they both were originally from Wilkesboro, both had a mother named Judith and each had been sold as children to owners who lived in some proximity to each other. And by the way, both ladies were "fair of complexion."[133]

If Anthony was not Martha's father, then who might have he been? The best we can do is make informed speculation. What is known is that young slave women often became victims of rape by masters seeking sexual gratification. In fact, it was considered unlawful for a female slave to resist the sexual advances of her owner. To do so was to risk discipline for insubordination. Succinctly stated, she had no alternative and no recourse. Frequently, children were born to the unions of white owners and female slaves. These offspring were generally of fair complexion and referred to as "mulatto."

Was there a white male who had access to Judith and could have fathered a child by her? The most obvious answer would point in the direction of William Peden. His being Martha's father is a mathematical possibility. She was born in November 1844. Judith would have most likely conceived her sometime in February of that year. Peden was not killed until May 1844—about five and a half months before Martha was born. Might Mary Taylor have importuned Sister Fanny to sell this mulatto slave child so as not to besmirch the reputation and legacy of a community leader recently slain?

Judith gave birth to another daughter, Mimia, in April 1848.[134] According to relatives and burial records, her father was Anthony. She would eventually marry Minor Wilborn about 1865 and, over the next thirty-one years, give birth to eight children.[135] The sixth child, Martha, was blinded as a child and lived with Mother Mimia, performing whatever tasks were assigned to her. Relatives recalled that she raised hogs that were known to be the "largest in the area at killing time."[136] Martha also possessed a mellifluous

singing voice that she did not hesitate to use. Mimia was credited with preserving Mammy Judy's hand-hewn bed and used it before passing it on to other family members. On October 12, 1942, Mimia Wilborn died at the approximate age of ninety-four. She is interred in the Old Damascus Church cemetery along with her husband, her mother and some of her sisters. Her grave site remains unmarked. Lillie Barber remembers "Aunt Mimia" as "a dear sweet person. She was kind and always welcomed you into her home."[137]

Mimia Barber Wilborn, Judith Barber's fourth daughter, was born in 1848. *Treasure Troves*.

On May 17, 1849, another child was baptized, "sponsored" by Fanny Williams and her sister Mary Taylor Peden. Judith's fifth daughter, Mary, was born in March 1849, according to the most accurate records. The 1930 U.S. federal census lists Mary, age eighty-one, as residing in Wilkesboro's District 31 with her daughter, Mamie Denny.[138] That record tends to corroborate a birthdate of 1849. Family members remember Mary as being a short lady with an Indian-brown complexion much like her mother's.[139] Notably, when she married William Locke in September 1867, the marriage license recorded "Judah Williams" (Judith) as her mother; her father is simply listed as "colored"—essentially unnamed.[140] Again, the query arises: If Anthony was not her father, then who might have been?

THE AMBIGUOUS LIFE OF MAMMY JUDY

I was growed up when the war came. And I was a mother before it closed. Babies was snatched from their mother's breasts and sold to speculators. Children was separated from sisters and brothers and never saw each other again. Course they cry; you think they not cry when they was sold like cattle? I could tell you about it all day, but even then you couldn't guess the awfulness of it.

—Delia Garlic, former slave, Montgomery, Alabama[141]

Throughout the South, the lives of free persons of color (FPC) were both ambiguous and tenuous at best. John Hope Franklin, in his book *The Free Negro in North Carolina, 1790–1860*, maintains that skin tone defined free persons of color as "potential servants," yet their legal status gave them rights reserved for the white population. Franklin quotes North Carolina Supreme Court justice Frederick Nash, who opined that, "From the earliest periods of our history, free people of color have been among us as a separate and distinct class requiring from necessity, in many cases, separate and distinct legislation."[142] Certainly, they resided in an area of ambiguity. Kathy Staley, writing on the subject in 2005, summarizes it this way: "Neither citizen nor slave, their very existence defied racial mores and legal code. As a result, their freedom was unstable and could be revoked if they became indebted or convicted of criminal activity."[143]

Few realize that Wilkes County had one of the highest concentrations of FPC among the counties in western North Carolina. Census data reveal that Wilkes ranked first in 1850 and second in 1860. In fact, between 1790 and 1860, the FPC population consistently increased. Three distinct groups made up the FPC population in Wilkes: native freeborn, eastern migrant freeborn and those newly emancipated. In a multiplicity of cases, the Wilkes natives were resident in the county prior to 1820. Generally landless, these households were headed by single mothers. Their children were characteristically apprenticed or bound out to white families who owned plantations in the county.[144] The eastern freeborn residents usually migrated from the southeastern part of Virginia and likely moved to Wilkes County after 1820. Unlike their counterparts, these families owned land and were composed of two parents with children. Contrary to local tradition and family folklore, it appears that few free people of color in Wilkes were emancipated slaves. Extant records list very few exceptions to this claim.

However, families whose "heads-of-house" were females seemed to have fallen under greater scrutiny. According to Staley, these women were either widows, married to other slaves, or merely single. Without question, their children were bound out or apprenticed by county officers.[145] In 1992, Victoria Bynum examined this eventuality. She argues, in her book *Unruly Women: The Politics of Social and Sexual Control in the Old South*, that juvenile apprenticeship was a de facto method for controlling sexually promiscuous women and enslaving their free children of color.[146]

Succinctly stated, there were absolutely no assurances that the social and legal status of FPC in Wilkes County were consistently recognized and honored by those elected to positions of authority. Immediate and absolute

revocation of their fragile freedom was a constant fear—a fate shared by others who were similarly situated in both the North and the South.

But Mammy Judith, Anthony and her children were born into slavery. Slaves were accustomed to laboring daily under the clouds of ambiguity and tenuousness of social status, living with the knowledge that their lives could be precipitously and permanently altered at the will and whim of the person who owned them. None enjoyed the privilege of moving about freely, as did the FPC. Rather, their movement was closely monitored. Willful departure from the terms by which they were allowed to leave plantations was severely punished.

Enslaved adults did not possess the human right to defend themselves against attacks by their masters. Sadly, parents could not even protect their children from the powers of white people who might forcibly remove them to another plantation, another county or another state. They did not own themselves; they were chattel. Even under the most genial of circumstances, the enslaved lived with the miserable, menacing prospect of eventual heartache.

Judith was no stranger to that heartache. Already, at the fragile age of twelve, she had been purchased by a Surry planter, likely apart from her parents. Though there is no written account of her reaction to being sold away from her mother, it is certain that the transaction must have been traumatizing for both of them. Doubtless, Judith's experience was similar to that of other slave children. In *Help Me to Find My People*, Professor Heather Graham described the emotional commonalities of children torn away from their mothers: "the jolt of sudden loss, holding onto the faint hope of reunification, and the searing, lasting memory of confusion and loss."[147]

Graham cites the experience of former slave Charles Ball, who, at the age of four, witnessed the heart-rending distress of his mother when he was sold away. Despite the sympathetic assurances that his new owner offered his grieving mother, she nonetheless ran after him, "took me down from the horse, clasped me in her arms, and wept loudly and bitterly over me." Recounting the scene a half century later, Ball recollects, "Young as I was, the horrors of that day sank deeply into my heart…the terrors of the scene return with painful vividness upon my memory." He never again heard the voice of his poor mother.[148]

Perhaps Judith told her own children about that horrific day in 1832 when she was forcibly removed from her parents and a piece of her heart died—there is no documentation that suggests she ever saw their faces

or heard their voices again. How could she have possibly foreseen that a daughter whom she would give birth to twelve years after her own date of sale would eventually be sold to a slaveholder in Tennessee?

Born in November 1844, Martha was, in all likelihood, Judith's third child. Fair of complexion, she is thought to have been fathered by a white man. Parish records from SPPR dated January 7, 1849, attest to the baptisms and confirmations of four children belonging to Fanny Williams: Lucy, Rachel, Martha and Mimia. All are believed to be Judith's first four children.[149] Based on the most accurate family records, it can be inferred that Lucy would have been about nine years of age; Rachel, seven; Martha, four; and Mimia, about one.

No one seems to know at what age Martha was purchased, though the sale had to have been transacted subsequent to January 1849. There is no other record of her until, as an adult, she was noticed by Reverend Wood while he was ministering in Jellico, Tennessee. (Reverend Wood was married to another of Judith's daughters, who ostensibly favored Martha.)[150]

The motivation for the sale remains a mystery. It has been speculated that Martha may have been sold to protect the identity of her birth father. The selling of a slave child to spare a white family the embarrassment of being implicated in the birth of a "mulatto" is a documented, common practice of slaveholders. William Henry Singleton, in his *Recollections of My Slavery Days*, maintains that he was sold at age four by his New Bern, North Carolina owner to a buyer in Atlanta. Why? Because the master was "embarrassed and annoyed" that his brother was Singleton's father. Fortunately, he was eventually reunited with his mother. [151] Judith, however, never saw Martha again.

As was previously established, Mary—Judith's fifth child—was born in 1849. SPPR may provide the first record of this daughter. It lists a child named Mary, sponsored by Fanny Williams and Mary T. Peden, who was baptized on May 17, 1849.[152] At that juncture, she would have been only a couple of months old.

The identity of Mary's father remains an enigma. She was born shortly before the collection of the 1850 Census Slave Schedule. At that time, Judith was a servant in the Peden-Williams household under the watchful protection of Colonel William Waugh. Fanny Williams and Mary Taylor Peden are identified as slaveholders assigned seven slaves and three slaves, respectively. Of the family's ten slaves, there is only one man, age thirty-one, who could have conceivably fathered a child.[153] The only other man is a six-year-old boy. Most likely, the adult was Anthony.

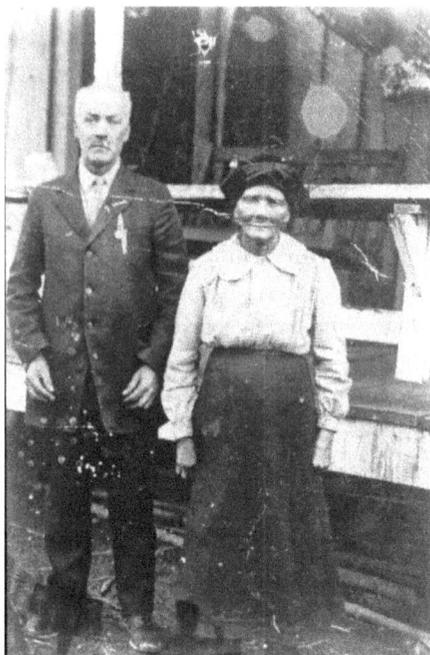

Above: Laura Williams Nichols, sixth child of Judith Barber, was born in 1851. She lived in this cabin with her husband, Rufus. *Treasure Troves*.

Left: Mary Williams Barber, Judith Barber's fifth daughter, was born in March 1849. She is pictured here with her husband, William Locke Barber. *Treasure Troves*.

However, in 1867—two years after the conclusion of the Civil War and three years after Anthony's death—Mary married William Locke. Officiating at the ceremony was the Reverend Richard Barber. Of interest is the designation of the bride's mother and father on the marriage license. "Judah" (Judith) is recorded as the mother; the father is curiously denoted as "colored." If Anthony, though deceased at the time, had been Mary's biological father, would not his name have appeared on the marriage certificate? The conspicuous omission of a father's name begs the question of identity.

In seeking an answer to this conundrum, attention turns to Colonel William Waugh. Previously, he had demonstrated a penchant for women of color. Coincidentally, in the same year that Judith was purchased by Joseph Williams—1832—Waugh gave two bonds, totaling £250, to prevent the removal of two orphans of color from the county. Wilkes County Court Minutes stipulate that one was a boy of eight years and the other a girl of seven years, both children of a free woman of color named Matilda Grinton.[154] It is logical to implicate the colonel in the birth of these two youngsters. It is commonly held that the boy was Henderson Waugh. (His story can be found in the next chapter.)

Clearly, William Waugh spent an increasing amount of time at the Wilkesboro home of Mary Taylor and Sister Fanny subsequent to his

grandnephew's assassination. He would have had ongoing contact with all of their servants, including Judith, and he could have fathered a child even though he was in the sixth or seventh decade of his life.

Judith's sixth child, Laura, was born on October 13, 1851. According to SPPR, a child named "Louisa" or "Lousa" was baptized on November 4, 1851; parents are listed as "Anthony and Judith, servants of Fanny Williams."[155] However, with subsequent scrutiny of the original documentation, it becomes apparent that if the letters *a* and *r* are substituted for the *o* and the *s* in the name "Lousa," then the name "Laura" results. There are no birth records that document that Judith bore a child named Louisa or Lousa—only one named Laura. When she was about twenty-years of age, Laura married Rufus Nichols and eventually gave birth to six children. The census of 1900 locates her and her husband in Wilkesboro and stipulates that she was the mother of six children, four of whom were still living.[156]

A couple of months prior to Laura's birth, a young priest rode into Wilkesboro to pastor the St. Paul's Episcopal congregation. Once again, the ambiguous, tenuous life of Mammy Judy was about to undergo change.

"...LET NO MAN PUT ASUNDER"

I did not want [the minister] *to make us promise that we would always be true to each other, forsaking all others, as the white people do in their marriage service, because I knew that at any time our masters could compel us to break such a promise.*

—*The Narrative of Bethany Veney*[157]

In order to subjugate or enslave a people, those who dominate must think themselves superior—in every aspect—to those whom they seek to dominate. It becomes, then, an obligation—even an inalienable right—to become a "master" who wields the power of influence to civilize, instruct, guide and protect their subjects. The enslaved are regarded as simple-minded children who are incompetent and, therefore, incapable of supervising their own lives and affairs. Even their social contracts are viewed as transient and their emotional expressions as puerile in comparison to those of the "master." Surely, the institutions of marriage and family cannot bear the same import to slaves as they do to the overseer.

For white society, nineteenth-century weddings customarily commenced with, "We are gathered together before God and these witnesses to join this man and this woman in holy matrimony." Then the presiding official would proceed to solemnize the vows between a bride and her groom. The ceremony generally concluded with the biblical injunction "What therefore God has joined together, let no man put asunder."[158]

When Mississippi slave owner Francis Terry Leak undertook to officiate at the wedding of his two slaves, Moses and Pal, he included none of the aforementioned phrases. In fact, he arrogantly recorded the wording of the ceremony as a "model" to be used in the future:

> *"We are assembled here together again on an interesting occasion. It is another marriage occasion that has brought us together. The parties to be married to night [sic] are Moses and Pal, who now stand before us hand in hand." Leak continued by administering vows, asking each partner to agree "before me and these witnesses…to solemnly pledge yourself to discharge towards her/him all the duties of an affectionate and faithful husband or wife."*[159]

Next, he voiced the pronouncement: "As all the parties have thus publicly agreed to enter into the marriage relation with each other and have solemnly pledged themselves to a faithful discharge of all its duties, it only remains for me to pronounce them and accordingly in the presence of these witnesses I do pronounce them married. Salute your bride."

Leak's obvious omission of traditional aphorisms of the marriage ceremony is indicative of the attitude with which slaveholders regarded the unions of slaves. He asked Moses and Pal to pledge themselves before "me and these witnesses." God was not in attendance. Further, though the couple committed to faithfully discharge all compulsory duties of marriage, they did not promise to do so for a lifetime. Moreover, Leak purposely omitted the customary charge, "those whom God has joined together, let no man put asunder." He knew, as did the enslaved bride and groom, that at any time their tenuous union could be dissolved by the person who owned them.

Even the North Carolina courts agreed with this perception. In the 1836 case *State v. Samuel*, Supreme Court justice Thomas Ruffin opined that enslaved people could not legally enter into the social contract of marriage without "essentially curtailing the rights and powers of the masters."[160] Years later, in an 1858 case, Chief Justice Pearson repeated what Ruffin had

concluded relative to the "fragile and tenuous nature of marriage among slaves." Pearson maintained that "the relation between slaves is essentially different from that of man and wife joined in lawful wedlock. The latter is indissoluble during the lives of the parties, and its violation is a high crime; but with slaves it may be dissolved at the pleasure of either party, or by the sale of one or both, dependent on the caprice or necessity of the owners."[161] In other words, marriages between slaves were, therefore, different from those of white society—they carried no legal weight and could be dissolved at the whims of their masters. Clearly, this view was the prevailing one for the duration of the slavery era.

Long have family members and county historians speculated about the marital status of Judith Barber and her partner, Anthony. When daughter Laura was born in October 1851, she became the fourth of Judith's children whose paternity can be attributed to Anthony. No document has been located that verifies a formal union between her parents prior to her arrival. Interestingly, Penny Stafford, genealogical researcher of Laura and her descendants, maintains that Judith and Anthony must have been formally married at some juncture. She wrote, "It seems, almost certain that, as a slave or employee of Richard Barber, none under his employ would be allowed to cohabit without the sanctity of marriage." She went on to explain that her research uncovered accounts of instances in which the Reverend Barber visited other plantations or areas within his circuit-riding ministry to perform marriage rites for the enslaved.[162] This latter assertion seems to be accurate. The SPPR records several instances— October 1851, September 1859, January 1862—in which Reverend Barber united servants of some of his parishioners.

It seems highly likely that Judith and Anthony saw little need to formalize their relationship. As was previously established by the high court of North Carolina, a slave couple could not legally enter into a binding social contract. Therefore, even if they had "married," the ceremony would have been little more than an empty ritual; their union could be disserved by their owner if her economic interests were better served. "Till death do you part...let no man put asunder" were affirmations enjoined within the context of "white marriages"—they had no applicability to the union of slaves. Richard Barber would have known that, even though he ostensibly performed at least three verifiable but superficial slave ceremonies during the first eleven years of his St. Paul's ministry. However, there is no record of his uniting in marriage either Judith or any of her daughters until over two years after the conclusion of the Civil War.

Moreover, the sanctity of marital vows could not be ensured—sexual exclusivity among them. A slave woman could have hardly promised to share herself with her husband alone, being faithful only to him. Doubtless, one of her salient functions was to bear children to replenish her master's workforce. At the behest of her owner, she might have to submit to another partner who was considered a superior candidate. Likewise, the master himself might draw her into his bed. She did not have the right to resist— she was property, subject to his overtures, victimized by institutionalized rape. Clearly, Judith had already born a couple of children whose paternity remains questionable. Was she consulted concerning the race and skin color of her partner? Of course not.

It was not until March 1866, less than a year after the cessation of the Civil War, that the general assembly of North Carolina legalized the marriages or common-law unions of former slaves. The state's Office of the Freedman's Bureau published an announcement stipulating that any couple who appeared before a justice of the peace or clerk of court, stating when they commenced living together as husband and wife, would be issued a certificate and considered lawfully married.[163] Thirty-six couples presented themselves to the proper authority at the Wilkes County Courthouse. Judith and Anthony were not among them. Anthony died in 1864, according to SPPR, two years prior to the passage of the Cohabitation Act of 1866.[164]

On June 23, 1853, the widow Mary Taylor Peden and the Reverend Richard Barber were united in marriage, joining the two households, replete with Mary's children, sister Fanny Williams and all of the slaves—including Judith, Anthony and their children. Later that same year, on November 16, Judith gave birth to twin girls: little Maria Wade and her sister, Susan. Kathy Staley wrote in her master's thesis, "Ante-Bellum People of Color in Wilkesboro," that it is believed Maria "was named for a free black family who worked within the Peden/Barber household."[165] Unfortunately, about a month after Mary and Richard Barber celebrated their first wedding anniversary, Maria Wade died. The precise date of her passing was noted in the SPPR: July 21, 1854. Ostensibly, she was baptized on the same day.[166] Maria was barely eight months old.

Elizabeth Grinton, in *Treasure Troves*, described Susan as short of stature and of olive complexion.[167] That description suggests that Anthony was not her birth father. Instead, there was likely another father, a Caucasian male, one who would have had access to, or at least tacit approval to consort with, Judith. Attention turns to Reverend Barber, for he alone would have had some measure of continual contact with her.

The details of Susan's life are, at best, sketchy. As an adult, she married Frank Barber, with whom she had seven children. They lived on property given to them by Reverend Barber, purportedly in recognition of loyal service. Several of Susan's relatives reside there still. Some extant family members remember "Sue" as a very quiet, hardworking lady with a ready smile. Others depict her as a "good Christian mother to her children."[168] Her name last appears in the census of 1900, at which time she would have been forty-seven. Ten years later, in 1910, husband Frank is listed as a widower.[169] Sue evidently died between the two censuses; however, the date and circumstances of her death remain a mystery. Though Frank and at least one of her children are interred in the cemetery owned by Rickard's Chapel AME Zion Church in Wilkesboro, North Carolina, the whereabouts of Susan's grave are unknown.

Susan Williams Barber; one of Judith Barber's twin girls, was born on November 16, 1853. Her twin sister, Maria Wade, died in July 1854 at eight months. *Courtesy of Evonne Raglin.*

On October 14, 1855, Mary Taylor gave birth to her fourth child, William Wainwright—her first with Richard Barber.[170] Doubtless, Judith was by her bedside, serving in the role of midwife. But the irony of the moment could not have escaped Mary's thoughts—even amid her birth pangs—as she watched her childhood companion and servant of twenty-three years move about the birth room, her own "baby-bump" evident beneath her well-appointed clothing. Less than two months later, Mammy Judy gave birth to her ninth child. She named her Clara.

Clara was born on December 1, 1855, into slavery, the property of Fanny Williams—as were the sisters who preceded her. She was baptized on March 23, 1856, at St. Paul's Church. Relatives, who are alive and well, vividly remember her. Evonne Raglin, Clara's great-granddaughter, recently described her as being fair of complexion, suggesting that Anthony was not her father. Clara's granddaughter and Evonne's mother, Venie Smith Brooks, maintained that the "white master, William Wainwright Barber," was Clara's

father.[171] It is uncertain as to whom Ms. Brooks was actually referring. One possibility is that she was referencing Reverend Barber's brother William.

William Morgan Barber—whose middle name was "Morgan" in lieu of "Wainwright"—was a slaveholder who lived in Rowan County, whence Richard came. It is reasonable to conclude that he traveled from his home to visit his oldest sibling periodically and could have consorted with Judith to conceive a child. However, it should be noted that he didn't officially migrate to Wilkes County until he was admitted to the bar in 1859—four years after Clara was born. That fact alone could raise a reasonable doubt as to his having been her father.[172]

The only other white man who had access to Judith was the reverend himself. Is it possible that he fathered one or more of Judith's children, including Clara? Evonne Raglin avers that her mother, Ms. Brooks, was actually alluding to Richard Barber in the recounting of Clara's life.[173] At times, the priest was erroneously referred to as William Wainwright, in lieu of his correct name, Richard Wainwright. Rightly, then, Ms. Raglin's inference could, indeed, be accurate.

A few family members entertain the possibility of the reverend's involvement. In a tribute written about Judith Barber for the Find-a-Grave website, cemetery historian Mr. C. Fairchild suggests that some of Mammy Judy's descendants believe that Richard Barber likely fathered some of Mammy Judy's children. If, in fact, that speculation is accurate, it will prompt some to consider his actions inconsistent with his ministerial status. However, in order to comprehend the peculiarities of owning and overseeing forced laborers, it becomes necessary to view the institution of slavery through the moral lenses of the time.

Harriet Jacobs, herself a slave to a predatory North Carolina master, described the church's attitude relative to pastoral paternal practices in her memoir, *Incidents in the Life of a Slave Girl*. She observed, "If a pastor has offspring by a woman not his wife, the church dismiss [*sic*] him, if she is a white woman; but if she is colored, it does not hinder his continuing to be their good shepherd."[174] If the reverend did father any of Judith's children, then Wilkes County residents and the church's parishioners would have likely applied the same moral tenet to his extramarital activities.

It becomes highly improbable, then, that Reverend Barber would have insisted that Judith and Anthony be married in a meaningless ceremony he conducted, as was previously hypothesized. He would have been implicated in the abrogation of their marriage vows, thereby rendering "null and void" the admonition to "let no man put asunder."

CHILDREN OF ANOTHER FATHER

Writing history is an act of interpretation. The sources speak, but what we hear is filtered through our experiences, values, beliefs, expectations, and even desires. I pay close attention to the voices of the people about whom I write—mostly enslaved African-Americans, but also about the white people who interacted with or observed them.

—Heather Andrea Williams
Help Me to Find My People[175]

In the last of her novels, written in 1940, Willa Cather explores the complex, ambiguous and often turbulent relationship between slaves and their owners in the antebellum South. *Sapphira and the Slave Girl* paints a portrait of channeled resentment and subtle retribution directed toward a young, beautiful mulatto slave named Nancy by her jealous mistress, Sapphira Colbert. Once her owner's favorite, the slave finds her status diminishing in direct proportion to the mistress's waning youth and health. Frequently, Sapphira considers the prospect of selling Nancy, but her husband, Henry, has taken a fatherly interest in the slave girl and refuses to "sign" any such transaction that would remove her from the plantation.

It is Sapphira's daughter Rachel who actively opposes her mother's increasing persecution of the helpless servant, who has done nothing to merit disfavor. The proverbial "last straw" comes when Sapphira selectively ignores the unsolicited advances of a visiting nephew determined to force Nancy into his bed. Ultimately, Rachel appeals to her father, Henry—who hates slavery and never owned a slave prior to his marrying Sapphira—to intervene on behalf of the defenseless slave girl.

> *Father...are you going to stand by and see a good girl brought to ruin without lifting a finger...? You know that rake...is after Nancy day and night. He'll have her in the end....He'll catch her somewhere and force her.*

With his powerful fists clenched in rage, Henry is forced to decide between preserving the absolute sovereignty of a wife who adamantly maintains that if one of her slaves goes wrong from a visitor in the house "it's her own fault" and protecting an innocent from being victimized by a profligate nephew and Sapphira's unwarranted maltreatment.[176]



Sapphira and the Slave Girl brings to specific relief two salient characteristics of the institution of slavery: the owner's absolute authority to dispose of slaves at will, and the owner's prerogative to engage in sexual relationships with women in bondage. Often, both worked in tandem with each other.

Of all those in slavery, the woman suffered the most. Consider that she was most often forced to submit to the advances of white males—the master's or those of someone of whom the owner approved. Historians of the period concur that the majority of sexual interactions were nonconsensual and would, by today's standard of law, be considered rape.

Certainly, children could result from those involuntary interactions. Even though her owner might assure his black consort that she could keep her child, there was no guarantee that he would not renege and sell the newborn to another plantation, especially if the defining purpose of his female slave was to breed children to ensure the availability of able-bodied forced laborers.

Occasionally, a female servant would willingly consent to the overtures of her owner. But even these unions did not occur without consequence. Problems between the master and his wife frequently developed, especially when the lady of the house became jealous of the slave with whom her husband had slept. Resultant marital conflicts were usually mitigated if the owner agreed to the sale or the severe punishment of the servant.

Interestingly, the events in Cather's novel parallel those of the life of Judith Barber. In 1853, she became a part of the household of the Reverend Richard Barber—a man who, like Henry Colbert, did not own slaves prior to marrying a woman who already possessed them. His wife, Mary Taylor, had inherited slaves from her father in 1840. Judith, however, was not one of them. She and her partner, Anthony, as well as their children, belonged to Mrs. Barber's sister, Fanny Williams, who had resided with her younger sibling for over ten years.

Also, recall that Sapphira Colbert's slave girl, Nancy, had lost favor with her mistress for some indefinable reason and was in danger of being sold. Simultaneously, she was being relentlessly pressured to submit to the sexual advances of Sapphira's visiting nephew, who, at the least, had the tacit approval of his aunt. With assistance, Nancy escaped falling victim to his designs. Judith, on the other hand, ostensibly acquiesced to the sexual advances of a white male—perhaps initially with Mary Taylor Barber's first husband, William Peden. In 1844, she gave birth to Martha, who was of fair complexion and was allegedly sold to an owner in Tennessee named William Barnes. The sale may have been conducted in an effort to preserve

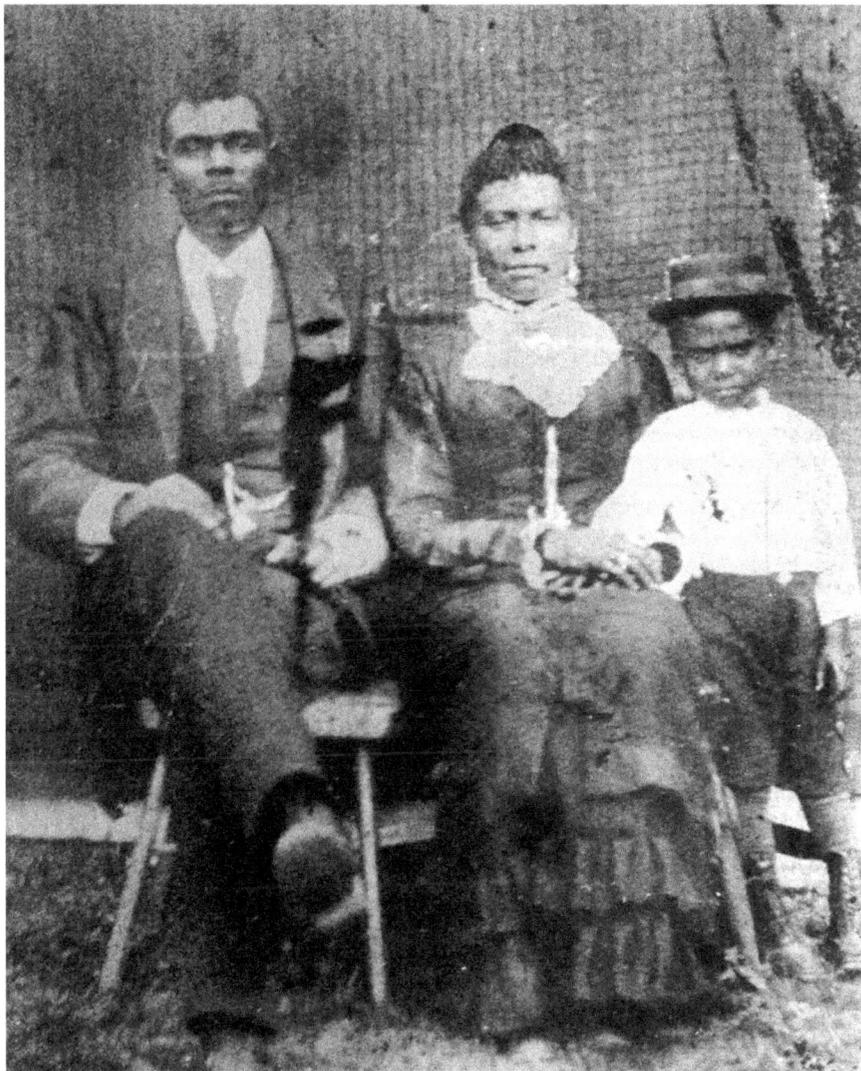

Clara Williams Barber Harris, Judith's ninth child, was born in December 1855. She is pictured here with her husband, Edmund, and their firstborn son John Andrew. *Courtesy of Evonne Raglin.*

the reputation of her white father, who was assassinated shortly before she was born. Then, two years after the marriage of Richard and Mary Taylor, Judith gave birth to another child of fair complexion, Clara, in 1855. Two paternal possibilities have been previously considered—one being Reverend Barber himself.

Though Clara was born into slavery, she and her family were liberated a little less than ten years after her birth. Despite her beginnings, she would go on to live a remarkable life. On November 24, 1880, at age twenty-five, she married twenty-three-year-old Edmond Harris, a free person of color from Virginia. The ceremony was conducted at Cedar Lawn, with Reverend Barber officiating. The couple would eventually move to Ashe County, making Clara the only one of Judith's children to leave Wilkes County of her own volition. She and Edmond led productive lives, and together they raised eight children.[177]

Venie Smith Brooks, Clara's granddaughter and Judith's great-granddaughter, characterized Clara in a short piece that she wrote: "Clara was witty and loved to talk." She possessed "an optimistic nature that was similar to a spark of electricity to others in enthusiasm. She was active and productive. It is thought that her brilliant mentality and highly creative 'turn of mind' was from her mother, Mammy Judy." Notably, Brooks recalled that Clara took her first airplane ride, from Pennsylvania to Illinois, when she was about ninety-five years old. Evonne Raglin, Brooks's daughter and Clara's great-granddaughter, recalled that she took a cane to facilitate her walking, "which she really didn't need but family insisted upon."[178]

Clara Harris died on March 5, 1957, a little less than nine months before her 102nd birthday. She was the only one of Judith's daughters to live that long. Raglin emphatically maintains that her great-grandmother's legacy was her devotion to education. "It was no accident that she could read and write so well or that most of her children would later become educators; that commitment to education has passed down through the generations—even now—that regard for advancement is attributed to her."[179] Venie Brooks memorialized her Grandma Clara with this insight: "She wanted to prosper in life, liberty, and the pursuit of happiness—and she did….We can be envious of her as she really enjoyed variety of life."[180]

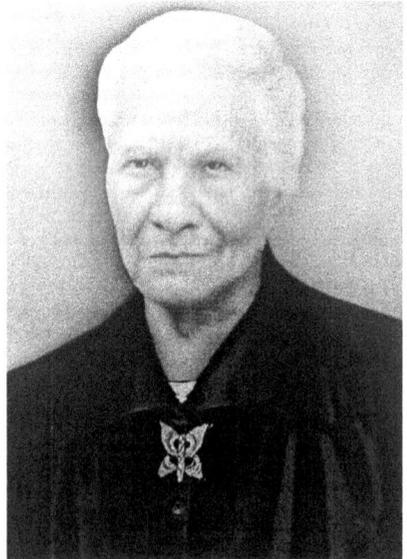

Clara Harris died in 1957, less than nine months before her 102nd birthday. She outlived all of the other children of Judith Barber. *Courtesy of Evonne Raglin.*

On January 5, 1858, Mary Taylor Barber gave birth to a daughter, also named Mary Taylor. "Mamie," as she was called, was the second and, as fate would have it, the last of the children to be born to Richard and Mary.[181] Perhaps Judith was called on once again to assist with the birth; however, she was likely pregnant at the time. On October 2, 1858, Judith gave birth to Jane, whose paternity is unknown. This tenth daughter was baptized on March 17, 1859, according to SPPR. Less than nine months later—two days after Christmas—she died. The cause remains a mystery, though between 1857 and 1859, there was an influenza outbreak in North America that claimed numerous men, women and children. Infants would have been especially vulnerable. Jane was approximately fourteen months of age.[182] Likely, she was buried in the church graveyard in one of the numerous unmarked graves.

According to the most reliable records, Judith would not give birth again until before the Civil War had officially begun in April 1861. There would be two more daughters—both born into slavery. One of the daughters, according to family tradition, was sold at a young age by the woman who owned her.[183]

SEPARATED IN LIFE, UNITED FOREVER IN SPIRIT

The Old Damascus Church Cemetery has two sections—an upper and a lower—separated by a shallow ravine replete with a sparse stand of shrubs and trees. In the lower section, the remains of "Aunt Judy" Barber have rested since 1912. In the upper sector, standing side by side, are the tombstones of two of her daughters, Martha and Alice. Kathy Staley, in her thesis "Antebellum People of Color in Wilkes County," averred that Fanny Williams sold two of Judith's slave children probably during the nine years of her sister's widowhood, and this story has been retold to countless descendants.[184] Family tradition has consistently maintained that those children were Martha and her younger sister, Alice.

Clearly, Martha could have been one of those. Born in 1844 during the beginning months of Mary Peden's widowhood, this daughter was the first of several whose fair complexion called into question the paternity of the child. Sometime after 1849, Fanny Williams purportedly sold her to an owner in Tennessee, likely to someone named William Barnes. Though Martha in later life would enjoy a reunion with some of her family, she would never again see her mother.

If, however, Ms. Staley's observation is accurate, then Alice could not have been one of the children who were sold. There are several conundrums that are intriguing parts of her history. First, the date of her birth, as inscribed on her tombstone, indicates that Alice Whitney was born on November 10, 1855. Yet, historical records document the birth date of Judith's ninth child, Clara, as being December 1. It is highly unlikely that Judith would have given birth to two daughters in successive months of the same year—unless, of course, they had been twins. Nothing in the records or in family tradition would recommend the conclusion that Clara and Alice were twins. Moreover, if the aforementioned birthdates are accurate, then it seems highly improbable, though not impossible, for twins to have been born twenty-one days apart. (Note: There have been instances in recent history in which twins have been born a substantial number of days apart and survived, though I have not discovered any nineteenth-century records documenting similar situations.) The most reliable data suggests a much later birthdate. In fact, in the 1880 federal census, the listings specify that Alice was born on November 11, 1861.[185] SPPR stipulates that Judith's eleventh daughter was born on February 11, 1861.[186] Whether in 1855 or 1861, either date falls outside the duration of Mary Taylor's widowhood, thereby calling into question the tradition that Alice was one of the two children whom Williams sold.

But the hypothesis that Alice was sold to another owner raises several interesting questions: Who had the right to sell her? When was she sold? And for what reason? In popular memory, there tends to be the perception that, at this juncture, Richard Wainwright Barber owned all the resident slaves assigned to his household and that his wife, Mary, even controlled those of her sister's through some nineteenth-century social code affording her precedence over an older spinster.[187] It would follow, then, that Richard and Mary could have sold Judith's daughter without consulting Fanny Williams. With due respect to those traditions, no records have been located to support the existence of any such social precedent. In fact, the opposite is true. As previously stated, Joseph Williams bequeathed Judith's family to daughter Fanny in his 1840 will. Any subsequent children lawfully belonged to her, as well. Moreover, in the 1850 slave census, Mary Taylor's slaveholdings and those of Sister Fanny were listed separately, although the two women were living together at that time.[188] SPPR unequivocally corroborates other documents that substantiate Williams's ownership of Judith's family. The 1850 Wilkes County court record sentencing Anthony to the whipping post stipulates that he belonged to Fanny Williams.

Of course, some maintain that when Mary Taylor married Reverend Barber, Fanny's ownership rights were somehow abrogated. Yet when the last slave census was recorded in 1860, it listed Barber's servants and those belonging to Fanny Williams separately, even though she was a part of the reverend's household.[189] If all the slaves were under Barber's proprietorship at that juncture, it seems that they would have been subsumed by his name and his name alone. It is only logical to conclude that Judith's family belonged solely to Fanny Williams from 1840 until the general emancipation in 1865. Therefore, any transactions pertaining to them would have legally fallen under her purview. When Mary and Locke Barber were married on September 28, 1867—two years after the conclusion of the Civil War— "Judah" (Judith) Williams is listed as the mother of the bride, Mary, who, incidentally, also uses the surname "Williams."

Given the accuracy of an 1861 birthdate, Fanny Williams would have had to have sold Alice when she was an infant or toddler. Most slave records indicate that young children were typically sold—or simply given away as a package deal—with their mothers. However, accounts detailing the purchases made by large slaveholders reveal that children age two to ten were acquired apart from their mothers.[190] Certainly the 1860 slave census corroborates this cruel reality, because one-fourth of all single-owned slaves in mountain counties (Wilkes County included) were ten years old or younger.[191] Moreover, slave children as young as two or three might have already been assigned domestic chores: childcare, collecting trash, gathering kindling, toting water, weeding, plucking grubs off plants or chasing away birds. So, maintaining that Alice could have been sold during the years 1861–65 is not outside the realm of possibility.

But why would Alice have been sold at such a young age? Doubtless, it would not have been out of dire need for money. Perhaps, as tradition holds, the reason had something to do with the fact that she was of fair complexion, likely the daughter of a white father—perhaps the Reverend Barber himself. Conceivably, a jealous, incensed Mary Taylor could have importuned Sister Fanny to get rid of the mulatto child as a retributive measure. Elizabeth Grinton, in *Treasure Troves*, hints at such a rationale:

> *The scene, I cannot visualize, which took place on the Barber Plantation when Alice was sold. There must have been great stress for mother Judith and her girls....Do I hear sobs? From where does it come? Judy, the girls— surely not the Madame of the house.*[192]

It should be noted that, as of this date, a bill of sale has not been located detailing a transaction in which Alice was traded to another household; therefore, questions remain. But if this eleventh daughter was sold, then she—unlike Martha—would eventually be reunited with Mammy Judy. The census of 1880 documents that a nineteen-year-old Alice was living in a household of which her mother was the head. Sisters Lucy and Eliza were also listed, along with two of Judith's granddaughters and three of her grandsons.[193]

Other documents provide some insight into Alice's adult life. Twenty years later, the census of 1900 locates her in Whitley County, Kentucky, in the Black Oak district, married to a miner named George W. Woods. At that time, the couple had been married for twelve years, setting the date of their wedding sometime in 1887 or 1888. No children were born to their union.[194] However, George and Alice ostensibly acquired property in the city of Jellico, Campbell County, Tennessee. In fact, land records obtained by Evonne Raglin from the register of deeds of Campbell County indicate that on August 2, 1913, Mr. Woods deeded two plots of land to Alice.[195]

In addition to his mining activities, George must have served as an itinerant minister who frequently traveled from his home in Kentucky to Jellico, Tennessee, to preach. It was during one of his ministerial missions that he met a congregant who reminded him of his wife. Her name was Martha. He suggested to her that on his next trip he intended to ask his wife to accompany him in order for the two ladies to meet. Back home, Alice agreed to travel to Jellico to see this lady. When they were eventually introduced, the women naturally began to compare details of their lives. Much to their astonishment, they discovered that each was born in Wilkes County, North Carolina, to a woman named Judith. Sisters Martha and Alice—the third and eleventh of Mammy Judy's daughters—had found each another after many years of separation.[196]

George and Alice were still residing in Whitley County, Kentucky, when the census of 1920 was compiled. Next door to them there lived another childless couple, John and Emma Whitney. According to Campbell County, Tennessee marriage records, the Whitneys were wed on August 3, 1917. John, like neighbor George, was a miner; his wife, Emma, was at home keeping house. Whether or not the Woods and the Whitneys interacted with each other is a matter of informed speculation.

There is, however, one intriguing detail linking the two couples. Shortly after he was counted in the census of 1920, George Woods died on October 1 of that year. His death certificate specifies that he succumbed to an acute

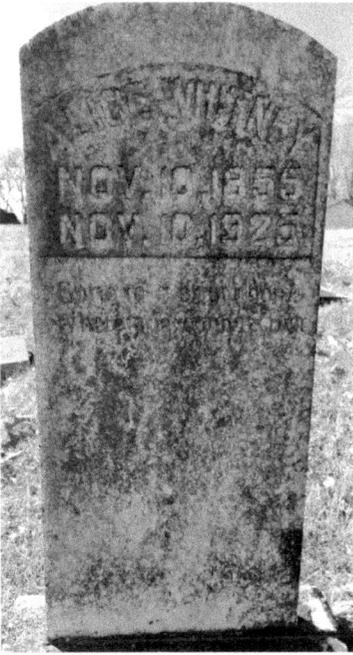

Left: Gravestone of Alice Woods Whitney (1861–1925), Judith's eleventh child. The grave is located in the Old Damascus Church Cemetery. *Author's photographic collection.*

Right: Gravestone of Martha Williams Barnes (1844–1928), Judith's third child. It is located in the Old Damascus Church, next to that of her sister Alice. *Author's photographic collection.*

digestive issue, forty minutes in duration. Though the document stipulates that he is "married," his spouse's name does not appear therein.[197] Curiously, on November 18, 1920—two months after she celebrated her forty-fourth birthday and forty-seven days after her neighbor George Woods's demise—Emma Whitney died from "general peritonitis, followed by a fecal compaction."[198] (Peritonitis is an inflammation of the lining of the stomach, usually caused by infection from bacteria or fungi. Left untreated, it can spread through the blood to other organs, resulting in multiple organ failure and death. One of the salient symptoms of the disease is the inability to have a bowel movement, resulting in fecal impaction.) Less than eight months after the death of his wife, widower John Whitney married Alice Woods in Campbell County, Tennessee, on July 9, 1921.[199] The proximity of the deaths of the two former spouses—George Woods and Emma Whitney—and the similarity of the causes to which they succumbed appear "coincidental" on the surface—or was it?

When Alice died in 1925 from the effects of dysentery, she was listed as widowed.[200] Her body was conveyed back to Wilkes County for interment by her niece Annie Jones. Simultaneously, Sister Martha was brought to Wilkes to live with relatives—Ms. Jones and her daughter Marion Jones Dula. She lived with them for three years before dying on November 16, 1928—three years and six days after the death of Alice.[201] The remains of both repose side by side; once separated in life, their spirits are forever united.

...A TIME TO MOURN AND A TIME TO DANCE

Life may not be the party we hoped for. But while we're here, we should dance.

—Jeanne C. Stein

The Civil War had been raging for over a year when Judith Williams gave birth to her daughter Alice. Combative conflagrations had already exacted a large toll on both armies, and the casualty list began to grow as names were added almost daily. Wilkes County households felt the sting of grief early in the conflict—the first of its sons had fallen during a battle in Oak Hill, Missouri. Hugh Thomas Brown, the eldest child of Hamilton and Sarah Gordon Brown, was slain on August 10, 1861. Word of his demise came to the family via James B. Gordon to his half brother Hamilton Allen Brown:

> *How shall I tell you the name of our dear Brother, Capt H T Brown was in the list. It was to me my dear Brother the most terrible shock I ever experienced; to think he has fallen by the hands of an invading foe on the plains of Missouri far from home and kindred, and God alone knows where his remains may now be....I fear to hear the effect of the news upon our aged and afflicted parents. I can't as yet have the heart to communicate it to them.*[202]

Over a year later, on September 17, 1862, Confederate and Union forces clashed near Sharpsburg, Maryland, in what would prove to be the bloodiest single-day battle in U.S. history. After the guns were silenced and the smoke cleared the battlefield at Antietam Creek, 22,720 dead, wounded and missing combatants were added to the casualty list. Of that total, 7,750 Rebels lay wounded. Lieutenant Joseph W. Peden of Wilkes County was one of them.[203]

Born the middle of three children to Mary Taylor Peden Barber and William Peden, the lieutenant was assigned to Company A of the First North Carolina Regiment. According to government service records, he sustained a severe wound to the thigh while embroiled in the skirmish near Sharpsburg.[204] In his book *The Land of Wilkes,* Johnson Hayes related the story that Peden and Wilkes County native Captain Thomas Bouchelle were both seriously wounded that day and assisted each other as they hobbled away from the fray. Fellow Wilkes native Colonel Hamilton Allen Brown commanded his men to carry the two injured officers to the rear. Bouchelle, whose lower jaw had been crushed by a mini-ball, somehow managed to communicate that he and Lieutenant Peden were able to convey themselves to the surgeon's tent and that the soldiers should continue on.[205]

Joseph Peden was eventually transported to a hospital in Virginia to recover. Word of her son's injury reached a fretful Mary Taylor Barber, whose two Peden sons were among the first to join the Confederate army in 1861. According to family historian Betsy Barber Hawkins, stepfather Richard Barber traveled to Virginia to bring their wounded son back home to Cedar Lawn. The bullet would remain in Joseph's thigh for the duration of his life. Pain was his constant companion; relief was briefly experienced through the euphoric numbing induced by morphine, a drug to which he would become addicted.[206]

It was within this mélange of misery and apprehension that forty-three-year-old Mammy Judy gave birth to the last of her twelve daughters, Eliza Jane. Census data collected from 1880 through 1920 establish an 1863 birthdate for her; cemetery records for Ricard's Chapel AME Zion Church indicate that she was born on February 2, 1863.[207] SPPR records her baptism on July 12, 1863.[208] There is widespread agreement that Eliza Jane was of very fair complexion.

In fact, extant photographs of Eliza suggest that she was the offspring of mixed parentage. Even more compelling are the descriptions of living relatives who remember her as being fair of complexion, perhaps the lightest of all of Judith's daughters. Paulette Turner was herself a child of six or seven years when her great-grandmother Eliza died. Ms. Turner—whose father, Joseph Whittington, was "Granny" Eliza's grandson—remembers her as being of "light, fair complexion."[209]

Ninety-six-year-old Dwight Jones—Eliza's grandson—has similar recollections of his grandmother. "She was short, only about five feet tall, with a beautiful, light complexion," described Mr. Jones in a telephone interview from his home in Queens, New York.[210]

As with the three living sisters who preceded her in birth, Eliza was likely the daughter of a white male and not Judith's partner, Anthony. Family tradition speculates that Richard Barber was her father. Biographical information accessed through the Find-a-Grave website echoes the belief that Eliza Jane was a daughter of questionable paternity and adds—parenthetically—that the father is "purported to be Reverend Richard Wainwright Barber."[211]

Is it plausible that Mr. Barber could have consorted with Judith to conceive this child? In 1863 and 1864, most of the able-bodied men associated with the Barber household were away at war. Even though a wounded Joseph Peden had returned home, his Brother John and Uncle William Morgan Barber were still serving the Confederacy. According to diocesan records, Reverend Barber was listed as a chaplain but was not assigned to any specific unit—he was still at Cedar Lawn.[212] He had both opportunity and access.

About four months after Eliza arrived, the Barber household experienced loss. On June 27, 1864, Judith's partner, Anthony, died. The cause of death remains a mystery. SPPR notes his passing, indicating that he was forty-six years old and a servant of Fanny Williams.[213] Likely, his remains were laid to rest in the churchyard; his unmarked grave was among many under the trees of the main cemetery.

In October 1864, tragic news again shook the Barber family's foundation. On September 30, Colonel William M. Barber had been gravely wounded in battle near Jones Farm, south of Richmond. He was conveyed to a Petersburg hospital. The thirty-year-old officer lingered about three days before succumbing to his wounds. He died on October 3. His body was initially interred at Petersburg but later exhumed and reburied in the St. Paul's Episcopal churchyard. SPPR records his passing, though the date of death and his age were recorded incorrectly.[214]

Joseph Peden was recovering at Cedar Lawn from a crippling gunshot wound to the leg. He writhed in excruciating pain, soothed only by the anesthetizing effect of morphine. Death had taken Anthony—Judith's partner and father of several of her children. And now, a dear younger brother, brother-in-law, husband and father had been slain in battle. The Barber family was reeling from constant consternation comingled with grief.

It was amid this turmoil that Eliza Jane spent a portion of her childhood. Despite the good intentions and efforts of adults and older siblings who might have attempted to shelter her, she could not have been completely insulated from the consequent emotional effects wrought by the tragic circumstances swirling around her family. Tradition holds that she grew up in Judith's

cabin, located away from the plantation house at Cedar Lawn.[215] The census of 1870 was the first in which Eliza could have appeared; however, she is not numbered among those living in the household of which "J. Barber" is the head. She can be found in the census of 1880 as a seventeen-year-old girl living with Mammy Judy, her older sisters Lucy and Alice, and six of Judith's grandchildren.

Details of Eliza's journey from childhood to adulthood are sketchy at best. But family historians provide some insight in descriptions recorded in *Treasure Troves*. Under Judith's guidance, "she became skilled in several ways—cooking, laundry, and her pride and joy quilting, making beautiful quilts."[216] A ninety-one-year-old grandniece remembers hearing stories about parties that Eliza used to give, replete with banjo and guitar music. And she loved to dance! Once, she "won a contest at Lincoln Heights doing the 'Charleston.'"

When asked to describe what he remembers of his grandmother Eliza, Dwight Jones recalled, "She was a good-talker and would send me on errands for her at least once a month when I was a boy." One of those errands was to walk to the local store to purchase snuff. His grandmother, like so many others of that time, had developed a penchant for "dipping." He also kindly informed me that his grandmother was married twice and proceeded to name all the children to whom she had given birth.[217]

The first of Eliza's husbands was Walter Suddith, a man of Cherokee descent. The couple was married on June 8, 1881. Four children were born to their union: Bessie, Edward and twins Fannie and Mamie. Mamie did not reach adulthood. Mr. Suddith died, and sometime thereafter, Eliza married John Barber, with whom she gave birth to eight children: Philo, Gaither, Henry, Milton, Dwight, Lura, Jura and Alice. "Lura was my mother," Dwight Jones informed me. "And Alice, she was the baby."

Alice was born on November 11, 1909. She attended Livingstone College in Salisbury, North Carolina, and subsequently joined the Women's Army Corps (WAC). She attained the rank of sergeant, was stationed in Argentina and eventually returned home to care for her mother and brother. In 1947, thirty-eight-year-old Alice married thirty-nine-year-old Albert Taylor (1908–1972).[218] The couple had been married just over a decade when, on Tuesday, October 7, 1958, at 4:45 p.m., she sustained a gunshot wound to the chest during a "fray"—a domestic dispute. The wound proved fatal. Alice died thirty-four days before her forty-ninth birthday.[219] Albert lived twenty-four more years before dying eleven days shy of his sixty-fourth birthday—December 10, 1972. Though his death certificate indicates that

he is buried at the Wooten Cemetery in Durham County, his name does not appear on burial records there. On a common granite grave marker shared by husband and wife, Alice and Albert Taylor repose side by side in the Ricard's Chapel AME Zion Church Cemetery.[220]

Lillie Barber wrote in *Treasure Troves* that "Granny Eliza and Grandpa John owned a surrey that was kept under a specially built shed. It was used only on Sundays to ride to Church. We grandkids could only climb in and sit. Of course we lined and sang hymns. We couldn't even eat plumbs gathered from the trees. We didn't care, we just sat in it and felt proud!"[221]

Centenarian Ms. Artie Gilreath (1916–2016) during her initial interview with the author. She was the granddaughter of Reverend George W. Petty and related to the Barber family through marriage. *Author's photographic collection.*

In the fall of 1995, Elizabeth Grinton and other family members— all ladies—embarked on an "expedition" to find Granny Eliza's old home place, ensconced within the forest's overgrowth at the end of Dula Road. After a daunting trek through briars and downed trees, the explorers caught a glimpse of the old tin roof glistening in the sunlight. Upon reaching the house's remaining structure, they climbed an old staircase to an upstairs attic, where they discovered a few relics. After descending the staircase, treasures in hand, the party alighted on old wooden boxes and planks to reminisce amid the droning of the hornets near the back of Eliza's house. One recalled the animals and food grown there; another remembered the spring water she drank as a child. Ms. Grinton described the indelible image, forever etched in her memory, of a Lincoln Heights first-grader who walked the road to Granny Eliza's every morning to have her hair combed before school.[222]

On February 12, 1950, Eliza Jane Suddith Barber died at the age of eighty-six. She reposes in the cemetery of Ricard's Chapel AME Zion Church, surrounded by a couple of her children and a host of family members. Her headstone is a simple, understated one, belying the fact that she was a colorful, ebullient lady.

Eliza Williams Suddith Barber (1863–1950) was Judith's twelfth and final child. She was known for her dancing ability. *Courtesy of Evonne Raglin.*

Centenarian Artie Gilreath—herself a family member through marriage—recalled that Eliza "had long hair down her back which she wore in a ball on her neck." She "liked to party with and entertain people younger than herself." Ms. Gilreath observed, "She acted younger than her age—real lively." Then, she laughed. There could not be a more fitting benediction to an exuberant life well lived.[223]

"...A GOOD AND FAITHFUL SERVANT..."

You know how soon important facts are obscured, if not forgotten, and the importance of searching for truth, while they are fresh in the remembrance of all.

—*D.L. Swain, former governor of North Carolina*
Letter to General S.F. Patterson, May 2, 1866[224]

For the Confederacy, it was just a matter of time. Over two years after Judith's last daughter, Eliza, was born in Wilkes County, the port of Wilmington on the Carolina coast fell into the hands of Union soldiers on February 22, 1865. Southern states had no viable means available to them through which munitions, clothing and foodstuffs could be shipped in an expeditious manner to sustain their cause. Federal forces had disserved the last major lifeline; the blockade of the coast was complete.[225]

As word of the fall of Wilmington trickled inland, it portended an inevitable conclusion: the war, for all intents and purposes, was done. Perhaps for the first time, Southerners began to grapple with the fact that life as they knew it was about to undergo substantial change. It was the intention of Abraham Lincoln to readmit the bellicose states to the fractured Union as soon as possible, with open arms of liberality. Following the tragic death of the president six days after the surrender at Appomattox, Andrew Johnson assumed the mantle of leadership and proceeded to pursue Lincoln's course for reconstruction. Radical Republicans, as they referred to themselves, intended otherwise. The national stage was set for political clashes that culminated in the near removal of a president and the implementation of punishing policies that plunged the conquered South into a period of reconstruction for the next twelve years.

Subsequent to surrender, provisional governments began to appear in Southern states, and North Carolina was no exception. The Confederate

governor, Zebulon Vance, issued a proclamation on April 28, 1865, attempting to calm the citizenry and quell any future acts of insurrection by those predisposed to continue resistance.

> *I earnestly appeal to all good citizens who are now at home, to remain there; and to all of the soldiers of this state to retire quietly to their homes, and exert themselves in preserving order…and I would assure my fellow citizens generally, that…I will do all that may be in my power to settle the Government of the state, to restore the civil authority, and further the great ends of peace, domestic tranquility and the general welfare of the people.*[226]

Vance's ability to "settle the Government of the state" was short-lived. He was arrested about two weeks later—on his birthday, May 13, 1865—and conducted to prison in Washington, D.C., for Confederate activities. President Johnson appointed Vance's political nemesis, William Holden, as the state's provisional governor to replace the imprisoned chief executive.[227]

Wilkes and surrounding counties were spared any immediate impact of Radical Reconstruction. The first "winds of coming change" likely announced themselves in the form of a "zephyr" known as the Freedmen's Bureau. President Lincoln had authorized the formation of the bureaus to provide whatever assistance was needed to the newly liberated citizens, inclusive of negotiating labor contracts, setting up schools and establishing churches. Some even aided former slaves seeking to reunite with lost family members. Though the original plan stipulated that all bureaus were to finish their work within a year, congressional extensions were granted during the Andrew Johnson administration, over his strong objections manifested in a "veto."[228] A Freedmen's Bureau was located in Wilkes County and conducted its business for about six months. However, the National Archives maintains that there are no extant records of its brief operations.[229]

The voices of Wilkes County residents from that era have long since been silenced; but some left their impressions in letters written to friends and family as Reconstruction dawned. In a missive dated January 2, 1866, Walter Lenoir wrote to Sister Sade decrying the political and social revolution in the offing. "It is very odious," begin his mephitic musings, "but the rising and future generations of the South must be more or less yankeeized." After arguing that Northerners had "grossly slandered" the institution of slavery because they found it "incomprehensible," he contrasts for his sibling the genial manner of the Southern tradition and the "coarser, harder, more

selfish" demeanor of the "Yankee." In his concluding paragraphs, Lenoir lamented, "I have used the past tense in speaking of the South, because the true southern character is passing away; and when this generation has been numbered with the dead, much of it will only live in the memorials of the past....God grant that the social differences between the north and the south may never be entirely obliterated."[230]

From Tennessee, Ms. Hugh Gwyn wrote to her sister Sarah "Sallie" Lenoir on March, 2, 1866, describing how the "farm is very much out of repair; fencing nearly all to make over; barn, cribs and outhouses generally nearly destroyed." Then she complained that "we are still having trouble here with the Yankees," who seem "determined to have everything we have anyway." She concluded with a yearning for a day of reckoning. "I long for *their day* to arrive—it surely will come!" The emphasis is hers. A day of reckoning never came.[231]

On Christmas Day 1866, William Bingham, principal of the Bingham School in Mebanesville, North Carolina, penned a lengthy letter to his cousin Walter Lenoir. "The Yankees are gone mad," he declared. "Liberty is gone forever; it took flight when Lee surrendered....I would prefer a southern republic; but the hope of that has fled forever; I would prefer next 'the Union as it was,' but that is eternally departed."[232]

Surely, it was lost on no one that Southern society—as it was expressed in the antebellum days—was a memory that now "belonged to the ages" and that those held in forced labor to sustain the economy were henceforth and forever emancipated. Slaveholders were stripped of their human chattel without consideration or compensation.

Siamese twins Eng and Chang Bunker, who once were Wilkes County's most illustrious residents, jointly owned thirty-three slaves in 1864 with a collective value approaching $27,000. In his book *From Siam to Surry*, family historian Melvin Miles wrote that the twins were forced to tell all of their thirty-three slaves that they were free. With that announcement, servants laid aside hoes and shovels, formed their own lines and marched off the Surry plantations, exercising their rights as free citizens. Within a few days, a former slave returned and asked to resume his job—as a paid employee. Miles indicated that within weeks most of the former servants applied to work for the Bunkers. The preponderance quickly discovered that they had no place to go, no jobs or money and no houses in which to live. So, they voluntarily returned to Eng and Chang's farms to work for salaries. To their credit, the twins hired as many as they could afford. However, with this new "overhead," the fifty-four-year-old showmen were forced to

go back on the road to entertain for funds with which to support their families, farms and new employees.[233]

Doubtless, a similar scenario played itself out on the Barber Plantation. Some of the slaves of Fanny Williams and Mary Taylor Peden Barber had been with the families of the two sisters since 1832, Judith among them. She and the other slaves had been residing at Cedar Lawn for seven years when the war ended. Daughter Clara had vivid memories of the Civil War; she was almost ten when it ended. Much later, she recounted for her family the joy and happiness exhibited by slaves both young and old when the conflict ended and freedom, for which they had prayed for so long, was theirs at last. After a season of celebration, some had to wonder what the future might hold.[234]

Few documents exist that provide insight relative to the living conditions of the Reverend Richard Barber family and their former slaves during Reconstruction. Perhaps some of the most accurate depictions can be found in oral traditions related by family historians. Betsy Barber Hawkins, great-granddaughter of Richard Barber, wrote that Reconstruction and the hard times that followed prevailed in the state well into the 1880s, though it officially ended in 1877. "Sheer poverty in the South dominated the entire economic scene from top to bottom." It seemed that all the families in Wilkes County suffered from the financial turmoil that resulted from paying for a civil war. Her forebears were not exempted.[235]

The small boarding school for boys that Richard had started sometime after moving to Cedar Lawn began to flounder. Families could no longer afford to send their scions to the Barber academy, as money was tight and sons were needed to assist with recovery efforts. Daughter Mamie, who graduated from St. Mary's College in Raleigh, returned home to assist her father with the school. Finally, falling enrollment at the academy prompted Mamie to open a boarding school for young ladies and girls. Established in 1879, Mamie Barber's Home School would prosper for the next forty years.[236]

Reverend Barber's pastoral duties had increased since the war's conclusion, especially as outlying missions commenced to grow. Though responsibilities increased, he rarely received his stipend from the diocese. Mary Taylor usually accompanied him to support his endeavors.[237] However, the stresses of the last decade had taken their toll, having a deleterious effect on her health, not the least of which was her concern for son Joseph, who had sustained a life-altering injury at the Battle at Sharpsburg.

Writing to her cousin Carrie Patterson on November 22, 1862, Mary informed her that Joseph's condition was deteriorating and that he was mostly confined to his bed.

He was wounded in the upper part of his thigh and the ball is still in it. He suffers the most excruciating pain…unless under the influence of morphine. He is much depressed in spirits also, which is against him.… If he should ever recover, I fear that he will be a cripple for life.…Oh! It is so heartrending to see a dear son in his youth…suffering as he does and no hope of his recovering soon, if ever.

She concluded her letter by saying, "I will dwell no longer on this subject, for it is a sad one to me."[238]

According to family tradition, Joseph Peden was consumed by his suffering and became more addicted to alcohol and morphine. Vestigial bonds between him and his family were strained to the point of breaking before his untimely death on January 5, 1884, which was also the birthday of his half sister Mamie. Joseph was buried beside his assassinated father, William Peden, in the Wilkesboro Presbyterian Church cemetery. Curiously, his brother and sister are interred at St. Paul's Episcopal Church, alongside their mother and stepfather. Mercifully, perhaps, Mary Taylor never witnessed the outcome of her son's suffering—she had died a year and a half earlier, on June 7, 1882, at sixty-two years of age.[239] Fanny Williams, who was five years older than Mary, died less than three years later, on March 2, 1885, likely from the effects of dementia.

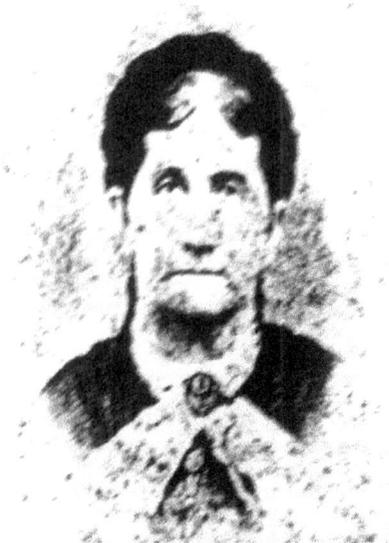

Later photograph of Mary Taylor Williams Peden Barber. *Archival files of St. Paul's Episcopal Church.*

For Reverend Richard Barber and his family, life would go on. Betsy Barber Hawkins wrote that her great-grandfather continued to be productive as a priest, farmer and Wilkes County's first school superintendent—a position he would hold for about sixteen years.[240] He resigned as rector of St. Paul's Episcopal Church in 1896, when failing health rendered him incapable of performing pastoral duties for a congregation that he had served since 1851. SPPR noted the passing of the beloved rector on December 19, 1907.[241] Upon his death, the local newspaper eulogized him with an anecdote: "He has said for the last 10 years that he considered his work done and that he

was waiting for the final summons and for the hoped commendation of, 'Well done, thou good and faithful servant.'"[242]

Judith Williams had been a slave for the first forty-five years of her life; her children had also been born into slavery. Moreover, their lives had been inextricably bound to the Williams-Peden-Barber families for thirty-three years. Now they finally belonged to themselves. There are a few extant documents that provide glimpses into their lives during the days of Reconstruction and after.

Ms. Hawkins recounted, in her history of Richard Barber, that Mammy Judy and some of her daughters remained at Cedar Lawn to continue the duties they had performed before the war, "but now, for small wages." Tradition holds that Judith's oldest daughter, Lucy, worked with Mamie at her Home School for Young Ladies and Girls, serving them biscuits and molasses that students ostensibly remembered for years afterward. But Lucy was also listening to and memorizing the instruction offered to the girls in order to teach her own sisters at home. Hawkins

Later photograph of Richard Wainwright Barber, rector of St. Paul's Episcopal Church. *Wilkes Genealogical Society Files.*

also maintains that the good reverend gave Judith and her children some land near the south boundary line of the plantation on which to build houses. In addition, land was allocated for a church—likely the Old Damascus Church that Judith and others established sometime in 1866.[243]

In *Treasure Troves,* Daughter Susan Barber's descendants described the process by which Reverend Barber distributed land: "He…rode a great red stallion about his plantation.…When he saw that one was a good worker, trustworthy, dependable, and capable, he promised and kept his word by giving this slave a home site.…To this day, 'relatives' or 'offspring' are still dwellers on 'the sights' so named."[244]

Mammy Judy maintained her own home, a little cabin located in present-day Highland Park. To date, there is no extant record establishing a date

for the cabin's construction and habitation. Some speculate that Judith may have already been living in it with one or more of her daughters prior to the end of the war. Certainly, the descendants of Judith's twelfth daughter, Eliza, born in 1863, contend that she was born and raised in that cabin. Yet, the first record firmly establishing her mother's independent residence was the 1870 census.

It is likewise a conundrum as to when and why Judith assumed the surname Barber. According to the 1867 marriage license issued to her daughter Mary, Judith was still using the surname Williams. She was, after all, the "property" of Fanny Williams at the conclusion of the war. However, by 1870, she had ostensibly commenced to use the Barber surname. The census simply denotes her as "J. Barber." Yet, in one 1873 entry recorded in SPPR, Judith is still referred to as "Williams."[245] Clearly, the transition between the two surnames is not indicative of a definite break with one in favor of the other.

Some descendants believe that Mammy Judy and her family assumed the name Barber out of a heartfelt respect for the reverend and his family. Others postulate that the change was enacted subsequent to receiving land from their former master. While the latter rationale carries a bit more weight than the former in the context of Judith's history, the definitive reason for the conversion remains elusive. And it is reasonable to infer that the adoption of the surname was a combination of love and land ownership.

One fact, however, is not in question: all who knew Judith Barber appear to have held her in high esteem. To her descendants, Mammy Judy was a woman of "strength, dignity, and faith." In *Treasure Troves*, they wrote that she "wanted all her daughters to be self-supporting and able to make a living." Elizabeth Grinton noted that Judith "was a progressive person for her times, who encouraged education." She had a desire to learn and coveted the chance for her girls to acquire reading and writing skills. Notably, her daughters, whose names appeared in census data across decades, indicated that they can either read or write or both. Judith never claimed to possess either ability, though doubtless she did. Above all, she taught them early on the value of being honest and trustworthy.[246]

When the need arose, she contributed to the health and welfare of the community, according to Ms. Grinton. She was a midwife who facilitated the birth of both white and black children and trained some of her daughters to perform the service, as well. Judith had also learned to treat many common ailments and was often seen riding in a buggy, being conveyed to the house of a suffering soul.[247] Mamie Barber, Richard and Mary's daughter, agreed: "She always responded to every appeal for help

Photograph of Judith Williams Barber believed to have been taken a few years before her death in 1912. *From Treasure Troves.*

in time of sickness or sorrow…and…never neglected or abandoned a case of sickness committed to her care."[248]

"It not surprising that many of Judith Barber's descendants have committed themselves to acquiring education and indefatigable service for the benefit of humankind," said great-great-granddaughter Evonne Raglin. And all these accomplished people seem to attribute their drive to succeed and their commitment to serve to the family matriarch, Mammy Judy.[249]

By the time that Judith Barber died on September 9, 1912, at the home of her granddaughter Annie Jones, she had outlived all those who once enslaved her. It was the daughter of one of them, Mamie Barber, who eulogized the "faithful colored woman" whom she had known all her life in an oft-quoted article that appeared in the *Wilkes Journal*: "She was highly esteemed by all who knew her.…Fidelity was the keynote of her character.…Her relatives and friends have this assurance that she has now the blessed encomium, 'Well done, good and faithful servant.'"[250]

It is of interest to note death's irony. The Reverend Richard Barber and Judith Williams Barber held vastly different stations in the society of which they were a part—he the master, she the servant. Yet, in the final analysis,

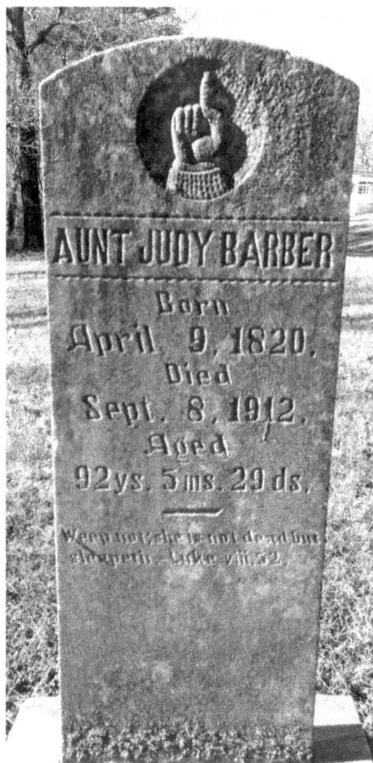

Left: Gravestone of Judith Williams Barber, located in the Old Damascus Church Cemetery. She died in 1920, having outlived all who enslaved her. *Author's photographic collection.*

Right: Gravestone of Richard Wainwright Barber, who died in 1907. Ironically, he was eulogized with the same encomium as that given to Judith Williams Barber: "Well done, good and faithful servant." *Author's photographic collection.*

both aspired to the same goal, and both were venerated with the same benediction: "Well done, good and faithful servant." Within this aphorism resides the legacy of a slave woman, a lady of small stature with Indian-brown complexion who transformed a life of slavery into one of dedicated service to humankind.

On a White Horse

The Ballad of Henderson Waugh

"Coloured" Child

No one knows for sure what day it was, or what year it was, when Henderson Waugh came back to town. Family lore recalls that it was subsequent to the Civil War, in the early stages of Reconstruction in Wilkes County. But as the story goes, when he did return, he was "riding gallantly upon his big white horse."[251]

William Henderson Waugh's early life is shrouded in mystery. The identity of his mother and father as well as the year of his birth can only be extrapolated from extant historical documents. Where he was raised, how old he was when he left the county and returned and for what reasons are all questions the answers of which are matters of informed speculation at best.

Waugh was likely the son of a free woman of color named Matilda Grinton and the illustrious Colonel William Pitt Waugh—plantation owner, merchant, community leader, churchman and slaveholder. In the census of 1830, Grinton is listed as a free person of color who was the head of a household of four—herself, two girls under ten and a boy under ten. Two years later, in October 1832, Wilkes Court Records show that "two coloured children of Matilda Grinton, a boy 8 yrs old 1 Jan 1833 and a girl, 7 yrs in Feb 1833, [were] bound to Colonel William P. Waugh." The bond was posted in the fall of 1832 and paid in January and February 1833, respectively, in the amount of £250 (the equivalent

of $1,200).[252] A comparison to 2015 currency provides insight into the relative worth of that transaction: $1,200 in 1833 would be the equivalent of $34,286 today.

But why would Waugh have these children bound to him? Certainly it appears to have been a common practice for children to be bound out as apprentices to county planters—particularly those who were born to households headed by single females. It is reasonable to infer that the colonel may have executed the bond for that purpose—he was, after all, a plantation owner as well as a merchant with stores in several states. But why these two children, as opposed to other options conceivably available to him? Might there have been a more personal motive? The reason notwithstanding, the substantial sum paid by the colonel may be more indicative of a stronger personal connection to Ms. Grinton and her two biracial children than a pragmatic one.

It seems probable that this boy and girl were two of the three children counted in the census data of 1830 and assigned to the household of Matilda Grinton. The identity and whereabouts of the third child, a girl, remain a mystery; however, one thread of family oral tradition might provide a modicum of insight. Thomas Harvey Mitchell, Henderson's great-grandson and family historian, wrote, "It is said that he [William Waugh] fathered twins and that Henderson Waugh was one of the twins."[253] Yet no historical record has been located to substantiate the claim. But the census of 1830 suggests that the two *women* under ten years of age might have been the twins whom tradition erroneously reported as being men.

Clearly, the Waugh descendants believe that the identity of the male child referenced by the census was that of Henderson. If the assertion is correct, then young Waugh was born in either 1824 or 1825 and his sister(s) in 1825 or 1826. But how likely is it that this is the "Henderson" of family folklore? Equally, how likely is it that he is the son of Matilda Grinton and the colonel? No document has been located that associates his name with either of them. Yet, there is compelling evidence to suggest that he is the man to which the aforementioned documents refer. Precious little is known about Matilda Grinton; however, the details of William Waugh's life have been substantively documented. Widely accepted is the fact that Colonel Waugh never married, although he proposed marriage to a much younger Mary Taylor Williams prior to her decision to wed his nephew William Peden in 1839. Marital status notwithstanding, Waugh appeared to have a penchant for women of color, and his descendants have long held that he did father children—how many

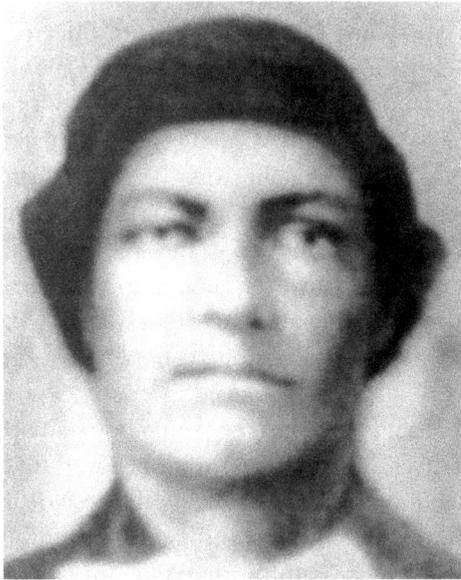

Photograph of William Pitt Waugh
Jr. (1844–1880), allegedly the
son of Martha "Patsy" Laws and
William Pitt Waugh. Laws made the
unsubstantiated claim that she and
Waugh were married. *Find-a-Grave.*

has been a topic of speculation. The bond posted in the fall of 1832 would support both of those claims. But the bond isn't the only evidence.

In 1844—the year that Waugh's nephew William Peden was assassinated—a baby boy was born in Wilkes County to a mother named Martha "Patsy" Laws. Laws had been previously married in October 1830 to a man named Sherrod Seagraves, with whom she conceived and bore a son, Moses, in 1832.[254] The couple was evidently separated at the time she gave birth to her second son in 1844. She named this boy William Pitt Waugh Jr. Laws claimed that this child was fathered by the colonel, to whom she was married. No record of the marriage exists, just Laws's assertion promulgated through the years via family lore.

Though a photograph of Patsy Laws has not been located, one glance at the adult picture of William Pitt Waugh Jr. would suggest that this is a man of color. Little is known about his life subsequent to his Wilkes County birth in 1844. He married a woman from Johnson County, Illinois, named Cyrena Elizabeth Stacy, herself a woman of color by all appearances. She and Waugh had eight children—five sons and three daughters. Waugh Jr. appears once in census records, in 1870, identifying himself as a "miller" who lives with his family in Henderson County, Tennessee. Apparently his life was a brief one. According to Find-a-Grave records, William Pitt Jr. died in February 1880 at the age of thirty-six. His wife, Cyrena, lived another nine years before succumbing

in 1889. The Waughs, along with Patsy and her first husband, Sherrod Seagraves, are buried in the Waugh-Seagraves Cemetery in Carroll County, Tennessee, a little north of Henderson County.[255]

There is no indication that Colonel William Pitt Waugh ever recognized Waugh Jr. or acknowledged "Patsy's" claim that he was the boy's birth father. Of course, there is no historical record of Waugh's recognition of Henderson. And neither of these men was mentioned in the colonel's will following his death in 1852. Taken together, however, their very existence does provide additional substantiation for the inference that Waugh Sr. seemed to have a predilection for women of color and that he did, in fact, father several biracial children.

The legend of Henderson Waugh, as it is told, has the young boy sent up north by the colonel to live with relatives. The senior Waugh believed that his biracial son would be able to live a much freer, safer life in the North than he could in the antebellum South. But there is sufficient reason for calling into question this assertion. It seems doubtful that William would have posted bond for Grinton's two children in an amount exceeding the 2015 equivalent of $34,000 and then immediately have sent one or both of them away. The 1840 census stipulates that in William P. Waugh's household there were two male and one female "free colored persons" between the ages of ten and twenty-three.[256] In 1840, Henderson would have been fifteen or sixteen—a teenager, not a young boy. Could one of the male free persons of color assigned to the colonel's household in 1840 have been Henderson? Just as intriguing is this dual-faceted question: If the young Waugh was sent up north to reside, then how old was he when he left Wilkes County, and to whom was he sent?

NORTHERN FLIGHT

On Wednesday, May 26, 1897, at 8:00 p.m., in Atlanta University's Ware Memorial Chapel, participants from around the United States assembled for a conference exploring the nature of problems concerning "Negro City Life." Among the congregants was W.E.B. Du Bois, whose detailed reports of the proceedings stand as a written history of the event. He and other conferees took note as an intense woman in her mid-thirties, with rigid posture and "ivory-cast" skin, approached the podium, dimly illuminated by gas chandeliers. Adella Hunt Logan, alumna of Atlanta

University and a teacher at the Tuskegee Institute in Alabama with Booker T. Washington, spoke eloquently regarding prenatal and hereditary influences:

> How rarely in the every day ordering of our lives, do we give any attention to that silent but powerful thing known as heredity? To be sure, the grandfather sowed wild oats, and it is charged that a great-great-grandmother was born out of wedlock, but that was generations ago…it may be so far back indeed, that no living person remembers having heard of the peculiarity.…The force of heredity cannot be checked by a generation…we are reaping what was sown not by our fathers alone, but by their fathers and grandfathers… "unto the third and fourth generations of them" was the decree thundered down from Mt. Sinai by the voice of Almighty God![257]

In writing about the event in 1991 in her book *Ambiguous Lives: Free Women of Color in Rural Georgia, 1789–1879*, Adele Logan Alexander poses the question as to why the speaker was so passionate about her topic. "Did her intensity betray a personal identification?" Perhaps. Ms. Logan came from a family with an African American and Cherokee grandmother and an Anglo American father. She also had a grandfather who sowed wild oats, resulting in children fathered outside of wedlock. That, Ms. Alexander wrote, "may have been more the rule than the exception among her antecedents and for many others."[258]

Adella Hunt Logan said of herself on another occasion, "I was not born a slave, nor in a log cabin." Rather, she was an accomplished woman who, as author Alexander summarized, belonged to a social class that lived in the ambiguous world of a free person of color (FPC). "Neither black nor white, affluent nor impoverished, enslaved nor truly free, these women of color lived and died in a shadowy realm situated somewhere between the legal, social, and economic extremes of empowered whites and subjugated blacks."[259]

Henderson Waugh was similarly situated. Less than fifteen years before his birth and until 1840, Wilkes County experienced a steady, substantial increase in its population of free people of color. In fact, Wilkes had one of the highest populations of free people of color in western North Carolina. Census data reveal that the county ranked first in 1850 and second in 1860.[260] As in other states, in both the North and the South, their lives played out within that "shadowy realm" and were no less uncertain and their freedom no less fragile.

One of the groups of FPC in Wilkes prior to 1820 was the "native freeborn." Generally landless, households of these persons were headed by single mothers. Their children were characteristically apprenticed or bound out to white families who owned plantations in the county.[261] Matilda Grinton, allegedly Henderson's mother, indisputably fell into that category.

The census of 1830 is the first record of Ms. Grinton; she is designated as a free person of color who is the head of a household with three children—one boy, two girls—under ten years of age. Two years later, her name appears in Wilkes Courthouse records as the mother of a boy and a girl that Colonel William Pitt Waugh had bound to him. Family tradition maintains that the eight-year-old boy was Henderson. The census of 1850 locates Matilda in Ashe County, living in the home of merchant James Gentry and his wife, Mary. In 1860, a sixty-three-year-old Ms. Grinton is living in the southeastern district of Ashe County on a farm with the Bone family. She is designated as a "house woman."[262] This document is the last in which her name appears; she simply vanishes. It is reasonable to speculate that between the 1860 and 1870 censuses Matilda Grinton died.

Neither Henderson nor his sister(s) are listed by name in any of the census records. It is likely that in 1830, they are the children listed in the Grinton household and could have been counted among the FPC that William Waugh listed in 1840. Regardless, two of Matilda's biracial children lived under the protection afforded by the bond granted to the colonel in 1832 and paid in 1833. They could not be forcibly removed from the county by slave-traders who were gathering coffles of slaves to "sell down the river." Though the children may have been treated contumeliously by county residents, no harm would befall them, because they were protected by a man with community status whom few would challenge.

However, all of that was about to change. In 1850, Colonel Waugh owned real estate valued at $53,721 ($1,627,909.09 in 2015 currency).[263] Clearly a wealthy man, he was also the largest slaveholder in Wilkes County, with thirty-five slaves. But he was seventy-five years old, and his health was declining. Perhaps it was at this time that a decision was made to arrange for Henderson to leave Wilkes County. If anything should happen to him, his biracial son would no longer enjoy the protection that the force of Waugh's community standing afforded him. Henderson's future could no longer be assured in the slaveholding, slave-trading county of Wilkes.

According to popular memory, Henderson was sent north to reside with relatives, where he could live much more freely and productively without the dogged fear of being shanghaied and sold into slavery by those seeking financial gain. The tradition, however, maintains that he was sent north as a young boy; it is unlikely that this was the case, for two reasons. When the colonel posted bond for Matilda Grinton's two "coloured children" in 1832 or 1833, he paid £250 to do so (more than $34,000 in 2015 currency). It certainly is improbable that he would pay such an exorbitant amount for the two children, only to send at least one of them away.

The second, more compelling, reason is that a number of the relatives to whom Waugh might have sent his son were living in Wilkes County. The Waughs were a very large family. The elder William Waugh—the colonel's father—resided in Adams County, Pennsylvania. He and his two wives, Jane McClure and Elizabeth Kinkead, produced eleven children— six boys and five girls.[264] A listing of their names appears in older brother David's will in 1815: Alexander, William Pitt, John, James, David, Andrew, Elizabeth, Jane, Margaret, Amelia and Mary.[265] All of the Waugh brothers eventually migrated to Wilkes County. Elizabeth, who married John Peden, eventually became a resident of Indiana. The whereabouts of the remaining four sisters is a mystery. To date, no official document, aside from David's will, has been uncovered in which their names appear.

Most sources agree that the brothers Waugh came to Wilkes County in or around 1803.[266] David, who would die in 1816, had moved back to Adams County prior to his demise.[267] The others remained in Wilkes. In his will, written less than a month before his own death in August 1852, William Waugh mentions only two brothers by name, James and John. Like his older brother, John was a bachelor. He apparently resumed residency in Adams County prior to the writing of the colonel's will.[268] It seems altogether probable that when John returned to Adams County, Henderson accompanied him. If he left Wilkes County around 1850 with his uncle John, Henderson would have been about twenty-six years-old—a young man, not a boy of eight or nine. For all intents and purposes, he existed in virtual obscurity for the next twenty years.

Suddenly, Henderson makes his "debut-by-name" in the census of 1870, about two years after U.S. Grant began his first term as president. He was listed in the household of an industrial magnate, George Lobdell, in New Castle County (Wilmington), Delaware, some 110 miles from Adams County. Waugh is designated a "Black" man, ostensibly serving the family as one

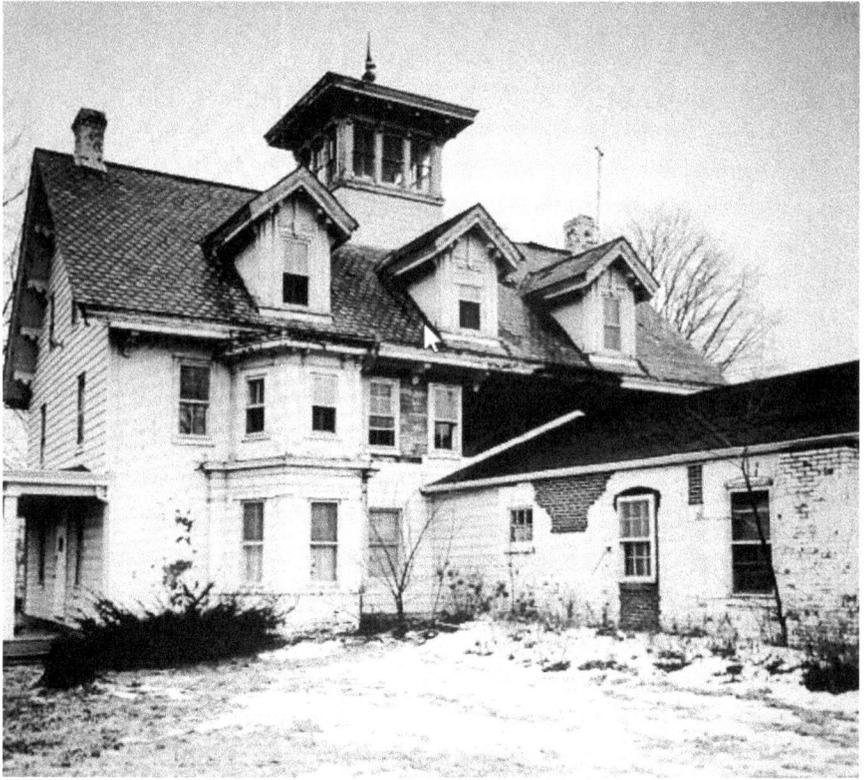

The summer home of George Lobdell, New Castle County, Delaware. Henderson Waugh worked for the Lobdell family as a groom at this house and likely at their house in Wilmington. *Lobdell House website.*

of two "Grooms" responsible for the care, feeding, exercising and general appearance of horses. It is noteworthy that he claims to be able to read, but not write—a fact that may explain why in subsequent legal documents he simply "makes his X mark."[269]

A perusal of the census record of George Lobdell's household suggests that he was a man of means. The first five individuals listed appear to belong to the family proper; following them is a seventy-seven-year-old without occupation and six "blacks" serving the residence—Henderson among them. The family likely maintained residences both inside and outside of the city of Wilmington, requiring the services of an extensive domestic staff. The total value of listed personal property and real estate was estimated in 1870 to be $200,000 (in 2015 currency, $3,636,364). Indisputably, the Lobdells were a wealthy family.[270]

George Lobdell's life did not begin famously. Born in 1817, he was orphaned at a young age and subsequently moved, in 1832, to the Wilmington, Delaware home of his uncle Jonathan Bonney. He was apprenticed as an ironmaster in a business owned by his uncle and one of the wealthiest men in Wilmington, Charles Bush. Bonney & Bush specialized in the casting of iron wheels for railroad cars at a time when railroad companies were laying track all across the United States. Young George demonstrated an aptitude for the business and was often asked to run the shop when Bonney was away calling on clients.[271]

When Bonney died prematurely in 1838, twenty-one-year-old George assumed his uncle's interest in the newly named firm of Bush and Lobdell. He supervised all production and sales and conducted a vigorous research-and-development program to ascertain more productive means of manufacturing wheels and locomotive tires. In 1855, Charles Bush, the remaining founding partner of the firm, was killed in a carriage accident. Lobdell continued the partnership with the Bush family until 1859, when he purchased their share of the business. Under his management, the company became the largest producer of railroad parts in the nation by the time the Civil War commenced in 1861. George believed that the war was being waged to save the Union, not to emancipate slaves or subjugate the South. He supported the war effort by ensuring that railroads had parts to facilitate strategic military troop and supply movements required to sustain the Union cause. He finally incorporated the firm as the Lobdell Car Wheel Company in 1867.

It is not certain at what point Henderson Waugh became an employee of the Lobdell family; all that is known is that he was a member of the household in 1870. It is reasonable to conclude that Waugh, forty-six, was paid well for the services that he provided for the Lobdell family at their city home and summer place. He was likely saving money for whatever opportunity might materialize. It must have been sometime between 1870 and 1873 that Henderson's thoughts wandered back toward the state and the county whence he came. So, as the story goes, he saddled up a horse—perhaps a white stallion obtained from the Lobdells during his employment—and embarked on a long journey that would take him back to the Carolina county of Wilkes.

HOMEWARD BOUND

"Old [Colonel Waugh] was dead.…This must be distinctly understood, or nothing wonderful can come of the story I am going to relate."[272] As a matter of fact, even his business partner and cousin, John Finley, had

died on November 4, 1865, shortly after the conclusion of the Civil War. Both of these community icons were reposing in proximity to each other in the Wilkesboro Presbyterian Cemetery when Henderson Waugh rode into town "on a white horse" sometime between 1870 and 1873.

But the Wilkes County to which he returned was vastly different from the one that he had left. The pall of the punishing policies of Radical Reconstruction had settled over the community. Surviving servicemen had made their ways back to families and homes to commence the arduous task of rebuilding their lives. Much of the county had experienced the devastation of war in varying degrees, though Wilkes did escape the wanton destruction characteristic of Stoneman's raids—owing in no small measure to the intercession made by Calvin Cowles to General Stoneman.[273]

Slaves had been emancipated, and the state legislature began enacting laws to accommodate these "new citizens." In 1866, a bill was passed that legitimized common-law unions of former slaves; thirty-seven couples appeared at the Wilkes County Courthouse that same year to obtain the sanction.[274] Marriages could now be performed for black couples in legal ceremonies officiated by ministers or magistrates, replacing symbolic rites between slave partners often conducted by their owners. In 1867, William Locke Barber and Mary Williams were married in a ceremony at the Cedar Lawn plantation of Rector Richard Wainwright Barber, doubtless one of the first of its kind in Wilkes County.

Freedman's Bureaus began to appear in every county across the state. Before his death, President Lincoln had authorized the formation of bureaus to provide whatever assistance was needed to the newly liberated citizens, including negotiating labor contracts, setting up schools and establishing churches. Some even aided former slaves seeking to reunite with lost family members. Though the original plan stipulated that all bureaus were to finish their work within a year, extensions were granted during the Andrew Johnson administration, over his strong objections expressed in a "veto." A Freedmen's Bureau was located in Wilkes County and conducted its business for about six months. The National Archives, however, maintains that there are no extant records of its brief operation.

Carpetbaggers—so named for the large carpetbags in which they transported their belongings—commenced to insinuate themselves in the new politics of the South. Eric Foner, in his book *Reconstruction: America's Unfinished Revolution 1863–1877*, described the average carpetbagger as a person who "probably combined the desire for personal gain with a commitment to taking part in an effort 'to substitute the civilization of

freedom for that of slavery.'" In fact, he continued, most viewed Southerners as being "devoid of economic initiative and self-discipline; they believed that only 'Northern capital and energy' could bring 'the blessings of a free labor system to the region.'"[275]

Suffice it to say, leery locals generally resented these interlopers and organized resistance against them. In 1867, a secretive vigilante organization known as the Ku Klux Klan (KKK) began to spread across the South. Deriving its name from the Greek word *kyklos*, meaning "circle," the Klan targeted emancipated blacks and their allies in an effort to restore "white supremacy."

On May 18, 1868, newlywed Milly Gwyn Brown penned a missive to her parents, "Mr. and Mrs. James Gwyn in Wilkes County," in which she declared that a "brighter day is dawning for our poor country." She indicated that she and Allen Brown were "much elated at the news of [Andrew] Johnson's acquittal." Millie continued:

> *We find many strong rebels out here* [in Knob Creek, Tennessee]. *There has been and still is a good deal of excitement in regard to the "Ku Klux." It seems to be a regularly organized band, though there is such profound secrecy observed in regard to their movements and regulations.... The good people however think it a great institution and say they have been a great protection....They are a great terror to the Radicals and the negroes, have dispatched a good many of both classes in rather an unceremonious manner. Allen will give you some amusing accounts when we get home.*[276]

Certainly, the Klan's methods of murder, beatings, burnings and other forms of violence struck terror within the black community and among white Reconstruction Republicans, many of whom were counted among the ranks of carpetbaggers. But between 1870 and 1871, the federal government passed three Enforcement Acts, which were used to prosecute Klan crimes, thereby thwarting its intimidation. For a time, the KKK was suppressed, though vestiges of the organization persevered.[277]

To add insult to injury, the *New York Herald* sent a reporter to Wilkes County to cover a developing story of the murder of a young woman involved in what appeared to be a love triangle. Her disappearance in May 1866 resulted in arrests and a manhunt for one of the men who had inexplicably left the county. Less than two years later, on May 1, 1868, this young man, convicted of murder, was hanged near the Statesville train depot. His body was conveyed back to Wilkes for burial. The reporter's coverage of the drama as it unfolded garnered national attention and served to reinforce the

Northern notion that many Southern folk "living on the spurs and ridges of the mountains, [are] ignorant, poor, and depraved. A state of immorality unexampled in the history of any country exists among these people, and such a general system of freeloveism prevails that it is 'a wise child that knows its father.'"[278] Indeed, as Johnson Hayes opined in his book *The Land of Wilkes*, this was a "time that tried men's souls." And into this menacing mélange of malcontent rode Henderson Waugh. But for what purpose?

Henderson's reappearance does pose a conundrum: Why would a man of color living in the North return to the Southern County of Wilkes? If, as family tradition holds, he was sent up North as a young boy to live a freer life, it seems illogical that he would migrate back to an area where there was ferment and demonstrative hostility toward people of color and Northern carpetbaggers. What allure would have been planted in a young boy's mind that could have possibly enticed him back—as a middle-aged man—to county in which he had lived for so short a time?

If, as a twenty-six-year-old, Henderson exited Wilkes for Adams County, Pennsylvania, with his uncle John Waugh to seek a more fulfilling, freer life, why would he have ridden back into the maelstrom in the throes of Reconstruction? Every conceivable incentive for returning to the land of one's birth appears not to apply in this instance. Old Colonel Waugh, Henderson's alleged father, had been dead for almost two decades when

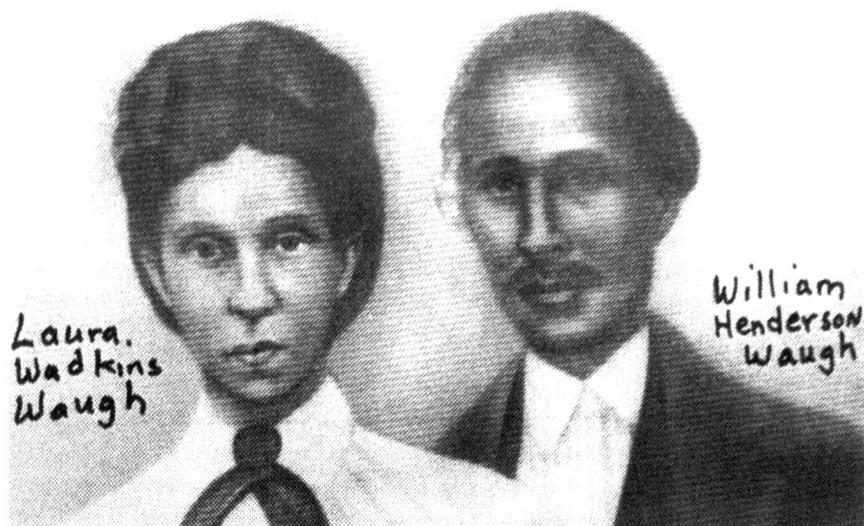

Photograph of Laura and Henderson Waugh. *Courtesy of Wilton "Bud" Mitchell.*

his biracial son resumed county residency. Matilda Grinton, believed to be his mother, likely died between 1860 and 1870. No records clearly indicate that the younger Waugh had any siblings at all, let alone any living in the community. Moreover, he was not a married man; he had no in-laws encouraging his return. Therefore, it is highly improbable that he relocated to be near family.

As far as can be determined through examination of extant documents, Henderson received no inheritance from the considerable land and cash holdings of William Waugh. In fact, he is not mentioned by name in the will. It seems unlikely, then, that inherited property was beckoning him back to Wilkes. However, it is possible that the sole rationale for Henderson's return could have had something to do with land and his employment by George Lobdell.

Following the Civil War, Northerners turned their sights toward the South, as it was perceived to be a land of opportunity. Newspaper stories reported that there were substantial profits to be made in the cultivation of cotton. Many businessmen, some of whom were carpetbaggers, commenced to purchase or lease plantation properties from Southern owners who could no longer finance their operations. These entrepreneurs hired freedmen to work for them for pay and other incentives. Even former Union soldiers, who battled on Southern fields, invested their life savings for the promise of huge returns. Of equal import is the fact that Northerners were successful in assuming control of Southern railroads, often abetted by state legislatures. As Henderson Waugh was working for the Lobdell family in New Castle County, Delaware, in 1870, Northern businessmen had already acquired control of 21 percent of the South's railroad mileage and about a fifth of their directorships.[279] Maury Klein, in an article for *Business History Review* entitled "Southern Railroad Leaders, 1865–1893: Identities and Ideologies," wrote that by 1890, Northerners controlled 88 percent of the mileage and almost 50 percent of the directorships.[280] And Waugh's employer, George Lobdell, was interested in both the natural resources of Southern properties and railroads.

In 1867, Lobdell freed himself from fiscal obligations to Jonathan Bonney's partner, the late Charles Bush and surviving family members. At that time, he incorporated the firm under the name of a single individual, the Lobdell Car and Wheel Company. According to Henry Conrad's *History of the State of Delaware*, the company's capacity for railroad parts production had increase to 250 wheels per day, with an annual value of $500,000. The firm employed two hundred persons and had a capital value of $200,000. This expansive growth spawned a concomitant need for an increased, continual

supply of raw materials. To accomplish that objective, Lobdell purchased ten thousand acres of "ore, wood, and farming land" in Virginia and about five thousand acres of timber and farming land in North Carolina. Moreover, the company continued the practice of procuring raw materials from its Southern holdings until early in the twentieth century.[281]

Perhaps it was from the Lobdells that Henderson first heard of business opportunities in the South; he would have especially noted the firm's acquisition of substantial acreage in his home state. If Henderson left this county as a young man in his twenties, he doubtless could recall—even after twenty years of absence—the vast plantations and open fields in Wilkes, a portion of which his father had owned. Might it have been, at that crucial point in time, that he entertained the notion of returning to his homeland to seek a fortune in land ownership?

All that can be said with confidence is that, by 1873, Waugh had journeyed, astride his "white stallion," into Wilkes County with the intent to acquire land. On February 28, 1873, a transaction was formally executed between Henderson Waugh of Delaware and one of the area's prominent citizens for one hundred acres of property. Waugh purchased the land for $800—cash.[282]

WAUGH LAND PURCHASES

It was on a Wednesday—Christmas Day 1878—that Dr. James Calloway drew his last breath. Born on the South Fork of New River in Ashe County on Wednesday, July 23, 1806, Calloway was one of twelve children of Elijah and Mary Cuthbert Calloway. His ancestors had migrated from Bedford County, Virginia, in 1740. Historical records agree that James was the grand-nephew of Daniel Boone, who resided in Wilkes and Ashe Counties before trailblazing westward to adventure and fame in what certain native tribes called *ken-tah-the*, meaning "land of tomorrow"—Kentucky.

After being educated locally, Calloway journeyed to Philadelphia at the start of the 1830s to study medicine at Jefferson Medical College. (Founded in 1824 by Dr. George McClelland—father of Major General George McClelland, general-in-chief of the Army of the Potomac—the college grew in enrollment and prestige. It is now subsumed by Thomas Jefferson University as the Sidney Kimmel Medical School and boasts of having awarded over thirty-one thousand medical degrees since its inception.)[283] According to grandson Dr. Fred Hubbard in his book *Physicians, Medical Practice and Development of Hospitals in Wilkes County, 1830 to 1975*, Calloway also

attended lectures at the University of Pennsylvania medical school in 1832 and 1833. Dr. Hubbard related that Calloway's notebook conscientiously details nineteenth-century thinking related to the practice of medicine and the treatment of patients. Dr. Calloway's practice spanned some forty years across seven North Carolina counties to the edge of Virginia. In fact, for several years, he was the only practicing physician between Statesville and Wytheville, Virginia.

In addition to his time-consuming medical pursuits, Calloway was enamored of politics and represented Ashe County in the Carolina legislature for three terms—1829, 1830 and 1831. Some thirty years later, he was sent as a Wilkes County delegate to the state convention in Raleigh to cast a vote related to secession. Though initially opposed to departure from the Union, the good doctor reversed his views and voted to secede in May 1861, subsequent to the firing on Fort Sumter.[284]

While visiting New York in 1839, Calloway attended an exhibit at Peale's New York Museum, where the Siamese Twins were showcased. The young physician was so impressed with their personalities and intelligence that he inquired as to the possibility of a face-to-face meeting with them. Astonishingly, his request was granted, and he was ushered into their dressing room. In the course of the conversation, the twins, Eng and Chang Bunker, revealed a predilection for hunting and fishing. Calloway immediately seized the opportunity to invite them to Wilkes County, where clear mountain streams held "fine fish" and the rolling hills and mountains were home to both large and small game. After exhibiting in North Carolina, the Bunkers recalled the doctor's invitation and decided to travel to Wilkes for a long vacation.[285] Neither the twins nor their manager, Dr. Charles Harris, realized at the time that this decision would alter the course of their lives and the histories of two counties.

After leaving medical school, James Calloway began to invest in real estate in both Wilkes and Ashe Counties. By 1850, he was regarded as the wealthiest "Whig" in Wilkes. His largest land holdings, however, were west of the Mississippi River, in Missouri and Kansas. When the war concluded, Calloway's professional and financial affairs were both complicated and embarrassing. Concerned about the management of his Kansas properties, he moved to that state to oversee them in 1870. Two years later, his health failing, the sixty-six-year-old physician was forced to return to Wilkes County.[286] Likely, he had only been back for a short time when, in February 1873, he was approached by a forty-nine-year-old gentleman of color named Henderson Waugh regarding a possible land purchase.

If Waugh's rationale for resuming his county residency was to acquire land, it is conceivable that he may have already possessed knowledge of James Calloway's extensive real estate holdings. While settling in, he could have also heard the locals discussing the fragile condition of Dr. Calloway's finances. Regardless, it seems logical to commence a search for potential land acquisitions by approaching one who holds significant acreage in two counties. Presumably, this is what Henderson did. On February 28, 1873, a land indenture was executed between Waugh and Calloway and the doctor's second wife, Annie, for one hundred acres of land ("more or less") for $800 cash, the equivalent of $16,000 in 2015 currency.[287] The property, situated in the Reddies River Township, had previously been purchased by Dr. Calloway from James N. Hamby.

Several years later, in 1877, two significant events transpired in Henderson Waugh's life, both documented in county records. The first occurred on January 11, when he extended his property by purchasing 32 acres from Wilkes notable Calvin Cowles and his wife, Ida, who were by then residing in Mecklenburg County. The acreage had also been owned by the Hamby family and was connected to the 100 acres that Waugh purchased from Calloway.[288] The price was $95 ($2,159 in 2015 currency). Henderson was now the owner of 132 acres of Wilkes County real estate, purchased from two of the area's most prominent citizens.

As late spring gave way to early summer that same year, Henderson married Laura Wadkins, the oldest of John and Fanny Chavis Wadkins's five children. However, Laura was not the first of the Wadkins siblings to marry; an older brother, William, had married Lucinda Luper earlier that year. Interestingly, Henderson was a witness to that ceremony, performed on February 22 at Lucinda's residence. When he and Laura married on June 24, the ceremony was conducted at the family home of John Wadkins and witnessed by the bride's oldest brother, Jordan, and family friend Caswell Isaiah Smith. In the North Carolina Marriage Register, Waugh is listed as a "colored" man, fifty years of age.[289] Likely he was about three years older than that. Curiously, Laura, thirty-one, is identified as a white woman. The 1860 census clearly establishes that the John Wadkins family was comprised of seven free persons of color.[290]

In 1878, Laura gave birth to her first child, Hattie. Later, the Waughs' firstborn would describe her father, Henderson—known by most people as "Hence"—for her own daughter, Catherine Poole.

He was very proper about his appearance…[and] *would often wear a white shirt and comb his hair each evening before supper. He was considered*

Photograph of the house of John William Henderson Waugh before it was razed. *Courtesy of Wilton "Bud" Mitchell.*

to be "well off" for the times. He employed white men to help with farm work and paid them in pigs, chickens, and produce. He owned a nice carriage and horse and was allowed to store the carriage at Blairs [sic] Barn when in the downtown North Wilkesboro area.

The last sentence is probably a reference to the barn located on the home site of North Wilkesboro stalwart E.S. Blair. At his death, Blair was editorialized as one of the largest landowners in the county.

Ms. Poole wrote that her mother, Hattie, was very fond of her father and recounted one of the stories that her mother told about him:

One time he planted a cedar tree in the front yard when she was younger. He told her that when the tree grew big enough to shade a grave he would die. So, my mother cut the small tree down because she did not want her father to die. Grandpa Hence was going to switch her for cutting the tree down, but when he discovered why she destroyed the tree he changed his mind.[291]

FAMILY ADDITION AND MORE LAND ACQUISITIONS

George Massey Foster was a little more than a month shy of his thirteenth birthday when his third cousin Laura disappeared and was later found buried in a shallow grave on a ridge near the Bates place in the opening days of September 1866. Foster's grandfather George Jr. and Laura's grandfather Thomas were brothers—both sons of George Sr. and his wife, Sarah. George Massey's father, Robert Burton, and Laura's father, Wilson,

were first cousins. (Wilson Foster's sister Carlotta "Lotty" Triplett Foster was the mother of Angeline Pauline Triplett Foster Melton—Ann Melton. So, George Massey Foster was also a third cousin to Ann.)[292]

Foster and his wife, Sylvania "Viney" Minton, lived in the Reddies River area of the county, likely on property that Viney inherited from her father, Jesse Minton. One of their neighboring families was Henderson Waugh and his wife, Laura, who lived on property purchased from Dr. James Calloway and Calvin Cowles. Waugh seemed to possess a propensity for adding to his landholdings. In November 1879, he and Foster agreed to a deal: 150 acres that was part of Viney's inheritance, purchased for the sum of $250, the equivalent of $6,000 in 2015 currency. But this contract was not the only one between the two men on that November 4. George and Viney ostensibly borrowed $50—the equivalent of $1,191 in 2015 currency— from Henderson, offering as collateral their interest in 75 acres situated near the waters of Fish Dam Creek in the Reddies River Township. The Fosters agreed to pay back the loan at 6 percent interest in three years, which they apparently did, reclaiming their collateral.[293]

On December 13, 1879, Henderson and Laura welcomed their second child, John William Henderson Waugh.[294] Known to family and friends as "Bud," John would eventually build a house on land purchased by his father. It was there that he and his wife, Paulina, farmed the land (as his father had done before), raised their children and lived out their lives.

Nothing remains of the original structure of the Waughs' home, except the foundation on which it was built and the greater portion of one chimney. However, Wilton "Bud" Mitchell, the grandson of John and Pauline and the great-grandson of Henderson and Laura, spoke eloquently of "many great childhood and adult memorable events" that transpired there. Mitchell, also known to family and friends as "Bud," is an educator and artist whose works have been exhibited in venues throughout North Carolina and beyond. "I've painted and drawn this scene [of the John Waugh home place] in every medium (oil, acrylics, pastel, watercolor, and pencil)." Mitchell, who lived with his grandparents for a time, continued, "I was married in the living room with my grandfather, John 'Bud' Waugh serving as best man."[295]

When his parents died, it was son John who eventually assumed legal guardianship of his younger brothers and sisters when he came of age. He maintained this role until the need no longer existed.[296] John William Henderson "Bud" Waugh died on January 2, 1963, at the age 83.[297] His wife, Pauline, succumbed on September 10, 1988, less than two months shy

Photograph of the remnants of the John William Henderson Waugh house. *Author's photographic collection.*

of her 104th birthday. Grace Dean Waugh Gilreath remembers her mother as being "very witty. She loved to recite poetry." According to Ms. Gilreath, there was one poem that she recited frequently—the last time when she was 101 years old. "The author remains unknown, but Mama could very well have been the composer." It was entitled "Remembering You:"

I have a house inside of me, a house that people never see, it has doors through which none pass, and windows but they're not made of glass; Most times I like to go inside and hide, and hide, and hide. And doctor up my wounded pride; And then when I find I am to blame, I go inside and cry for shame; And get my mind in better frame, and my tongue and temper the same; And when I'm made quite strong, then I go outside where I belong, and sing a new and different song; Then I hear the people say, that I am boney, brittle, and gay; It's just because I feel that way; They don't know the price I pay.[298]

In 1880, Henderson Waugh appears for the final time in a census record. He is listed as a "mulatto," age fifty-one (he was likely four years older than that) and a farmer who is living in the Reddies River area. Laura,

two-year-old Fannie H. (Hattie) and four-month-old John W.H. Waugh are also included in household. Four pages of census documentation separate Henderson from the listing of George Massey Foster, from whom he purchased property just months before the census taker appeared.[299]

On January 6, 1881, the Waughs paid $775 ($18,023 in 2015) for a 12-acre parcel of land from T.F. Bolick; his wife, Sarah; and others.[300] Over three weeks later, Henderson divested himself of the land that he purchased from the Fosters. In a deed dated January 31, 1881, he sold the 150 acres acquired from George and Viney, for which he had paid $250, to C.W. Minton for the sum of $300,

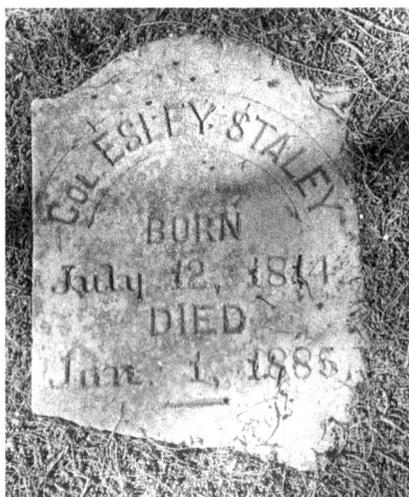

Gravestone of Esley Staley, sheriff of Wilkes County who hanged Kit Robbins in 1856. Henderson Waugh purchased the Rock Creek property from Staley's descendants. *Author's photographic collection.*

the equivalent of $7,000 in 2015 currency. Henderson made a modest profit from the sale.[301]

In April 1882, the Waughs borrowed $100—$2,326 in 2015 currency—from M.C. Williams, offering the 125 acres of property on which they were living as collateral. The loan was apparently repaid with 8 percent interest and the collateral reclaimed.[302] On June 24, 1882, he and Laura purchased two tracts of land totaling 42 acres from Rufus Triplett and his wife, Mara, for the sum of $900 ($20,930 in 2015). On that very same day, however, the Waughs sold a tract consisting of 12 acres to Mara Triplett in consideration of $1,000, $23,256 in 2015.[303] This sale more than covered the cash outlay of Henderson's previous purchase from them.

On February 19, 1883, Robert Gibbs and Samuel Hampton offered 32 acres of property as collateral against a $400 loan ($9,524 in 2015 currency) from Waugh. The sum was ostensibly repaid by the specified date of October 1 and the collateral returned to the two borrowers.[304] Eight days later, Henderson acquired an additional 100-acre tract from W.M. Robb Church, his wife, Virginia, and Ann Triplett for the sum of $2,200 ($52,381 in 2015).[305] On March 3, the Waughs sold the 132 acres purchased from Dr. James Calloway and Calvin Cowles to Virginia

Church and Ann Triplett for $1,000—$23,810 in 2015 currency.[306] The first decade of Henderson "Hence" Waugh's return to Wilkes County was characterized by the acquisition and divestment of properties—but for what purpose? Though he retained ownership of significant acreage in the Reddies River area, his sale of substantive tracts of land—inclusive of the acreage on which he was residing—suggests that a relocation of his family was imminent, perhaps to another area of the county. It was not until the fall of 1885 that a clue as to the reason for his business transactions became manifest in official county documents.

ACQUISITION OF PROPERTY IN ROCK CREEK TOWNSHIP

It is hard to believe that a black man could own all that property in those days.

—A Wilkes resident, commenting on Henderson Waugh

On April 4, 1856, while the mournful notes of a hymn lingered in the ears of the attendees who had gathered for the occasion, Sheriff Esley Staley hanged Christopher Robbins, likely from the Tory Oak. Kit Robbins, as he was known, was a notorious slave driver whose six-county operation was mostly centered in Surry. One of his stepdaughters, fourteen-year-old Martha "Mattie" Mayberry, in her testimony at his trial, indicated that he was a "right good fellow" with a conscience when sober, but wicked and cruel when inebriated. Such was the case on a July evening in 1855 when a drunken Robbins—with malice aforethought—systematically tortured his faithful slave, Jim Beard, to death.

Esley Staley had been elected the seventeenth sheriff of Wilkes County in 1852, about four years before the Robbins hanging. He was subsequently reelected for a second term that expired in 1860, less than a year before the outbreak of the Civil War. However, he was the presiding sheriff when a new jail was erected in 1859 to potentially house Yankee prisoners in the event of a war between the states.[307] The Old Jail still stands, adjacent to the Wilkes Heritage Museum, as a reminder of an era similar to that described by G.A. Studdert-Kennedy in his poem "Indifference": "Those were crude and cruel days, and human flesh was cheap."[308]

Born on July 12, 1814, Staley married Martha Cleveland, with whom he raised five children. Following his tenure as sheriff, he served the county in

Death certificate of young Hazel Waugh, daughter of Ben and Daisy Waugh. She allegedly died due to a lack of immediate critical care by Wilkes Hospital's emergency staff. *Wilkes County Death Records.*

sundry civic capacities.[309] Interestingly, the census of 1880 records that sixty-five-year-old Esley Staley was the head-of-household and operating a hotel in Wilkesboro with the assistance of family members.[310] On June 1, 1885, Staley died, about a month shy of his seventy-first birthday. He reposes in the Wilkes Presbyterian Church cemetery.[311]

While residing in Kansas in 1869, Robert Martin—Esley and Martha's oldest child—acquired two tracts of land from his father for $1,300—the equivalent of $22,807 in 2015 currency. One tract consisted of one hundred acres and the second of forty-seven acres; both were located in the Rock Creek Township. Robert and his wife, Mary, retained ownership of the property until 1885, when it was purchased by Cornelia Jane (C.J.), the second oldest of the Staley children.[312] In a deed executed from Cloud County, Kansas, Robert and Mary sold both parcels of land to C.J. for the sum of $350, the equivalent of $8,750 in 2015 currency—clearly substantially less than the price paid some sixteen years earlier.[313]

It was in November of that same year that Henderson Waugh approached Miss Staley with an offer to purchase one of those tracts—one hundred acres located in the Rock Creek Township near the rock quarry. On November 14, C.J., her sister Amelia and her husband, Reverend Gwaltney, deeded the acreage to Waugh for the sum of $2,500—$62,500 in 2015 currency. Two weeks later, Henderson and Laura executed a mortgage deed for three notes, totaling the cost of the transaction, to be repaid to lender "William R. (?) Reeves"—two for $1,000 each and one for $500—each due at specified intervals, the last of which was to be paid by January 1, 1888.[314] Apparently,

all were reimbursed as per agreement, because it was to this property that Waugh relocated his family.

No one knows for certain when Henderson removed his family from the Reddies River Township to the Rock Creek area, where he would live out the remainder of his days. One clue might be gleaned from an examination of the birth dates of his children. Hattie, the oldest of them, was born on June 29, 1878. She eventually married the Reverend John Hawkins, with whom she raised eight children before dying in the Kate Biting Hospital in Forsyth County on New Year's Day 1961, at age eighty-two. Hattie was interred at the Chapel Hill Cemetery next to her husband, John, who preceded her in death by only thirty-six days.[315]

It has been previously established that John William Henderson Waugh, the oldest son, was born on December 13, 1879. He died two years and one day after his sister, Hattie, in the Wilkes General Hospital at the age of eighty-three. John and his wife, Paulina, repose in the family cemetery on the land procured by Henderson and Laura in 1885.

Henderson Garfield, child number three, was born on September 30, 1882, according to his World War II Draft Registration Card. Garfield, as he was known, was unmarried and lived most of his life in California, employed by the fruit industry. However, when he registered for the draft in 1941, Garfield was fifty-nine years old, living on East Fifty-First Street and working as a laborer for the Works Progress Administration (WPA) in Los Angeles on the Figueroa Tunnels Project. On his registration card, he designated a man named Herbert Threatt as a contact living near him who would always know his address.[316] The California Death Index indicates that Garfield died on October 16, 1967, at age eighty-five, in Los Angeles.[317]

James Calvin was born on June 20, 1883. He married Mae Harris, with whom he raised a family of seven children. James was a farmer and was also employed by Southern Railway, from which he officially retired. "He was the quiet and shy one," recalled his daughter Lola. "If he saw you first, then you did not see him. He was a hard worker…[who] quietly supported his wife, Mae, who was a 'Preacher of the Gospel' at a time when it was not popular for women to be in the ministry."[318] James and Mae were residing on K Street in North Wilkesboro when he died in Wilkes General Hospital on February 13, 1964, at age eighty. He is buried at Mountlawn Memorial Park in the Fairplains area of the county.[319]

It seems highly probable that the first four Waugh children were born in the Reddies River area. As previously noted, the census of 1880 indicates that Hattie and John were living with their parents in Reddies River. Garfield

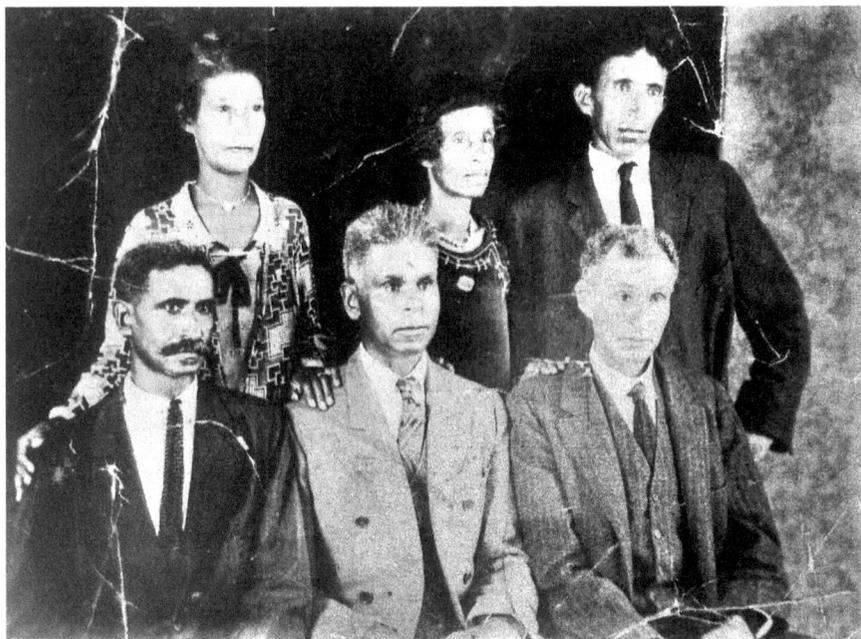

Above: Children of Henderson and Laura Waugh. *From left to right, front row*: James Calvin, Henderson Garfield, and John William Henderson; *back row*: Amy Lou, Hattie, and Benjamin Harrison. *Courtesy of Wilton "Bud" Mitchell.*

Left: Photograph of Caswell Isaiah Smith, Henderson Waugh's brother-in-law and co-executor of the Waugh estate. Like his brother-in-law, Smith had substantial property holdings in Wilkes. *Courtesy of Evonne Raglin.*

and James were added to the family prior to the purchase of the Rock Creek property in 1885, so it is reasonable to infer that they were residing in the Reddies River Township, as well. However, from the birth of son James, it would be almost five years before two more children, Benjamin and Amy, were added, in 1888 and 1889, respectively. Likely, the Waughs had relocated to Rock Creek prior to their arrivals.

Benjamin Harrison, the youngest son, was born on May 10, 1888. He married Daisy Smith, with whom he fathered fifteen children—a dozen of them living to reach adulthood. For most of his working life, Ben was employed by Carolina Mirror in North Wilkesboro, where the family resided. "Papa was a quiet man devoted to Mama Daisy," recalled daughter Martha Waugh Barnes. "He loved watermelons and could always pick the sweetest ones. He carried a bag of brown sugar in his overalls because he loved the sweet. He kept his hands in his back pockets and walked 'slue-footed.' One of his favorite terms was 'confound it all' when he didn't want to be bothered."[320]

The year 1924 was not kind to Ben and Daisy Waugh. On May 26, Daisy gave birth to a set of female twins who were stillborn.[321] Then, on October 19, their daughter, six-year-old Hazel, sustained a gunshot wound on the right hip and thigh in what proved to be a deadly accident. Hazel was rushed to Wilkes General, but she did not receive the expeditious emergency treatment needed. She died at three o'clock that afternoon from shock and hemorrhaging. Coincidentally, the physician who signed her death certificate was Dr. Fred Hubbard, the grandson of James Calloway, who sold one hundred acres to Henderson Waugh in 1873, shortly after his return to Wilkes County from Delaware.[322] Ben Waugh died suddenly at his home on December 16, 1963, at age seventy-five. His wife, Daisy—to whom he was devoted—had preceded him in death. Both repose at Pleasant Hill Cemetery in Fairplains.[323]

The youngest of the Waugh children was Amy Lou. Born on September 27, 1889, she married Wessley Oliver Watkins, and the couple raised thirteen children. Wessley was a farmer, and Amy spent her life working diligently to create a caring, supportive home for her husband and children.[324] On March 7, 1949, Wessley suffered a coronary attack, precipitated by hypertensive heart disease for which he had been treated throughout the last year of his life. He died at the age of sixty-seven. Suffering from coronary heart disease herself, Amy was stricken with an attack on the afternoon of January 13, 1955. By the time she was transported to the hospital, the youngest of the Waugh children had breathed her last. Amy Lou was only sixty-five. Like Ben and Daisy, she and Wessley rest in the Pleasant Hill Cemetery.[325]

On March 2, 1887—less than a year before Benjamin was born—Henderson and Laura divested themselves of the last of their Reddies River property holdings. William B. Reeves, likely the person who loaned the Waughs cash with which to purchase the Rock Creek property in 1885, obtained the remaining 192 acres located in the Reddies River Township for $2,500—$62,500 in 2015 currency.[326] This land divestment essentially reimbursed the Waughs for their Rock Creek purchase less than two years before. Even so, Henderson's "balance sheet" for all land transactions over the last decade and a half was clearly in the red. For all intents and purposes, his expenditures for property acquisitions far exceeded receipts garnered from land sales.

BLACK LAND BARONS OF WILKES

Local lore and tradition maintains that you could walk along Highway 18 all the way to Highway 268 without stepping foot off land owned by Caswell Isaiah Smith. C.I., as he was often addressed, had a passion for accumulating property, and that fact seems to support this oft-repeated anecdote regarding the extent of his holdings in the Fairplains area, according to grandniece Evonne Raglin.[327]

Isaiah Smith was born three days after Christmas in 1839 in Wake County, the sixth child of Eldridge and Jane Smith, both free persons of color. The date of the Smith family migration from Wake to Wilkes is uncertain; however, it must have been accomplished prior to the 1850 census. In that document, Eldridge, Jane and their considerable family are counted among Wilkes County residents. Isaiah is listed as a "mulatto" son, fifteen years of age, though he was likely four years younger. It stipulates that he was born in Wilkes, but that notation is doubtless inaccurate.[328]

What is not widely known is that there is evidence to suggest that C.I. served for a brief period as a soldier during the Civil War. The *Civil War 1890 Veterans Special Schedule* indicates that Mulberry resident Caswell I. Smith was mustered in Wilkes County in July 1864 as a "Private" assigned to F Company of the Third North Carolina Mounted Infantry (Third NCMI).[329]

In his book *Kirk's Raiders: A Notorious Band of Scoundrels and Thieves*, Matthew Bumgarner writes that the Third NCMI was formed through a special order from General John Schofield to Captain George Washington Kirk. The behest directed Kirk to raise a contingent of two hundred men from North Carolina, Tennessee and other Southern states who were Union loyalists.

Their primary mission was to destroy supply stores and means of transportation utilized by General James Longstreet's Rebel army. The order authorized employment of destructive tactics such as "burning bridges, trestle-work, water tanks, cars, etc., and tearing up track."[330]

The first recruits were enlisted in June 1864, though there were already troops on the roster as early as April 1864. Led by the controversial Kirk, their first mission was to capture Camp Vance in Morganton, a known Burke County training site for Confederate conscripts. Though the camp was captured without fanfare, the Third NCMI failed to achieve the primary military objective of destroying the railroad bridge spanning the Yadkin River north of Salisbury.

Gravestone of William Henderson Waugh and Laura Wadkins Waugh, located in the Waugh Family Cemetery on property that Henderson and Laura owned. *Author's photographic collection.*

Unlike the Second North Carolina Mounted Infantry under the direction of Lieutenant Colonel James Albert Smith of Kentucky, the Third NCMI allowed black men to serve within the ranks. They were usually relegated to performing cooking and blacksmithing tasks. However, Company F, to which Private C.I. Smith was assigned, was eventually ordered to prison guard duty. In fact, a great number of the company's members marched Rebel prisoners to Camp Chase in Ohio.[331] The nature of Private Smith's duties is fodder for speculation, but his military service in the Third NCMI is a matter of federal record. It is noteworthy that on March 12, 1900, application number 1245.759 was filed by Caswell I. Smith, requesting pension for his service in the Third NCMI during the Civil War.

Shortly after his return from the war, Smith married Lucy Wadkins, thirteen years his junior. She was the third of five children born to John and Fanny Chavis Wadkins. Between 1870 and 1880, the Smiths added seven children to their family—three boys and four girls—all residing in Mulberry near Lucy's parents. In the census of 1880, Isaiah is listed as a farmer, and John, ten, is "working on the farm."[332]

It must have been between the years 1873 and 1877 that C.I. Smith became acquainted with Henderson Waugh. Perhaps the two gentlemen were first introduced during Waugh's courtship of Lucy's older sister, Laura. Whatever the case, when Henderson and Laura married on June 24, 1877, one of the witnesses was Laura's brother-in-law Isaiah Smith.

Though about fifteen years his senior, Henderson had a common bond with Isaiah. These brothers-in-law were men of color with an ostensible insatiable desire to own land. Their names appear frequently in records maintained by the office of the Wilkes Register of Deeds. Waugh's first verifiable transaction is in 1873, Smith's in 1891.[333]

What is not apparent is how each of these men raised the capital needed to invest in their respective real estate transactions. Previously, it has been acknowledged that Henderson's balance sheet appears on the surface to be in the red. In order to continuously acquire property over the course of eighteen years, he had to have access to funds exceeding the amount of profit he garnered by selling off portions of his holdings. But from what source(s)?

Inferences can be drawn by considering several possibilities. Although it seems improbable, Henderson may have received some financial assistance from Colonel William Pitt Waugh's estate. If the colonel sent his son northward around 1850 to live a freer life under the watchful eye of his brother John, it would be logical to assume that he made some provision for a successful transition. Of course, Henderson's name did not appear in his father's 1852 will; however, John was bequeathed "property and other means at its fair value" in the amount of $20,000 ($625,000 in 2015 currency). There is neither rationale for the bequest nor stipulation as to how the funds were to be disbursed, only that he was to "retain for himself" the designated amount.[334] Might it have been that before his death William Waugh privately conveyed his intention that some of those funds were to be devoted to securing Henderson's future?

Of course, for about twenty years, the young Waugh disappeared from official records, even census data. It was a common practice for free persons of color to eschew census takers, as they did not wish to call attention to themselves. This practice, they averred, was a means of safeguarding the fragile freedom of their ambiguous lives. But during these two decades, Henderson was surely gainfully employed and almost certainly saving money with which he planned his future. He emerges by name in the 1870 census, listed as a member of the household of a wealthy entrepreneur, George Lobdell, and working as a groom. It is reasonable to conclude that he was

being paid well for his service and putting aside savings from his earnings. Perhaps when he returned to Wilkes County, he carried with him substantial savings with which to establish himself as a landowner.

A third possibility is that Henderson was selling the natural resources from his property to Northern companies. Clearly, "Hence" was a successful farmer who employed other men on his farm, including white men. However, it seems implausible that the selling of fruits and vegetables, which he cultivated, brought sufficient capital with which to engage in land purchasing. More likely, he was selling timber harvested from his acreage to Northern industries that possessed an incessant need for raw materials with which to manufacture products. Perhaps, he was engaged in a partnership with his former employer, George Lobdell, who owned the lucrative Lobdell Car and Wheel Company in New Castle County, Delaware. This company consumed enormous amounts of timber and coal in its manufacturing processes and had purchased ten thousand acres of "ore, wood, and farming land" in Virginia and about five thousand acres of timber and farming land in North Carolina. Moreover, Lobdell continued the practice of procuring raw materials from its Southern holdings until early in the twentieth century, long past the lifespan of Henderson and Laura Waugh. Hence may have been lured back to Wilkes because he remembered that the area was rich with timber; he may have entertained the notion that he could sell to his old boss.

In the final analysis, it must be borne in mind that all of these scenarios are, at best, informed speculation. The actual source(s) of his cash remains a mystery.

Equally as intriguing is the question of the origin of Isaiah Smith's working capital. In the Wilkes property records, C.I. Smith's name occurs only four times as the "grantee" (the party that is buying acreage); he appears thirty times as the "grantor" (the person who is selling or disposing of land).[335] Yet, an examination of these historical documents offers more questions than answers and yields precious little insight about how and when he acquired his extensive landholdings.

Smith was also regarded as a successful farmer and, according to county records, was a teacher in the Wilkes school system for most of his adult life. In fact, during the year 1899, he once "sold" a half acre of land to the "colored" School District No. 5, in which he taught, for the sum of one dollar.[336] In 1883, he was approved by the U.S. Treasury Department as a "storekeeper and Gauger." A gauger was an excise man who inspected taxable bulk goods and products, such as the "product" manufactured by

a multiplicity of "fruit distilleries" in Wilkes County at that time. For this activity, Smith received a wage of three dollars a day.[337] The profits and wages from these endeavors, however, cannot adequately account for the resources required to procure substantive acreage.

It may have been that some of Smith's property was inherited from his father, Eldridge, who was also a landowner and farmer residing in the county. But when questioned, none of his descendants seem to possess any information that could account for the financial success and considerable landholdings of their antecedent.

What is sufficiently evident is that both Henderson Waugh and his brother-in-law C.I. Smith were successful men of color. Both were businessmen in their own right, both had managed to acquire substantive acreage during and after the tumultuous Reconstruction era and both were afforded respect within the community by whites and blacks. Notably, none of the extant documents located to date indicates that the two entrepreneurs ever collaborated relative to any land purchase, yet their lives would be inextricably linked with each other until their deaths.

"TRUSTED FRIEND"

And my trusted friend, C. I. Smith…

—Last will and testament of Henderson Waugh, 1896[338]

It was in the year 1890 that the North Western North Carolina Railroad (NWNCRR) proposed a track stretching from Greensboro through Winston and Elkin, and on to Wilkes, the terminus of which was to be located one mile from the Wilkes County Courthouse. The rail system was crucial to an area aspiring to economic development. In fact, Judge Johnson Hayes wrote in *The Land of Wilkes* that the railroad "revolutionized the county economy." He continued, "At that time, there was no railroad in Alleghany, Ashe or Watauga Counties. The terminus of the railroad at North Wilkesboro meant almost as much to the citizens of those counties as it meant to those of Wilkes."[339]

Specifically, the NWNCRR stipulated that it would construct the line if the county subscribed to $100,000 of the railroad's stock, issue bonds to subsidize the venture and gain approval from Wilkes qualified voters. The commissioners concurred with the conditions, and a vote was taken on June

16, 1887. The measure passed easily, 2,895 votes in favor out of 3,738 total votes cast.

A subsequent question arose related to the legality of the vote, necessitating a second election scheduled for November 6, 1888. In addition to the previous stipulations, NWNCRR agreed to complete its contract with the county by September 16, 1890, and to construct—at its expense—a bridge at Reddies River over which vehicles could cross. Commissioners had to agree to establish and maintain a public road leading to it. Once again, the majority of the voters gave a nod to the project. According to Hayes, "Both the railroad and the bridge across Reddies River were completed by September 16, 1890.[340]

Curiously, on that same day, an indenture was made between Henderson and Laura Waugh and the NWNCRR for a strip of land, one hundred feet wide, which traversed their Rock Creek property. The deed was executed in consideration and receipt of $300—the equivalent of $7,982 in 2015 currency.[341] The railroad company had acquired right of way through the Waugh property for its proposed line from Wilkes to Greensboro, via Elkin and Winston.

Earlier in the year, 149 Rock Creek residents met with representatives from the railroad to hear the details of the construction project. They were informed that oversight of the venture was assigned to engineers from the Richmond and Danville Railroad Company, which had acquired North Western Carolina in 1871. Subsequently, an agreement was drawn up that all attendees signed; Henderson Waugh's "X" mark was among the signatures. Each of the signers afforded the railroad a right of way measured "on each side of parallel to and fifty feet distant from the center line of the Road as may be located and constructed by said company."[342]

According to county real estate records, Henderson Waugh's final land transaction involved acreage that was part of an inheritance from his father-in-law, John Wadkins, and executed on October 25, 1890. He and Laura, along with two of her brothers and their respective spouses, C.I. Smith and John's widow, Fanny, conveyed to the youngest Wadkins sibling, Alfred, twenty-six and a half acres in the Fairplains area, bounded by land owned by Smith and Calvin Rash. A sum of $10 was exchanged, tantamount to $263 in 2015 currency. Designated as "Lot No. 2," this tract was Alfred's distributive share of property bequeathed by his father and agreed on by the other heirs.[343]

Also on that day, Alfred and the aforementioned heirs sold twenty-six and a half acres to Henderson and Laura in consideration and receipt of

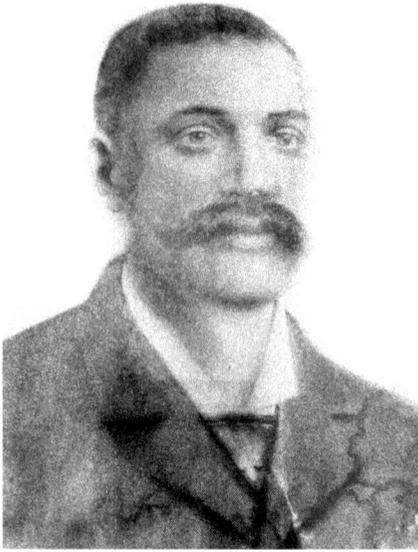

Photograph of a young William Henderson Waugh. He was allegedly the son of Matilda Grinton and William Pitt Waugh. *Courtesy of Wilton "Bud" Mitchell.*

ten dollars. Designated "Lot No. 5," this parcel was their inherited distribution bequeathed by Laura's father, John. Other distributions were made on October 25. Fanny, John's widow, was deeded twenty-six and a half acres, including the house and other building located on the property. Though executed on the same day as the other transactions, this deed wasn't officially certified and registered until June 24, 1924.[344]

There is precious little documentation providing insight as to Henderson's activities during the subsequent few years of his life. Likely, he continued farming responsibilities until he became physically unable to do so. On October 7, 1896, an ailing Henderson Waugh called to his bedside attorney John S. Cranor for the purpose of dictating a last will and testament. Perhaps Cranor was known to him as a county register of deeds or a state senator elected three years before. Whatever the case, Cranor arrived that day, paper and pen in hand, to assiduously record the wishes of a dying man. D.L. Henderson and J.C. Brewer bore witness.[345]

The concise will adhered to the standard legal format of the day. Henderson first spoke of the disposal of his remains and the payment of debts before he turned attention to his family. He bequeathed his personal belongings and real estate, purchased from "Mr. Staley," to his wife, Laura. The estimated value was $2,000, the equivalent of $57,143 in 2015 currency. He further stipulated that all of those items should be divided among his children upon her death. The four sons—John William Henderson, Henderson Garfield, James Calvin and Benjamin Harrison—were to inherit the property upon their mother's death, if they each paid to their sisters Fanny Hattie and Amy Lou "$200.00 apiece." If the sons failed to do so, then Waugh instructed that his property was to be sold and the proceeds divided equally among his six children. The document being concluded, Henderson affixed his "X" for the final time.

On October 17, 1896, seventy-two-year-old William Henderson Waugh, biracial son of Colonel William Waugh and Matilda Grinton, drew his final breath. His body was conveyed to a plot adjacent to his house and laid to rest, the grave shaded by trees both deciduous and evergreen. The execution of his final bequests was now in the hands of Henderson's designated executors: "my beloved wife, Laura, and my trusted friend, C.I. Smith."[346]

THE DEATH OF LAURA WAUGH

During the first spring of a new century, Laura Wadkins Waugh passed away, less than four years after her husband, Henderson. Though her tombstone indicates that she was fifty years old, likely she was at least four years older, as determined through other historical documents.

As her health was failing, attention turned to securing the future of her children, all of whom were minors, save one, Hattie, the oldest. Three days before her untimely death, Laura dictated a missive to family friend Captain John Peden. In the letter, dated April 17, 1900, she invoked the friendship between John and her late husband and asked him to assume guardianship of her underage children should she succumb. "In case of my death, my children will then be exposed to a life without guardian or protection [on] this property which comes to them as the harvest fruits of the labor from my husband, Henderson Waugh….I therefore call upon you as a surviving friend of my husband to take the faithful guardianship of my children."[347]

John Peden's connection with Henderson was more than casual; in fact, they shared a common bond: Colonel William Pitt Waugh. Peden was the oldest child of Mary Taylor Williams and William Waugh Peden. Born in 1840, he was only four when his father was assassinated in Moravian Falls as he was returning to Wilkesboro from William Waugh's plantation. Subsequently, the Peden family became the beneficiary of protection afforded by the respected Colonel Waugh. Great-uncle William, as John would have known him, frequently visited the Wilkesboro house he had built for the Pedens as a wedding gift in 1839—perhaps, at times, with his biracial teenager, named Henderson, in tow. Possibly, it was during those visits that John became acquainted with young Waugh before the colonel sent him northward to live a "freer life." Peden, at this time, would have been about ten years old, Henderson a young man in his twenties.

When the Civil War erupted, John and his younger brother Joseph fought for the Confederacy. John served in the Fifty-Fifth Regiment Infantry, B

Company, as a captain, commissioned on July 3, 1863. On that same day, a decisive battle was concluded in the county from which John's great-uncle William had journeyed to Wilkes some sixty years earlier. After peace was concluded, he returned to Wilkesboro to his family and business endeavors and would later serve the county as a commissioner. Notably, on January 17, 1907, three days before his own sixty-seventh birthday, Captain Peden was a featured speaker for the Wilkesboro celebration commemorating the 100th anniversary of the birth of General Robert E. Lee.[348] Doubtless, when Henderson returned to Wilkes County sometime between 1870 and 1873, he and John eventually became reacquainted. It would be a proper and reasonable course for Laura to appeal to her husband's friend to serve as guardian of the Waugh children. However, she would never know whether or not her request was honored.

Portion of the last will and testament of Henderson Waugh, penned by John Cranor in 1896. It appoints "beloved wife, Laura" and "trusted friend, C. I. Smith" as executors. *Author's photographic collection.*

On April 20, she died. Her body was conducted to the little family cemetery sloping away from the family home and laid to rest in a grave nestled against her husband's. Her name was chiseled onto the gravestone they both share.

Within days after his sister-in-law's demise, Caswell Isaiah (C.I.) Smith moved to assume the executorship of Henderson Waugh's will. Four years earlier, Henderson had requested that Laura and Isaiah Smith serve as co-executors of his will. Until her death, Laura controlled both the personal and real properties of her husband, all of which were to be divided among her children when she succumbed. It now fell to Smith to execute the final bequests as Henderson stipulated.

However, six days after his mother's demise, oldest son John William Henderson Waugh filed an affidavit with the Wilkes Superior Court requesting that his Uncle Isaiah not be allowed to continue as the executor of his father's last will and testament. John, named as the affiant, maintained that he had substantive reason to believe that his father "had no knowledge of the appointment of…C.I. Smith as executor of his will." Further, he questioned his uncle's suitability for what he considered to be compelling reasons and requested that Smith not be allowed to continue until he appeared in court to qualify himself as the executor.[349] His petition was apparently granted.

On May 28, Smith made that appearance, offering a deposition in which he repudiated the allegations made by his nephew and asked the court to rescind the temporary restraining order and permit him to proceed with executorship. Preceding the judgement, witnesses came forward to file statements of support for both the affiant and the defendant. Prominent citizen James M. Wellborn appeared before Clerk Robert M. Staley to state that he believed Smith to be insolvent and therefore unfit to serve as executor of the Waugh estate.[350]

However, Isaiah Smith had long established himself as a respectable, capable individual within a circle of influential Wilkes citizens. Not only was he known to be a successful farmer with substantial property holdings, but he also taught in the Wilkes County school system and, according to Smith's ninety-five-year-old grandson and Wilkes native Clem Redmon, kept financial records for white merchants in the area.[351] It was not surprising when a cadre of reputable men came forward to attest to Isaiah's capabilities.

First, attorney John S. Cranor, to whom Henderson had dictated his will, confirmed that he had carefully recorded the decedent's words exactly as he said them and that Waugh had designated his wife, Laura, and trusted friend, C.I. Smith, as his executors. Sheriff John H. Johnson vouched for Smith's character and suitability to serve, while fellow educator Lytle Nowlen Hickerson—Major Lytle Hickerson's grandson—stated that he had found him to be "honest and honorable" in their "considerable business dealings."[352]

While awaiting the court's decision in the matter pending, daughter Hattie Hawkins filed a petition, dated May 19, in which she relinquished any right to administer her father's will and ceded said responsibility to family friend John Peden. Likely, Hattie made the request on the strength of her mother's letter to Peden, penned on April 17, asking that he become the guardian for her underage children.[353] On May 21, clerk of superior court Linville Bumgarner upheld the restraining order, prompting an expeditious appeal

by Isaiah Smith. That appeal was scheduled to be heard by the circuit judge during the May term of the superior court.[354]

Meanwhile, on May 26, Hattie Hawkins filed a second request with the clerk of court, written on stationery from Attorney Herbert L. Greene's office, renouncing her right to administer her father's will in favor of Frank B. Hendren. This second missive recommends to suspicion that John Peden declined her previous request to assume that responsibility. Two days later, attorney Hendren was sworn in as the administrator of the last will and testament of Henderson Waugh.[355]

WAUGH-SMITH DISPUTE

When the May term of the Superior Court of Wilkes County convened, it was Robinson Judge who heard the appeal and rendered his ruling. After reviewing all the evidence, the judge set aside ten of the eleven facts delineated in the clerk's previous ruling dated May 21, 1900. He upheld fact number three: "The evidence shows that C.I. Smith is a man of good character, of good habits and understanding and is fully qualified to administer and discharge the duties of his executorship of the estate of Henderson Waugh." The presiding jurist concluded, "There was no cause for the removal of the said C.I. Smith from his office as executor," and he directed and empowered Smith to proceed with his duties without being required to execute bond.[356]

A couple of noteworthy events transpired in the aftermath of the ruling. Five of the Waugh children were now without legal guardianship, likely living in their parents' residence under the watchful eyes of older siblings. Hattie, the oldest child, was the only one of the offspring of legal age who could bear responsibility. For reasons that are yet to be ascertained, she did not file for custody of her younger brothers and sisters. John was the oldest son; however, he was only twenty in the spring of 1900 and would not have his twenty-first birthday until December 13.

Sensing that death was imminent, Laura requested that John Peden take custody of her children if something should happen. However, in the absence of an extant record indicating Peden's response, one can only infer that he declined her request. Finally, on August 10, 1900, attorney Frank Hendren applied for and was granted guardianship of the minor Waugh children until John became of legal age. It would be almost thirteen months after his mother's death that John was granted guardianship of his minor siblings by the court in a ruling dated May 14, 1901.[357]

In his will, Henderson stipulated that landholdings were to be divided among his four boys—John, Garfield, James and Benjamin—upon the death of his wife, with one condition. Each of his sons was required to pay $200 to each of his sisters, Hattie and Amy, on reaching his twenty-first birthday. At that time, none of his sons was twenty-one; Ben, the youngest, would not turn twenty-one until 1909. That stipulation, however, was eventually set aside in the fall of 1900.

An affidavit filed in superior court by the Waugh men indicated that they were unable to pay the sum required of them by the will and requested that their father's property be apportioned among the six Waugh children. The court granted the petition and appointed three commissioners to subdivide both personal property and land among the brothers and sisters: Keener M. Allen, former principal of the Moravian Falls Academy and master contractor and surveyor; Robert N. Gray; and David Leander "D.L." Henderson, local grain mill operator and one of the men present during the writing of Waugh's last will and testament.[358]

On September 29, the commissioners filed their final report. Each of the Waugh children received approximately $73.00 worth of their parents' personal property ($2,086.00 in 2015 currency). Moreover, each was apportioned a tract of land from their father's Rock Quarry property, as surveyed by Keener M. Allen: 33.75 acres to Garfield, 25.0 acres to John, 27.3 acres to Amy, 27.3 acres to Hattie, 25.0 acres to James and 27.3 acres to Benjamin. On October 22, 1900, each of the heirs paid one-sixth of the processing cost, amounting to $7.11 per person ($203.00 in 2015).[359]

Five days later—October 26—Executor C.I. Smith filed the final settlement for the Waugh estate.[360]

To this day, a little over three miles outside of North Wilkesboro's city limits, toward Roaring River, off Rock Quarry Road, the 165.65 acres once owned by Henderson and Laura Waugh stretch across the Foothills. However, in 2016—120 years after Henderson's death—the property retains little of the pristine rusticity that it possessed when he located his family there. Open fields have been hewn out of forestland. Houses have been built where there weren't any; others, including the home places of "Hence" and Laura and that of their oldest son John, have been razed. The "Old Rock Quarry Road" still snakes its way down toward the creek that rollicks across river rock, creating a small waterfall. Waugh's great-grandson Wilton Waugh "Bud" Mitchell recalls bathing in it and eating Italian fare from Roselli's Restaurant just up the hill from the creek.[361] But the road no longer wends its way to Elkin as it once did; industry

Photograph of Warner Waugh, youngest child of John William Henderson and Paulina Waugh. He is the youngest of the two living grandchildren of Laura and Henderson Waugh. *Courtesy of Wilton "Bud" Mitchell.*

and the construction of Highway 268 closed it off. The old rock quarry, once operated in the mid-1940s and jointly owned by Waugh and Lea (D.L.) Henderson, is no longer mined and lies silently obscured by trees. But the railroad tracks initially laid down by the Northwest North Carolina Railroad on a swatch of land purchased from the Waughs in 1890 still bisect part of what was the yard surrounding Henderson's house.

"My Grandfather Hence was buried in his front yard," recollected eighty-three-year-old grandson Warner Waugh. "Now that plot lies on the other side of the 'Cut'—that's what we called it." Mr. Waugh, the youngest child of John William Henderson and Paulina Waugh, was born in 1932 and is one of three remaining descendants. He resides in Philadelphia, where he has lived since he was eighteen. "I caught the train at the little station there at the Cut and rode it to Philadelphia. I got a job at a summer camp, and when that camp closed in September of 1951, I immediately took a position at the Budd Company." He worked as an electrical wiring technician for that company for thirty-six years and retired in 1987.

Though his grandparents died before he was born, Warner remembers some of the stories related to him by his mother, Paulina. "My father was a quiet man; he didn't say much. It was from my Mother that I heard most of the information, though I wished that I had paid better attention than I did." He expressed this regret several times in the course of conversation.

"Most of my grandfather's property is still owned by descendants; however, a couple of plots have been sold out of the family. When my Uncle Ben [youngest of the Waugh sons] moved to Fairplains, he sold his land to James Dowell [another relative], who eventually sold it out of the family.... The plots that I once owned have been given to my sons."

When asked about his grandfather Henderson's significance to the history of Wilkes County, Mr. Waugh initially replied, "Well, he *was* the son of a

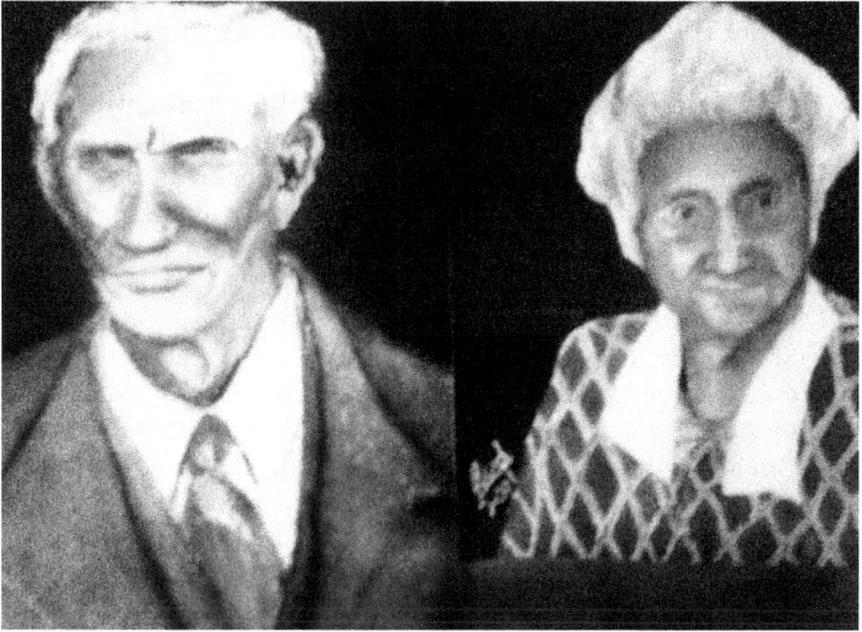

Painting of John William Henderson and Paulina Waugh by their artist grandson Wilton "Bud" Mitchell. *Courtesy of Wilton "Bud" Mitchell.*

very prominent man [Colonel William Waugh]."[362] And that distinction is arguably the initial step to understanding Waugh's importance to the county's history. If he had only been the son of a free person of color, Matilda Grinton, and a white Wilkes man of ordinary circumstances, Henderson might have escaped notice entirely. However, it is generally accepted and reasonably supported by extant documentation that he was one of two "coloured children" whom the colonel had bound to him in 1832 and 1833 for the modern equivalent of $17,000 apiece. That fact alone provided a modicum of protection during his childhood from slave-traders known to shanghai children to sell "down the river," and it was likely an advantage when he returned to Wilkes and proceeded to buy properties from notables such as Dr. James Calloway and Calvin Cowles—both of whom would have been well acquainted with William Pitt Waugh. Possibly Henderson's initial success in transacting business can be attributed to residents' vestigial respect for his father. However, that factor alone cannot account for the subsequent respect that he attained for himself among Wilkes County residents—white and black.

THE LEGACY OF HENDERSON WAUGH

In his book *The Land of Wilkes*, Johnson Hayes maintained that little changed in Wilkes County subsequent to the Civil War. "It can be said that Wilkes did not have to contend with the so-called carpet baggers. Her population remained native as it had before the war."[363] But neither North Carolina nor Wilkes County was able to escape the turmoil attendant to Reconstruction—especially the black community.

The year following ratification of the Thirteenth Amendment, the general assembly followed the lead of other Southern legislatures and passed a series of "Black Codes" designed to regulate the conduct of African Americans. UNC professor William Powell, once recognized as the state's most prolific writer of North Carolina history, describes the state's version of these codes in his book *North Carolina Through Four Centuries*. He reports that the North Carolina codes validated marriages of former slaves, afforded blacks the same rights and privileges as whites within the court system, mandated that criminal law be applicable to both races—with the exception of rape—stipulated that blacks could testify in court, and protected them from fraud and ignorance. They did not guarantee full civil rights.[364]

In June 1866, Congress passed the Fourteenth Amendment, bestowing full citizenship rights to blacks and assigning responsibility for enforcement to the federal government. Before a Southern state was readmitted to the Union, its legislature had to frame a new constitution and ratify the new amendment.

Early in 1867, most of the South was placed under military rule—North Carolina was assigned to the second of five military districts, placed under the command of Major General Daniel Sickles and, later, Brigadier General Edward R.S. Canby. At that time, reactionary secret societies began to appear in the South, protesting what they considered to be the intrusion of carpet-bagging Northerners and terrorizing the newly freed blacks in an effort to "keep them in their place." It was during this tumultuous time that the Ku Klux Klan made its debut in Tennessee and spread expeditiously to North Carolina.[365]

On July 4, 1868, North Carolina ratified the Fourteenth Amendment and rejoined the Union. Afterward, the grip of military rule was lessened. But a force of five hundred soldiers remained, headquartered in the state capital of Raleigh. That occupation would persist until 1877, when the state fully reclaimed the right to govern its own affairs.

Ulysses S. Grant was elected president later that same year, amid the rancor of Reconstruction and a nation torn apart. Voting rights for freed blacks had proven difficult to enforce, as the South resisted forced enfranchisement, and the North was allowed to ignore voting legislation altogether. In fact, of the twenty-one Northern states, only eleven allowed blacks to vote—even border states refused to comply.

Congress consequently responded on February 26, 1869, by passing the Fifteenth Amendment. This constitutional revision prohibited any state from denying a citizen the right to vote because of race, color or former condition of servitude. Knowing that resistance was useless, North Carolina promptly ratified the amendment on March 5. The Fifteenth Amendment was appended to the Constitution on March 30, 1870.

Interestingly, Delaware refused to ratify the amendment when it was presented to the state legislature on March 17 or 18, 1869. Ratification was not accomplished until February 12, 1901, thirty-one years after Henderson Waugh made his first official appearance in the census, as a black man residing and working in the George Lobdell household in New Castle County, Delaware. Though he may have lived a "freer life" in the North, it is likely that his full civil rights were not at all ensured.

The year 1870 was a trying one in the "Old North State" as the KKK sought to alter the political landscape in order to advance a "white supremacist" agenda. William Holden had reclaimed the governorship of the state, and his Unionist policies were insufferable to Klan members. Through threat, intimidation and violence, the KKK attempted to influence the outcome of elections. On February 26—the anniversary of the passage of the Fifteenth Amendment—Wyatt Outlaw was lynched by the Klan in Alamance County, east of Greensboro. A former slave and Union soldier, Outlaw was actively involved in the politics of the area. Less than three months later, state senator and Freedman's Bureau agent John W. Stephens was assassinated by the KKK at the Caswell County Courthouse, northeast of Alamance, for attempting to organize black voters there. Governor Holden dispatched troops to round up the perpetrators, only to watch them be released by federal judges.[366]

The Klan's terrorist agenda was likely a salient factor in the subsequent impeachment of Governor Holden. In March 1871, he became the first chief of state to be removed from office by a state senate, by a vote of 36–13. As the days of Jim Crow dawned, and certainly by 1876, white supremacy had successfully been reestablished in the state of North Carolina. By 1890, "separate but equal" had become the status quo.[367]

Into this milieu of malcontent, Henderson Waugh purportedly rode his "white horse" back to North Carolina and the county of his birth. Though the circumstances of his return remain enigmatic, the fact that Henderson was able to acquire significant acreage of Wilkes real estate has been irrefutably established. Moreover, he seemed to have garnered respect from prominent white leaders of the community.

Not only did he successfully transact cash purchases of land from notables Dr. James Calloway and Calvin Cowles, he ostensibly maintained genial relationships with other influential professionals: attorney and state senator John S. Cranor, who sat by his deathbed recording a last will and testament; attorney Frank B. Hendren, who eventually assumed guardianship of his underage children when wife Laura died; Captain John T. Peden, successful merchant, county commissioner and longtime friend of the Waughs; David L. Henderson, neighbor and a successful grain mill owner/operator; and E.S. Blair, noted for his substantial landholdings. Blair allowed Henderson to shelter his horse and carriage in his barn while visiting North Wilkesboro.

Though his familial tie to Colonel William Waugh might have facilitated his assimilation and acceptance, Henderson's success could be attributed to a couple of other factors as well. When he returned to Wilkes County, he apparently brought a cache of cash with him. Warner Waugh recounted a story about his grandfather that Paulina once related to him. She said that when Henderson came back to Wilkes, he had all this money. "He spread it out over the entire bed and told my Grandmother [Laura], that he had so much that he could make a bedspread out of it for her," recalled Mr. Waugh.[368]

Certainly county land records would support such a boast. In six of the documented transactions, Henderson paid cash at the time of purchase. Only once did he borrow money and offer land as collateral; at least twice he loaned money to other buyers. A perusal of his balance sheet reveals that his cash purchases exceeded receipts for sales, suggesting that he had other monetary resources at his disposal.

Additionally, Henderson was known to be a successful farmer and was reputed to be "well off" for the times in which he lived. He employed white men to assist with the farm and paid them with livestock and produce. Upon his death in 1896, the value of his property and personal effects was assessed to be $2,000 (the equivalent of $57,143 in 2015); by 1901, it was $3,000 ($85,714 in 2015).

Family tradition and popular memory maintain that Henderson Waugh returned to Wilkes County on a "white horse." "But, I doubt that claim,"

A painting of the home of John William Henderson and Paulina Waugh from the memory of artist grandson Wilton "Bud" Mitchell. *Courtesy of Wilton "Bud" Mitchell.*

ventured grandson Warner Waugh. "On one occasion when I was visiting in Woodlawn [in Fairplains], I stopped by the home of an elderly man who showed me a picture of a horse that he claimed belonged to my Grandfather Hence. He told me this was the horse that he rode from Delaware to Wilkes County and that my grandfather had named him 'Delaware.' He also said he eventually sold the horse to a man in Reidsville." The horse was black.

Mr. Waugh produced a document that was in the possession of his nephew and family historian Harvey Mitchell that substantiates the story, though it does raise questions. The document, entitled "*The Standard*—as Revised and Adopted by the American Trotting Register Association, May 19, 1891," stipulates that a horse named Prince Harbinger, bred by George G. Lobdell of Wilmington, Delaware, and foaled in 1873, was passed to Henderson Waugh, "by whom it was taken to Western North Carolina and sold to W.K. Gibbs, Reidsville, N.C."[369]

Was this the horse on which Henderson rode into Wilkes County originally? Warner is not at all certain, though he does believe that the

Page from *American Trotting Register* documenting transfer of a horse named "Prince Harbinger" from George Lobdell to Henderson Waugh. *Courtesy of Warner Waugh from Harvey Mitchell Records.*

picture shown to him by his elderly acquaintance was of Prince Harbinger, whom his grandfather renamed Delaware. "Who knows? Maybe he rode more than one horse into Wilkes at different times; one of them might have been white," hypothesized Mr. Waugh.[370]

In literature, a white horse is often depicted as bearing on his back a "hero victorious," often of regal origin—a champion of the people who prevailed against insurmountable odds. Perhaps the "white horse" referenced in the Waugh family tradition is more symbolic than real—a fitting conclusion to this ballad of Henderson Waugh. The "coloured" son of a prominent Wilkes County merchant and plantation owner, sent north to live a "freer life," prospers, returns to the land of his birth during an era of upheaval and uncertainty—particularly for people of color—and is able to acquire land while garnering respect from members of a predominately white Southern society.

Evonne Raglin, great-great-granddaughter of Judith Barber and grandniece of Henderson Waugh's brother-in-law C.I. Smith, maintained that Henderson was likely motivated by his drive to gain respect. "Respect was what the black man wanted more than anything else in life. Owning land was how [he] got it....He apparently never tried to be a community leader like C.I. [Smith]....However, Henderson was...bent on gaining respect the only way he knew how."[371]

Clearly, Henderson Waugh was a man of color who acquired substantial landholdings while gaining a respect that transcended racial distinctions during an era that "tried the souls of men." But he was not alone in those accomplishments. C.I. Smith in Wilkes, his brother Alexander Smith in

Ashe and Edmond Harris also in Ashe were men of color who amassed hundreds of acres of property and were esteemed by friends, neighbors and acquaintances of both races in the same time period.

In the final analysis, it is doubtful that Henderson ever entertained the notion that his life's story was significant enough to the history of Wilkes to be recounted in a book. Likely, he was merely content to be a productive citizen, a loving husband and a caring father who provided well for his family. And when he closed his eyes for the final time on October 17, 1896, perhaps his last sentient thought was of his children, coupled with a tacit hope that their lives might be as eventful as his had been.

ANTEBELLUM WILKES COUNTY: A HISTORY OF SLAVERY

AN AFTERTHOUGHT

*I*n 1864, as it became obvious that the outcome of the Civil War would not favor the South, Rufus Lenoir, General William Lenoir's grandson, expressed a desire to "divest himself of recalcitrant slaves" whom he considered dishonest. Clearly, the Lenoir family was growing weary of the burden of maintaining and managing their labor force. In March of the same year, Walter Waightstill—who by now had lost a leg at the Battle of Chantilly while serving as a captain in the Confederate army—articulated the growing frustration in a letter to his sister, "Aunt Sade: You know that I had made up my mind before the war that I would not again be a slave owner, not from doubt it was right for the people of the south in this age to continue to own their slaves, but because I prefer to avoid the trouble and worry of owning them."[372]

Evidence garnered from Lenoir family documents and letters suggests that periodic efforts were made to keep slave families together and children with their parents. However, any decision to do so was weighed against the exigence of ensuring that the plantation remained economically viable and profitable.

By the time North Carolina voted in February 1861 to decide the question of supporting a convention for secession, the Lenoirs of Fort Defiance were residing inside Caldwell County. Doubtless, the Lenoir men were counted among the majority who voted against the convention. Of the 801 votes cast, 615 men voted against secession—some 78 percent. Caldwell County joined Wilkes and eight of the fifteen western

North Carolina counties in expressing a desire to retain ties to a central federal government.

Curiously, area slaveholders like Calvin Cowles were outspoken Unionists—but not because of a fervent conviction that a strong federal government was an asset or some altruistic notion that slavery was immoral. The Cowles business ventures were oriented northward. He and other merchants, such as James Gwyn and partner Lytle Hickerson, transacted business in Washington, Philadelphia, New York and Boston. A civil war, if fought, would disrupt their access to those lucrative markets and reduce their profits. In the final analysis, it all came down to economics.

Cowles, like his father, Josiah, acceded to the inevitability of North Carolina's secession. In a letter to an acquaintance in New York dated May 6, 1861, Cowles asserted that "Congress should be assembled as quickly as possible and recognize the Confederate States as an independent nation. I think the good sense of the North will quickly see the folly of the effort to coerce 15 states...and give it up."[373]

Like Cowles, James Gwyn soon realized that an irrevocable course had been set. When the Washington Peace Conference failed, he expressed both his disgust and fear in a letter dated March 11, 1861, to his brother-in-law Rufus "Teddy" Lenoir: "There seems to be very little hope now of any settlement of the national difficulties....I think if all the Southern States had acted promptly and together that we might have had a peaceable separation, which would have been greatly preferable in my opinion to the Condition we shall be in for a year or two perhaps."[374]

Though slavery had been abolished in the North, the status of the blacks who lived there was not enhanced. As previously noted, even the abolitionist leadership in Washington was not prepared to acknowledge equality between the races. Sadly, the opposite was true, even for President Abraham Lincoln. Thaddeus Stevens was a rare exception. The distinguished representative from Pennsylvania worked all of his congressional career for racial equality and justice for former slaves at the expense of their owners. Though many disagreed with his methods, none questioned his motive. When he died, Stevens opted to be buried in a cemetery that permitted the burials of blacks. The inscription on his gravestone reads, in part: "I have chosen this that I might illustrate in my death the Principles which I advocated through a long life; EQUALITY OF MAN BEFORE HIS CREATOR."[375] Interestingly, a twentieth-century public figure who worked most of his adult life for racial equality was shot to

death on the 176th anniversary of the birth of Thaddeus Stevens—April 4, 1968—and almost one hundred years after Stevens's death on August 11, 1868.

In the final analysis, historic records reveal that Wilkes County slaves were not treated substantively different from others who were in forced servitude in the upper and lower South. They were bought and sold for profit. Families were divided, and children were sold apart from their birth parents if it was economically profitable to do so. Slaves were punished for insubordination, the severity of which was determined by masters who wielded absolute authority over their "human property." The only legal constraint was that there could be no overt intention to kill.

However, it would be inaccurate and unfair to demonize the majority of Wilkes County slaveholders as brutal taskmasters who, like Simon Legree, exacted a pound of flesh from the backs of their slaves. Wanton mistreatment of slaves, though it did occur, seems to have been more of an exception than the rule. Rather, slave owners were products of their time and stations in life. Slavery was an accepted, integral part of an agrarian South; few questioned its legitimacy, and most defended the right to own human chattel. And none apparently seem to think that slave ownership was inconsistent with their revered stations in the community or religious beliefs.

The institution of slavery was as old as the Dead Seas Scrolls. If history has taught us anything, it is that the subjugation of a people can only endure for a season and never produces favorable results—both those who are enslaved and those who enslave ultimately pay a formidable price. The death toll of the Civil War was staggering: Over 620,000 human beings—blacks and whites—lost their lives. About 260,000 Confederates died, of which 93,000 were killed in combat. Union deaths numbered approximately 360,000, of which 110,000 were combat-related. Disease claimed the majority of casualties—over 400,000. It is the deadliest war in the short history of the United States.[376]

It seems only fitting that the final commentary related to slavery should go to Wilkes County patriarch General William Lenoir. By his own admission, the general's view of forced servitude evolved over time to a conviction that slavery was just punishment—propitiation—for the transgressions of slaves' ancestors: "The sins of the fathers shall be visited upon the sons a thousand times to the third and fourth generations."

In 2015, a study was released that enumerated the ten states in this country in which living conditions were the worst. Mississippi, Alabama,

Arkansas, West Virginia, Tennessee, Oklahoma, South Carolina, Louisiana, New Mexico and Georgia made up the top ten. Notably, eight of the ten were among the states that had seceded from the Union in 1861.[377] If General Lenoir was alive today, would he amend his corollary to implicate not only the sins of slaves' ancestors, but also the sins of those masters who owned them?

NOTES

Introduction

1. Larry J. Griffin, "Children of Another Father."

Chapter 1

2. Ancestry.com, "1790 United States Federal Census."
3. United States Census Bureau, "History: 1790 Overview."
4. Ancestry.com, "1790 United States Federal Census."
5. Weaver, *1790 Federal Census*.
6. Kay and Cary, *Slavery in North Carolina*, 2.
7. Dunaway, "Put in Master's Pocket," 116.
8. Inscoe, *Mountain Masters, Slavery, and the Sectional Crisis*, 87.
9. Kay and Cary, *Slavery in North Carolina*, 21.
10. Staley, "Ante-Bellum People of Color."

Chapter 2

11. Ibid.
12. Staley, "Ante-Bellum People of Color."
13. Ibid.
14. Ibid.
15. *Waugh and Finley Account Books, 1815–1838* (North Carolina State Archives, Raleigh).
16. Ibid.
17. Ibid.

18. Ibid.
19. Staley, "Ante-Bellum People of Color."
20. Hayes, *Land of Wilkes*.
21. Walton, *Biographical Sketches from Burke County, NC.*
22. Compilation of the John Finley Family Records.
23. Hayes, *Land of Wilkes*, 72.
24. Interview with Pete and Betty Bishop, 2015.
25. Family records of John and Jane McDowell Brown (compiled by Joe L. Brown Jr. of Gulfport, MS.)
26. Ibid.
27. Ibid.
28. Last Will and Testament of John Brown.
29. Ibid.
30. *Family Records of John Brown*, compiled by Joe L. Brown Jr.
31. *Hamilton Brown Papers, #90.*
32. Dunaway, "Put in Master's Pocket," 123.
33. *Hamilton Brown Papers.*
34. Ibid.
35. "St. Paul's of Wilkesboro: The Origin of St. Paul's."
36. Hayes, *Land of Wilkes*, 126.
37. Inscoe, *Mountain Masters*, 65.
38. Ibid
39. Hayes, *Land of Wilkes*, 57.
40. Dunaway, *Put in Master's Pocket*, 123.
41. Ibid.
42. Ibid.
43. Lenoir Family Slaves and Slavery (compiled by family descendent Isaac Forester).
44. Ibid.
45. Ibid.
46. Ibid.
47. Ibid.
48. Ibid.
49. Inscoe, *Mountain Masters, 245.*

Chapter 3

50. Linney, "The Hanging of Kit Robbins."
51. "A Heinous Crime," Heritage Book of Wilkes County, Vol. 1, 21.
52. *State v. John Hoover,* 20 N.C. 365 (1839).
53. Meyer, "Slavery Jurisprudence on the Supreme Court of North Carolina, 1828–1858: William Gaston and Thomas Ruffin."

54. Twain, *Following the Equator*, 17–19.

55. Fletcher, *True Story of Tom Dooley*, 17.

56. Hamilton, *Correspondence of Jonathan Worth, Vol. 2*, 1205, 1207.

57. Helen T. Catterall, "State v. Negro Will, slave of James S. Battle, 18 N.C. 121 (1834)," in *Judicial Cases Concerning American Slavery and the Negro* (Washington, DC.: Carnegie Institution of Washington, 1926-1937. 5 vols.), Vol. 2, 1–266.

58. "Three-Fifths Compromise," Wikipedia, the Free Encyclopedia, accessed September 17, 2014, http://en.wikipedia.org/index.php?title=Three-Fifths_ Compromise&printable=yes.

59. Goodwin, *Team of Rivals*, 204–05.

Chapter 4

60. Hayes, *Land of Wilkes*, 71.

61. *Waugh and Finley Account Books, 1815–1838.*

62. McNeil, *Old Wilkesboro Cemetery.*

63. *Waugh and Finley Account Books, 1815–1838.*

64. Hayes, *Land of Wilkes*, 99.

65. "Mrs. Harper Tells Fascinating Story of Early Pioneers."

66. Last Will and Testament of Joseph Williams, 1840.

67. Hayes, *Land of Wilkes, 71.*

68. Ibid., 104.

69. "Reports of Cases at Law Argued and Determined in the Supreme Court of North Carolina, December Term 1845 to June Term 1846, both inclusive."

70. Ibid.

71. 28 NC 96, *STATE vs JAMES UNDERWOOD*, North Carolina Supreme Court Records, digitized by Google.

72. Ibid., 98.

73. "Reports of Cases at Law Argued and Determined in the Supreme Court of North Carolina, December Term 1845 to June Term 1846, both inclusive."

74. Ibid.

75. Ibid.

76. Ibid.

77. 28 NC 98, *STATE vs BENJAMIN DUNCAN*, North Carolina Supreme Court Records, digitized by Google.

78. Ibid., 106.

79. Richard W. Barber, *Dictates of Your Better Nature* (Sermon delivered February 13, 1859, Grogan's Chapel).

80. North Carolina Marriage Records 1839, document in author's collection (transcribed by Carol Robinson and Gail Swain).

81. Hawkins, *Mary (Peden) Barber*, 37.

82. *The Will of William Pitt Waugh, 1852* (Wilkes County Courthouse Records).

83. Hawkins, *Reverend Richard Wainwright Barber*, 9.

84. Ibid., 13.

85. Ibid.

86. Ibid., 14.

87. Ibid.

88. Ibid., 18.

89. Ibid., 29.

90. Ibid., 31.

91. Ibid.

92. Hickerson, *Echoes of Happy Valley*, 42.

93. Barber, *Richard Wainwright Barber*, 32.

94. Ibid.

95. Hayes, *Land of Wilkes*, 126.

96. Goodwin, *Team of Rivals*, 141–42.

97. Ibid.

98. Ibid., 143.

99. "Historical Events for Year 1820."

100. Ibid.

101. Goodwin, *Team of Rivals*, 61–62.

102. Ibid.

103. Grinton, et al., *Treasure Troves*, 1.

104. Stafford, *Remembering Tyra Glenn Alexander—His Ancestors and Descendants*.

105. Grinton, *Treasure Troves*, iv.

106. Hawkins, *Mary Taylor Williams (Peden) Barber*, 8.

107. Ibid., 10.

108. Staley, "Ante-Bellum People of Color."

109. St. Paul's Parish Register, 1849. SPPR is property of St. Paul's Episcopal Church, Wilkesboro, North Carolina, and kept in a safety deposit box to ensure preservation.

110. Hawkins, *Mary Taylor Williams (Peden) Barber*, 17.

111. Ibid.

112. Surry County Land Entries, Grant 1229, dated Jan. 1, 1779 (Surry County Land Records, Dobson, NC).

113. Hawkins, *Mary Taylor Williams (Peden) Barber*, 17–18.

114. Ibid., 20.

115. Ibid., 18.

116. Ibid., 18.

117. Ibid.

118. Ibid.

119. St. Paul's Parish Register, 1849.

120. Ibid.

121. Ibid.

122. Last Will and Testament of Joseph Williams, 1840.

123. Interview with Evonne Raglin (Great-great-Granddaughter of Judith).

124. Grinton, *Treasure Troves*, 1.

125. Barber, *Mary Taylor Williams (Peden) Barber*, 30.

126. Ibid., 31.

127. Ibid.

128. Ancestry.com, "1900 & 1910 United States Federal Censuses," database on-line, 2010. Provo, UT: Ancestry.com Operations, Inc.

129. Find-a-Grave.com (list of burials in the Old Damascus Baptist Church Cemetery).

130. Ancestry.com, "Federal United States Census, Slave Schedules of 1850." (Fanny Williams is listed with seven slaves, four males, three females, ages thirty-one years to three months of age.)

131. SPPR, 1849.

132. Grinton, *Treasure Troves*, 217.

133. Ibid.

134. Ancestry.com, "1900 United States Federal Census." Records indicate that Mimia was born in April 1848.

135. Grinton, *Treasure Troves*, 41.

136. Ibid.

137. Ibid.

138. Ancestry.com, "1930 United States Federal Census."

139. Grinton, *Treasure Troves*, 57.

140. Wilkes County Marriage Records.

141. Williams, *Help Me to Find My People*, 21.

142. Franklin, *Free Negro in North Carolina*.

143. Staley, "Ante-Bellum People of Color."

144. Ibid.

145. Ibid.

146. Bynum, *Unruly Women*, 103.

147. Williams, *Help Me to Find My People*, 24.

148. Ibid.

149. SPPR, dated January 7, 1849.

150. Grinton, *Treasure Troves*, 217.

151. Singleton, *Recollections of My Slavery Days*.

152. SPPR, dated May 17, 1849.

153. Ancestry.com, "1850 Federal Slave Census for Wilkes County, North Carolina."

154. Guardian, Indenture (Wilkes Genealogical Society, 18.1, p. 19), Wilkes County Court Minutes.

155. SPPR, dated November 4, 1851.

156. Ancestry.com, "1900 Federal United States Census."

157. Williams, *Help Me to Find My People*, 65.

158. *Mark 10:9*, King James version of the Bible.

159. Williams, *Help Me to Find My People*, 66.

160. Ibid., 50.

161. Ibid, 51.

162. Stafford, *Remembering Tyra Glenn Alexander*.

163. Powell, *North Carolina Through Four Centuries*, 383.

164. North Carolina State Archives, *Marriages of Freed People in North Carolina*.

165. Staley, "Ante-Bellum People of Color."

166. SPPR, dated July 21, 1854.

167. Grinton, *Treasure Troves*, 179.

168. Ibid.

169. Ancestry.com, "1900 Federal United States Census."

170. Hawkins, *Mary Taylor Williams (Peden) Barber*, 52.

171. Brooks, *Recollections of Clara Barber Harris*.

172. Hayes, *Land of Wilkes*, 156–57.

173. Interview with Evonne Raglin, daughter of Venie Smith Brooks and great-granddaughter of Clara Barber Harris.

174. Jacobs, *Incidents in the Life of a Slave Girl*, 64.

175. Williams, *Help Me to Find My People*, 6.

176. Cather, *Sapphira and the Slave Girl*.

177. Brooks, *Recollections of Clara Barber Harris*.

178. Ibid.

179. Interview with Evonne Raglin.

180. Brooks, *Recollections of Clara Barber Harris*.

181. Hawkins, *Mary Taylor Williams (Peden) Barber*, 54.

182. SPPR, dated December 27, 1857.

183. Grinton, *Treasure Troves*, 213.

184. Staley, "Ante-bellum People of Color."

185. Ancestry.com, "1880 United States Federal Census."

186. SPPR, dated February 11, 1861.

187. Staley, "Ante-Bellum People of Color."

188. Ancestry.com, "1850 Federal Census, Slave Schedules for Wilkes County, North Carolina."

189. Ibid., "1860 Federal Census, Slave Schedules for Wilkes County, North Carolina."

190. Inscoe, *Mountain Masters*, 83.

191. Ibid.

192. Grinton, *Treasure Troves*, 213.

193. Ancestry.com, "1880 United States Federal Census for Wilkes County, North Carolina."

194. Ibid., "1900 United States Federal Census for Wilkes County, North Carolina."

195. Land Records of Campbell County, Tennessee, dated August 2, 1913 (Register of Deeds, Dormas Miller, February 8, 2015).

196. Grinton, *Treasure Troves*, 217.

197. "Certificate of Death for George Woods, October 1, 1920."

198. "Certificate of Death for Emma Whitney, November 18, 1920."

199. "Tennessee State Marriages, 1780–2002, for John Whitney and Alice Woods, July 9, 1921."

200. "Certificate of Death for Mrs. John Whitney (Alice) dated November 10, 1925."

201. Grinton, *Treasure Troves*, 217.

202. Hickerson, *Echoes of Happy Valley*, 60–1.

203. Nps.gov., *Casualties at Antietam* (Official Records of the War of the Rebellion and the Antietam Battlefield Board).

204. Manarin, *North Carolina Troops*, Vol. 3, 155.

205. Hayes, *Land of Wilkes*, 170.

206. Hawkins, *Reverend Richard W. Barber*, 35.

207. Find-a-Grave.com (list of burials within the Ricard's Chapel AME Zion Cemetery).

208. SPPR, Baptismal Record for Eliza Williams Barber, dated July 12, 1863.

209. Interview with Paulette Turner, great-granddaughter of Eliza Barber.

210. Interview with Dwight Jones, Queens, New York, grandson of Eliza Barber.

211. Find-a-Grave.com., Burial Record for Eliza Jane Suddith Barber.

212. Hawkins, *Reverend Richard W. Barber*, 34.

213. SPPR, Death Record of Anthony Williams, Partner of Judith Williams Barber, dated June 27, 1864.

214. SPPR, Death Record of William Morgan Barber.

215. Grinton, *Treasure Troves*, 233.

216. Ibid., 233.

217. Interview with Dwight Jones, Queens, New York.

218. Grinton, *Treasure Troves*, 268.

219. "Certificate of Death for Alice Barber Taylor." North Carolina Certificates of Death, 1909–1976.

220. Find-a-Grave.com, Cemetery Record of Albert Taylor.

221. Grinton, *Treasure Troves*, 234.

222. Ibid., 271–72.

223. Evonne Raglin Interview with Artie Gilreath, 2015.

224. Hickerson, *Echoes of Happy Valley*, 110.

225. Wikipedia, "Wilmington, North Carolina in the American Civil War."

226. Hickerson, *Echoes of Happy Valley*, 107.

227. Hardy, *Watauga County North Carolina*, 88.

228. Wikipedia, "Freedman's Bureau."

229. Staley, "Ante-Bellum People of Color."

230. Hickerson, *Echoes of Happy Valley*, 107–08.

231. Ibid., 108–09.

232. Ibid., 112–13.

233. Miles, *From Siam to Surry*, 110–11.

234. Grinton, *Treasure Troves*, 89.

235. Hawkins, *Reverend Richard W. Barber*, 39

236. Ibid., 37.

237. Ibid.

238. Ibid., 62–65.

239. Ibid.

240. Ibid., 45.

241. SPPR, Death Record of Richard Wainwright Barber, dated December 19, 1907.

242. Hawkins, *Reverend Richard W. Barber*, 55.

243. Ibid., 44.

244. Grinton, *Treasure Troves*, 179.

245. SPPR, dated April, 1873.

246. Grinton, *Treasure Troves*, 1–2.

247. Ibid.

248. Ibid.

249. Interview with Evonne Raglin, relative to "Mammy Judy."

250. Mamie Barber, *Faithful Colored Woman Dead* (reprint of this news article found in *The Heritage of Wilkes County, Vol. I*), 92.

Chapter 5

251. Staley, "Ante-Bellum People of Color," 5.

252. Guardian, Indenture (Wilkes Genealogical Society, 18.1, p. 19), Wilkes County Court Minutes.

253. Waugh-Watkins Family Reunion Book, "Keeping Ties and Traditions Alive," 4.

254. Ancestry.com., North Carolina Marriage Records for Wilkes County, North Carolina (marriage record for Martha "Patsy" Laws and Sherrod Seagraves, 1830).

255. "Burial Record of William Pitt Waugh, Jr. (1844–1880)."

256. "1840 United States Federal Census for William P. Waugh Jr."

257. Alexander, *Ambiguous Lives: Free Women of Color in Rural Georgia, 1789–1879*, 4.

258. Ibid.

259. Ibid., 5.

260. Staley, "Ante-Bellum People of Color," 1.

261. Ibid., 2.

262. Ancestry.com, "1830, 1840, 1850 United States Federal Censuses."

263. Ibid., "1850 United States Federal Census."

264. "Burial Record for William Waugh (1739–1823)."

265. "Last Will and Testament of David Waugh, 1815."

266. Hayes, *Land of Wilkes*, 71.

267. "Last Will and Testament of David Waugh, 1815."

268. "Last Will and Testament of William Pitt Waugh, 1852."

269. Ancestry.com, "1870 United States Federal Census."

270. Ibid.

271. Derganc, "Lobdell Car Wheel Company," 1–4.

272. Line adaptation from *A Christmas Carol* by Charles Dickens (Reprint, New York: Fall River Press, 2013), 1–2. Original line read, "Old Marley was as dead as a doornail….This must be distinctly understood or nothing wonderful can come of the story I am going to relative."

273. Hayes, *Land of Wilkes*, 153.

274. "Marriage and Family Records, 1788–1912," *Marriages of Freed People, Wilkes County—Husbands' Index* (37 loose certificates located at North Carolina Archives, Raleigh, NC).

275. Foner, *Reconstruction*, 296.

276. Hickerson, *Echoes of Happy Valley*, 115. Knob Creek, Tennessee, is thirty miles from Pulaski, the town in which the Klan first appeared.

277. Wikipedia, "Ku Klux Klan."

278. Fletcher, *True Story of Tom Dooley*, 17.

279. Foner, *Reconstruction*, 137; 294–95.

280. Klein, "Southern Railroad Leaders, 1865–1893."

281. Derganc, "Lobdell Car Wheel Company," 4.

282. Wilkes County Land Records, Register of Deeds, Wilkes County Courthouse (grantee: Henderson Waugh).

283. Thomas Jefferson University: Home of the Sidney Kimmel Medical College, Jefferson.edu (university website).

284. Hubbard, *Physicians, Medical Practice and Development*, 6–7.

285. Miles, *From Siam to Surry*, 43–44.

286. Hubbard, *Physicians, Medical Practice and Development*, 8.

287. Wilkes County Land Records, Register of Deed, Wilkes County Courthouse (grantee: Henderson Waugh, grantor: James Calloway).

288. Ibid. (grantee: Henderson, grantor: Calvin Cowles).

289. "North Carolina Marriage Records 1741–2011 for Henderson Waugh."

290. "1860 United States Federal Census."

291. Waugh-Watkins Family Reunion Book, "Keeping Ties and Traditions Alive," 6.

292. Ancestry.com, "On-line Genealogical Search for the George Massey Foster Family."

293. Wilkes County Land Records (grantee: Henderson Waugh, grantor: George Massey Foster).

294. Waugh-Watkins Family Reunion Book, "Keeping Ties and Traditions Alive."

295. Interview with Wilton "Bud" Mitchell, great-grandson of Henderson Waugh.

296. "North Carolina, Wills and Probate Records, 1665–1998 for Henderson Waugh."

297. "North Carolina, Death Certificates, 1909–1976 for John William Henderson Waugh."

298. Waugh-Watkins Family Reunion Book, "Keeping Ties and Traditions Alive," 7.

299. Ancestry.com, "1880 United States Federal Census for Henderson Waugh."

300. Wilkes County Land Records (grantee: Henderson Waugh, grantor: T.F. Bolick.)

301. Ibid. (grantee: C.W. Minton, grantor: Henderson Waugh.)

302. Ibid. (loan from M.C. Church to Henderson and Laura Waugh.)

303. Ibid. (grantee: Henderson Waugh, grantor: Rufus Triplett; grantee: Mara Triplett; grantor: Henderson Waugh).

304. Ibid. (loan from Henderson Waugh to Robert Gibbs and Samuel Hampton).

305. Ibid. (grantee: Henderson Waugh, grantor: W.M. Robb Church).

306. Ibid. (grantee: Virginia Church and Ann Triplett, grantor: Henderson Waugh).

307. Hayes, *Land of Wilkes*, 80.

308. Studdert-Kennedy, "Indifference" (A Poem).

309. Hayes, *Land of Wilkes*, 91–2.

310. Ancestry.com, "1880 United States Federal Census for Easley Staley."

311. Hayes, *Land of Wilkes*, 124.

312. Wilkes County Land Records (grantee: Robert Martin Staley, grantor: Esley Staley).

313. Ibid. (grantee: C.J. Staley, grantor: Robert and Mary Staley).

314. Ibid. (grantee: Henderson Waugh, grantor: C.J. Staley, Amelia Gwaltney and W.R. Gwaltney).

315. "North Carolina, Death Certificates, 1909–1976 for Hattie Waugh Hawkins."

316. World War II Draft Registration Card of Henderson Garfield Waugh, 1942."

317. Index of California Deaths, Ancestry.com (Death Notice for Henderson Garfield Waugh).

318. Waugh-Watkins Family Reunion Book, "Keeping Ties and Traditions Alive," 6.

319. Wilkes County Death Records, death certificate for James Calvin Waugh.

320. Waugh-Watkins Family Reunion Book, "Keeping Ties and Traditions Alive," 6.

321. Wilkes County Death Records, death certificate for stillborn twins of B.H. Waugh.

322. Ibid., death certificate for Hazel Waugh.

323. Ibid., death certificate for Benjamin Harrison, Waugh.

324. Waugh-Watkins Family Reunion Book, "Keeping Ties and Traditions Alive."

325. "North Carolina, Death Certificates, 1909–1976 for Amy Lou Watkins."

326. Wilkes County Land Records (grantee: William B. Reeves, grantor: Henderson and Laura Waugh).

327. Interview with Evonne Raglin.

328. "1850 United States Federal Census for Isaiah Smith."

329. "1890 Civil War 1890 Veterans Special Schedule for Caswell I. Smith."

330. Bumgarner, *Kirk's Raiders*.

331. Ibid.

332. Ancestry.com, "1880 United States Federal Census for Isaiah Smith."

333. Wilkes County Land Records for Henderson Waugh and C.I. Smith.

334. "Last Will and Testament of William Pitt Waugh, 1852."

335. Wilkes County Land Records for C. I. Smith.

336. Ibid. (grantee: School District No. 5, grantor: C.I. Smith).

337. Barber-Harris-Smith, *Roots of Love Reunion Book, Caswell Isaiah Smith (C.I.)*, 111.

338. "Last Will and Testament of Henderson Waugh, October 7, 1896."

339. Hayes, *Land of Wilkes*, 185.

340. Ibid., 184.

341. Wilkes Land Records (grantee: NWNC RR, grantor: Henderson and Laura Waugh).

342. Ibid., (Agreement between NWNC RR and landowners of Rock Creek Township).

343. Ibid. (grantee: A.A. Wadkins, grantor: William Wadkins, et al).

344. Ibid. (grantee: Henderson Waugh, grantor: A.A. Wadkins, et al).

345. "Last Will and Testament of Henderson Waugh, October 7, 1896."

346. Ibid.

347. "North Carolina, Wills and Probate Records, 1665–1998 for Henderson Waugh" (John Peden letter from Laura Waugh).

348. Hayes, *Land of Wilkes*, 290.

349. "North Carolina, Wills and Probate Records, 1665–1998 for Henderson Waugh" (affidavit by John W.H. Waugh).

350. Ibid. (James Welborn affidavit).

351. Evonne Raglin, interview with Mr. Clem Redmon.

352. "North Carolina, Wills and Probate Records, 1665–1998 for Henderson Waugh" (statements of John S. Cranor, John H. Johnson and Lytle Nowlen Hickerson).

353. Ibid. (Hattie Hawkins letter).

354. Ibid. (Linville Bumgarner ruling).

355. Ibid. (Hattie Hawkins request and subsequent appointment of Frank B. Hendren).

356. Ibid. (ruling of Judge Robinson Judge).
357. Ibid. (Frank B. Hendren's appointment as temporary guardian).
358. Ibid. (appointment of three commissioners to subdivide Waugh properties).
359. Ibid. (final report of Waugh property commissioners).
360. Ibid. (final settlement filed by C.I. Smith).
361. Interview with Wilton "Bud" Mitchell, 2016.
362. Interview with Mr. Warner Waugh of Philadelphia.
363. Hayes, *Land of Wilkes*, 172.
364. Powell, *North Carolina Through Four Centuries*, 383.
365. "Reconstruction in North Carolina," nccivilwar150.com/hist.
366. Ibid.
367. Ibid.
368. Interview with Warner Waugh.
369. American Trotting Register Association, May 19, 1891, entry number 14384.
370. Interview with Mr. Warner Waugh.
371. Interview with Ms. Evonne Raglin

Antebellum Wilkes County

372. Lenoir Family Slaves and Slavery (compiled by family descendent Isaac Forester).
373. Inscoe, *Mountain Masters*, 251.
374. Ibid., 248–49.
375. Wikipedia, "Thaddeus Stevens."
376. "Civil War Casualties: The Cost of War, Killed, Wounded, Captured, and Missing."
377. "10 States with the Worst Quality of Life," Yahoo Finance.

BIBLIOGRAPHY

Books

Alexander, Adele Logan. *Ambiguous Lives: Free Women of Color in Rural Georgia, 1789–1879*. Fayetteville: University of Arkansas Press, 1991.

Bumgarner, Matthew. *Kirk's Raiders: A Notorious Band of Scoundrels and Thieves*. N.p.: self-published, 2000.

Bynum, Victoria. *Unruly Women: The Politics of Social and Sexual Control in the Old South*. Chapel Hill: University of North Carolina Press, 1992.

Cather, Willa. *Sapphira and the Slave Girl*. New York: Random House Vintage Books, 1975.

Catterall, Helen T. "State v. Negro Will, Slave of James S. Battle, 18 N.C. 121 (1834)." In *Judicial Cases Concerning American Slavery and the Negro*, vol. 5. Washington, DC: Carnegie Institution of Washington, 1926–1937.

Dickens, Charles. *A Christmas Carol*. New York: Fall River Press, 2013.

Dunaway, Wilma A. "Put in Master's Pocket: Cotton Expansion and Interstate Slave-Trading in the Mountain South." In *Appalachian and Race*, ed. John Inscoe, 87. Lexington: University Press of Kentucky, 2001.

Foner, Eric. *Reconstruction: America's Unfinished Revolution 1863–1877*. New York: Harper and Row, 1988.

Fletcher, John. *The True Story of Tom Dooley*. Charleston, SC: The History Press, 2013.

Franklin, John Hope. *The Free Negro in North Carolina, 1790–1860*. New York: Russell & Russell, 1969.

Goodwin, Doris Kerns. *Team of Rivals: The Political Genius of Abraham Lincoln*. New York: Simon & Schuster, 2006.

Grinton, Elizabeth, et.al. *Treasure Troves*. Winston Salem: Newsouth Printing Services, 1996.

Hamilton, J.G., ed. *The Correspondence of Jonathan Worth, Vol. 2*. Raleigh, NC: Edwards and Broughton Printing Company, 1909.

Hardy, Michael. *Watauga County North Carolina in the Civil War*. Charleston, SC: The History Press, 2013.

Hawkins, Elizabeth (Betsy) Wainwright Barber. *Mary Taylor Williams (Peden) Barber, 1819–1882*. N.p.: self-published, 2007.

———. *The Reverend Richard Wainwright Barber, 1823–1907*. N.p.: self-published, 2009.

Hayes, Johnson J. *The Land of Wilkes*. Wilkesboro, NC: Wilkes Heritage Museum, 1962 and 2010.

Hickerson, Thomas Felix. *Echoes of Happy Valley*. Published by the Author, Distributed by Bull's Head Bookshop, Chapel Hill, NC, 1962.

Hubbard, Fred C. *Physicians, Medical Practice and Development of Hospitals in Wilkes County, 1830 to 1975*. N.p.: self-published, 1975.

Inscoe, John C. *Mountain Masters, Slavery, and the Sectional Crisis in Western North Carolina*. Knoxville: University of Tennessee Press, 1989.

Jacobs, Harriet. *Incidents in the Life of a Slave Girl*. New York: Dover Publications, 2001.

Kay, Marvin L. Michael, and Lorin Lee Cary. *Slavery in North Carolina, 1748–1775*. Chapel Hill: University of North Carolina Press, 1995.

Manarin, Louis H., comp. *North Carolina Troops, 1861–1865*. Wilmington, NC: Broadfoot Publishing Company, 2004.

Miles, Melvin. *From Siam to Surry*. N.p.: self-published, 2013.

Powell, William S. *North Carolina Through Four Centuries*. Chapel Hill: University of North Carolina Press, 1989.

Singleton, William Henry. *Recollections of My Slavery Day*. Raleigh: North Carolina Division of Archives and History, 1999.

Twain, Mark. *Following the Equator*. Vol. 2. New York: Harper and Brothers Publishers, 1899.

Walton, Thomas George. *Biographical Sketches from Burke County, NC*. Morganton, NC: *Morganton Herald*, 1894.

Weaver, Jeffrey C. *The 1790 Federal Census for Wilkes County, North Carolina*. Saltville, VA: New River Notes Books, 2005.

Williams, Heather A. *Help Me to Find My People*. Chapel Hill: University of North Carolina Press, 2003.

Internet Sources

Ancestry.com. "Certificate of Death for Alice Barber Taylor." North Carolina certificates of death, 1909–76.

———. "Certificate of Death for Emma Whitney, November 18, 1920." Kentucky death records for Barren County.

———. "Certificate of Death for Mrs. John Whitney (Alice), November 10, 1925."

———. "Certificate of Death for George Woods, October 1, 1920." Kentucky death records for Whitley County.

———. "Death Notice for Henderson Garfield Waugh." Index of California deaths.

———. "1880 United States Federal Census for Esley Staley."

———. "1880 United States Federal Census for Henderson Waugh."

———. "1850 Federal Census, Slave Schedules for Wilkes County, North Carolina."

———. "1850 United States Federal Census for Isaiah Smith."

———. "1840 United States Federal Census for William P. Waugh Jr."

———. "1890 Civil War Veterans Special Schedule for Caswell I. Smith." Accessed January 15, 2016. http://interactive.ancestrylibrary.com/8667/NCM123_58-0736/518341?backurl=http://search.

———. "1860 Federal Census, Slaves Schedules for Wilkes County, North Carolina."

———. "Genealogical Search for the George Massey Foster Family."

———. "1900 United States Federal Census for Minor Wilborn."

———. "North Carolina Marriage Records, 1741–2011, for Henderson Waugh." Accessed July 9, 2015. http://interactive.ancestrylibrary.com/60548/42091_343633-00104/3.

———. "North Carolina Marriage Records for Wilkes County, NC." Marriage Record for Martha "Patsy" Laws and Sherrod Seagraves. 1830.

———. "Reports of Cases at Law Argued and Determined in the Supreme Court of North Carolina, December Term 1845 to June Term 1846, both inclusive." Accessed November 7, 2014. http://homepages.rootsweb.ancestry.com/~dobson/nc/ncwilke2.html.

———. "Tennessee State Marriages, 1780–2002, for John Whitney and Alice Woods, July, 9, 1921" (Campbell County record of marriage).

———. "United States Federal Census Collection." http://search.ancestry.com/search/group/usfedcen.

Ancestry Library.com. "North Carolina, Wills and Probate Records, 1665–1998 for Henderson Waugh." Accessed September 14, 2015.

———. "North Carolina Death Certificates, 1909–1976, for Amy Lou Watkins." Accessed January 9, 2016. http://interactive.ancestrylibrary.com/1121/S123_409-0175?pid=872.

———. "North Carolina Death Certificates, 1909–1976, for Hattie Waugh Hawkins." Accessed January 9,2016. http://interactive.ancestrylibrary.com/1121/S123_479-2809?pid=601.

———. "North Carolina Death Certificates, 1909–1976, for John William Henderson Waugh." Accessed July 7, 2015. http://interactive.ancestrylibrary.com/1121/S123_505-1363/?backlab.

———. "U.S. World War II Draft Registration Card of Henderson Garfield Waugh, 1942." Accessed January 9, 2016. http://interactiveancestrylibrary.com/1002/004669494_01555?pid=1.

Civil War.org. "Civil War Casualties: The Cost of War, Killed, Wounded, Captured, and Missing." http://www.civilwar.org/education.

Find-a-Grave.com. "Burial Record of Albert Taylor."

———. "Burial Record of Eliza Jane Suddith Barber."

———. "Burial Record of William Pitt Waugh. 1775-1852." Accessed July 28, 2015. http://www.findagrave.com/cgi-bin/fg.cgi?page=gr&GRid=47301037.

———. "Burial Record of William Pitt Waugh Jr. 1840-1844." Accessed July 9, 2015. http://www.findagrave.com/cgi-bin/fg.cgi?page=gr&GRid=42895440.

———. "Burials Within the Old Damascus Baptist Church Cemetery."

———. "Burials Within the Ricard's Chapel AME Zion Cemetery."

Finest of the Wheat.org. "Indifference." Poem by G.A. Studdert-Kennedy. http://finestofthewheat.org/indifference-a-k-a-when-jesus-came-to-golgotha/.

Google. NC 96, *STATE vs JAMES UNDERWOOD*. North Carolina Supreme Court Records.

———. NC 98, *STATE vs BENJAMIN DUCAN*. North Carolina Supreme Court Records.

HistoryOrb.com. "Historical Events for Year 1820." Accessed December 31, 2014. http://www.historyorb.com/com/events/date/1820.

Jefferson.edu. "Thomas Jefferson University: Home of the Sidney Kimmel Medical College." http://www.jefferson.edu/university.html.

NCCivilwar150.com. "Reconstruction in North Carolina." http://www.nccivilwar150.com/hist.

Nps.gov. "Casualties at Antietam." Official Records of the War of the Rebellion and the Antietam Battlefield Board.

St. Paul's of Wilkesboro. "The Origin of St. Paul's." Accessed October 9, 2014. http://stpaulwilkesboro.org/the-origin-of-st-pauls-pd-30.php.

United States Census Bureau. "History: 1790 Overview." Accessed March 2, 2016. history/www/through_the_decades/overview.

Wikipedia. "Ku Klux Klan." https://en.wikipedia.org/wiki/Ku_Klux_Klan.

———. "Thaddeus Stevens." https://en.wikipedia.org/wiki/Thaddeus_Stevens.

———. "Three-Fifths Compromise." Accessed September 17, 2014. http://en.wikipedia.org/index.php?title=Three-Fifths_Compromise&printable=yes.

———. "Wilmington, North Carolina in the American Civil War." https://en.wikipedia.org/wiki/Wilmington,_North_Carolina_in_the_American_Civil_War.

Wilkes County, North Carolina GenWeb. "Mrs. Harper Tells Fascinating Story of Early Pioneers." Accessed November 7, 2014. http://wwwncgenweb.us/wilkes/newspapers/gn-4-10-41.html.

Yahoo! Finance. "The 10 States with the Worst Quality of Life." http://www.finance.yahoo.com/news.

County Courthouse Records

Guardian, Indenture. Wilkes County Court Minutes as transcribed by Wilkes Genealogical Society, 18.1, p.19.

Land Records of Campbell County, Tennessee. Office of the Register of Deeds.

"Last Will and Testament of David Waugh, 1815." Wilkes County, North Carolina Courthouse.

"Last Will and Testament of Henderson Waugh, October 7, 1896." Wilkes County, North Carolina Courthouse.

"Last Will and Testament of Joseph Williams, 1840." Surry County, North Carolina Courthouse.

"Last Will and Testament of William Pitt Waugh, 1852." Wilkes County, North Carolina Courthouse.

Surry County Land Records. Surry County Courthouse, Dobson, North Carolina.

Wilkes County Death Records. Office of the Register of Deeds. Wilkes County, North Carolina Courthouse.

Wilkes County Land Records. Office of the Register of Deeds. Wilkes County, North Carolina Courthouse.

Wilkes County Land Records for C.I. Smith and Henderson Waugh.

Wilkes County Marriage Records. Wilkes County, North Carolina Courthouse.

Archival, Church and Family Records

American Trotting Register Association, May 19, 1891. Entry Number 14384. (Provided by Wilton "Bud" Mitchell.)

Barber, Richard W. *Dictates of Your Better Nature.* Sermon delivered February 13, 1859, Grogan's Chapel.

Brooks, Venie Smith. *Recollections of Clara Barber Harris.* Biographic Sketches of Her Grandmother, Clara Barber Harris. (Provided by Evonne Raglin.)

Heritage Book of Wilkes County, NC, Volume I.

John and Jane Mc Dowell Brown Family Records. Compiled by Joe L. Brown Jr., Gulfport, MS. (Provided by Pete and Betty Bishop.)

John Finley Family Records. (Document in the Possession of Wilkes Genealogical Society, Wilkesboro, NC.)

Last Will and Testament of John Brown, 1812. (Document in the possession of Wilkes Genealogical Society, Wilkesboro, North Carolina.)

Lenoir Family Slaves and Slavery. (Compilation by Isaac Forester.)

McNeil, George. *Old Wilkesboro Cemetery.* Presentation, October 24, 1999.

North Carolina Marriage Records, 1839. (Document in author's collection, transcribed by Carol Robinson and Gail Swain.)

North Carolina State Archives. "Marriages of Freed People in North Carolina." North Carolina Marriage and Family Records, 1788–1912—C.R. 104.606.1.

North Carolina State Archives. *Waugh and Finley Account Books, 1815–1838.* Account Books, AB 80.

Stafford, Penny J. *Remembering Tyra Glenn Alexander—His Ancestors and Descendants.* Compiled genealogy. (Provided by Evonne Raglin.)

St. Paul's Parish Register (SPPR), 1849.

University of North Carolina. *Hamilton Brown Papers.* Collection No. 90. Wilson Library, Southern Historical Collection, microfilm edition.

Waugh-Watkins Family Reunion Book, "Keeping Tie and Traditions Alive, 2002." Compiled by Thomas Harvey Mitchell.

Newspapers and Journals

Barber, Mary Taylor. "Faithful Colored Woman Dead." *Wilkes Journal,* 1912.

Dergnac, Christopher S. "Lobdell Car Wheel Company." *Historical American Engineering Record,* 1976.

Griffin, Larry J. "Children of Another Father." *The Record,* February 18, 2015.

Klein, Maury. "Southern Railroad Leaders, 1865–1893: Identities and Ideologies." *Business History Review* 42, no. 3 (1968).

Linney, Ruth. "The Hanging of Kit Robbins." *Wilkesboro Hustler,* July 25, 1956.

Meyer, Timothy C. "Slavery Jurisprudence on the Supreme Court of North Carolina, 1828-1858: William Gaston and Thomas Ruffin." *Campbell Law Review* 313 (2010): 318.

Interviews and Miscellaneous Sources

Barber, Elizabeth, of Wilkes County, North Carolina (deceased 2015), Judith Williams Barber family, interview with author.

Gilreath, Artie, of Wilkes County, North Carolina (deceased 2016), George Washington Petty and Judith Barber families, interview with author.

Jones, Dwight, of Queens, New York, descendant of Judith Williams Barber, interview with author.

Mitchell, Wilton "Bud," of Forsyth County, North Carolina, descendant of William Henderson Waugh, interview with author.

Raglin, Evonne, of Wilkes County, North Carolina, descendant of Judith Williams Barber, interviews with author.

BIBLIOGRAPHY

Raglin, Evonne, interview with Artie Gilreath, 2015.

Redmon, Clem, of Wilkes County, North Carolina (deceased 2016), descendant of Caswell Isaiah Smith, interview with Evonne Raglin.

Staley, Kathy. "Ante-Bellum People of Color in Wilkesboro." Master's thesis, 2005.

Turner, Paulette, of Wilkes County, North Carolina, descendant of Judith Williams Barber, interview with author.

Waugh, Warner, of Philadelphia, Pennsylvania, descendant of William Henderson Waugh, interview with author.

INDEX

T

Taylor, Susan 60

U

Underwood, James 24, 45, 46, 47, 48, 49

W

Wade, Maria 76
Walton, William 20
Watkins, Amy Lou Waugh 127, 134
Waugh, Benjamin Harrison 127, 134
Waugh, Henderson 72, 103, 106, 111, 114, 115, 117, 120, 121, 125, 127, 130, 132, 133, 134, 135, 136, 137, 138, 142, 144, 145, 146
Waugh, Henderson Garfield 125, 134
Waugh, James Calvin 125, 134, 162
Waugh, John William Henderson 120, 125, 134, 137, 140
Waugh, Laura Wadkins 118, 120, 124, 128, 130, 131, 133, 135, 136, 138, 144
Waugh, William P. 24, 28, 42, 44, 47, 50, 54, 55, 63, 71, 72, 103, 104, 108, 109, 115, 130, 135, 141, 144
Waugh, William Pitt, Jr. 105
Whitney, Alice Barber Woods 83, 84, 86, 88, 91
Wilborn, Mimia Barber 65, 68, 71

Williams, Anthony 24, 44, 58, 60, 62, 64, 66, 67, 68, 70, 71, 75, 76, 78, 80, 90
Williams, Fanny 32, 52, 55, 58, 60, 62, 64, 67, 68, 71, 76, 77, 80, 83, 84, 90, 97, 98
Williams, Jane 83
Williams, Joseph, Jr. 44, 47, 52, 54, 58, 59, 61, 62, 63, 72, 84
Williams, Joseph, Sr. 59, 60
Williams, Lucy 45, 58, 60, 62, 63, 64, 71, 86, 91, 99, 129
Williams, Rachel 64, 71

ABOUT THE AUTHOR

*L*arry J. Griffin, international education consultant and founder of The Griffin Education Institute for Study and Teaching (T-GEIST), is a dynamic trainer who is in high demand. He is an eloquent speaker and draws from his vast experience in early education to make his presentations, keynotes and trainings entertaining and relevant. He has trained thousands of teachers, administrators and parents across this country, in Canada and in Europe.

Locally, Larry has served as the curator for the Wilkes Heritage Museum, where he managed exhibits and conducted tours for individuals, school groups and other visitors to the museum. Additionally, he has served as a guide for the Historic Wilkesboro Ghost Tours, sponsored by the museum. Larry writes extensively about the history of Wilkes County for the *Record*, the county's first international newspaper, in a column entitled "Setting the Record Straight." Over the last three years, Larry has received four awards from the North Carolina Society of Historians—two of which were the distinguished Paul Jehu Barringer Jr. & Sr. Award of Excellence and the prestigious President's Award of Excellence. In 2015, he was elected vice-president of the society. A member of the Wilkes County Genealogical Society, he serves as editor of its publication. He teaches early childhood classes for Wilkes County Community College in area high schools and on the college campus.

Larry has a BA in early childhood and elementary education, with an emphasis in the social studies, from the University of North Carolina at Charlotte (UNCC). Additionally, he holds a MEd in education administration with an emphasis in curriculum and instruction, also from the UNCC.

www.ingramcontent.com/pod-product-compliance
Lightning Source LLC
Chambersburg PA
CBHW060801100426
42813CB00004B/898